GREEK POTTERY
AN INTRODUCTION

Brian A. Sparkes

Manchester University Press
Manchester and New York

Distributed exclusively in the USA and Canada by St. Martin's Press

Published by Manchester University Press
Oxford Road, Manchester M13 9PL, England
and Room 400, 175 Fifth Avenue, New York, NY 10010, USA

Distributed exclusively in the USA and Canada by St. Martin's Press, Inc.,
175 Fifth Avenue, New York, NY 10010, USA

A catalogue record for this book is available from the British Library

Library of Congress cataloging in publication data

Sparkes, Brian A.
 Greek pottery: an introduction / Brian A. Sparkes.
 p. cm.
 Includes bibliographical references and index.
 ISBN 0-7190-2236-3 (cloth). – ISBN 0-7190-2936-8 (paper)
 1. Pottery, Greek. I. Title.
 NK3840.S65 1991
 666'.3938—dc20 91-17266

ISBN 0 7190 2236 3 *hardback*
 0 7190 2936 8 *paperback* 6003680963

Typeset in Hong Kong by Best-set Typesetter Ltd
Printed in Great Britain
by Biddles Ltd, Guildford and King's Lynn

CONTENTS

List of illustrations vii

List of abbreviations xi

Preface xiii

I Introduction 1

II Making 8
 The potteries 8
 Forming 13
 Decorating 17
 Firing 21
 Scientific approaches 26

III Dating 28
 Relative dates 28
 Absolute dates 31
 Contexts 32
 Stylistic comparisons with other works 38
 History, myth and subject matter 46
 Inscriptions 52
 Scientific dating 59

IV Shapes 60
 Distinguishing functions 60
 The game of the names 62
 Potters 65
 Other materials 68
 Shapes and functions 71
 Occasions and contexts 73
 Aesthetics of shape 78
 Alphabetical list of vase names 79

V Decoration 93
 Monochrome 93
 Black-figure 95
 Red-figure 96
 White-figure and white-ground 98
 Polychrome 101
 Coral red 102
 Black gloss 103
 Inscriptions 110
 Painters and names 113
 Patterns 116
 Compositions and subjects 117
 Influences 122

VI Out of the shop 124
 Graffiti and dipinti 124
 Trademarks 126
 Prices 129
 Distribution 131

 Notes 136
 Bibliography 155
 Index 182

ILLUSTRATIONS

I Introduction

1. Stages in the history of a vase (adapted from Olin and Franklin 1980, 122, fig. 1).
2. The main vase gallery of the Berlin Museum, ca. 1900.
3. Modern museum display of Greek pottery, The Historical Museum, Bern.
4. Pottery from a well in the Athenian Agora.

II Making

1. Geological map of Greece (adapted from Jones 1986, 104, Fig. 3.1a).
2. Plan of modern potter's traditional workshop in Crete (adapted from Betancourt 1984, fig. 18-3).
3. Attic black-figure kylix, from Etruria (?). ca. 550 B.C. Ht. 13 cm; diam. of bowl 19.2 cm. Karlsruhe, Badisches Landesmuseum inv. 67/90.
4. Making a hydria (adapted from Cuomo di Caprio 1985, 76–7, fig. 13).
5. Attic red-figure bell-krater. ca. 430 B.C. Diam. 37.6 cm. Oxford, Ashmolean Museum 526. Painted by the Komaris Painter (Beazley 1963, 1063, no. 3).
6. Attic red-figure mug (shape 8c). ca. 430–420 B.C. Ht. 8.7 cm. Malibu, The J. Paul Getty Museum 86.AE.243 (Bareiss). Painted by the Eretria Painter (Beazley 1963, 1688 and 1705).
7. Corinthian votive plaque showing kiln. Sixth century. Paris, Louvre MNB 2856.
8. Modern reconstructed drawing of an ancient kiln (adapted from Winter 1978, 28, fig. 9 and Williams 1985, 9, fig. 5).
9. Unfinished Attic red-figure krater fragment, used as a test piece. ca. 460 B.C. Berlin Staatliche Museen V.I. 3362. Probably painted by the Methyse Painter (Beazley 1963, 634, no. 4).
10. Parian stamped transport amphora handle. ca. third century B.C.

Athens, British School at Athens, Stamped Amphora Handle Collection H72. Magnification × 49. Fragment of granite/gneiss and muscovite mica visible.

III Dating

1. Attic Geometric cremation grave of a woman, found in the Athenian Agora. ca. 850 B.C. (adapted from Smithson 1968, pl. 18).

2. Some of the contents of the grave of one of the Corcyrean ambassadors to Athens, found in the Athenian Kerameikos cemetery. ca. 433 B.C.

3. Detail of the Parthenon frieze (West XIII, 25) (Alison Frantz photograph).

4. Attic red-figure pelike, from Nola. ca. 430–420 B.C. Ht. 17 cm. Berlin, Staatliche Museen F 2357. Painted in the manner of the Washing Painter (Beazley 1963, 1134, no. 8). (Photo: Isolde Luckert).

5. Attic red-figure kylix, from Caere. ca. 480 B.C. Diam. of bowl 32.8 cm. Oxford, Ashmolean Museum 1911.615. Painted by the Painter of the Oxford Brygos (Beazley 1963, 399, below).

6. Attic red-figure hydria. ca. 465 B.C. Ht. 36.6 cm; diam. 29 cm. Würzburg, Martin von Wagner Museum ZA 20 (on loan from Takuhiko Fujita, Tokyo). Painted by one the Earlier Mannerists (the Agrigento or the Leningrad Painter).

7. Attic Panathenaic prize amphora, from Caere. 336–335 B.C. (Pythodelos archon). Ht. 83 cm. London, British Museum B 607. The Nikomachos series (Beazley 1956, 415, no. 4).

8. 'Hadra' hydria, from Hadra, Alexandria. 19 May 213 B.C. (Year 9, Hyperberetaios 30, Pharmeuthi 7; Timasitheos (son) of Dionysios of Rhodes, an Ambassador; by Theodotos, agent). Ht. 43.6 cm. New York, Metropolitan Museum 90.9.29 (purchase, 1890).

9. Rhodian transport amphorae and Rhodian stamped amphora handles. Third century B.C. Athens, Agora Museum SS 7581 and 7582, and SS 7584 (all from deposit B 13:7).

IV Shapes

1. Protocorinthian lekythos with vase name scratched retrograde in Cumaean (?) script, from a tomb at Cumae. ca. 675–650 B.C. Ht. 5.5 cm. London, British Museum GR 1885.6–13.7.

2. Protocorinthian (?) aryballos with name of pottery Pyrrhos painted retrograde in Euboean script. ca. 650 B.C. Ht. 5 cm. Boston, Museum of Fine Arts 98.900 (H.L. Pierce Fund). (Courtesy Museum of Fine Arts, Boston.)

3. Boeotian Geometric pyxis. ca. 700 B.C. Ht. 15 cm. Athens, National

Museum 11795.

4. Silver and black mugs, the silver from Dalboki, Bulgaria. ca. 400 B.C. Ht. 9.4 and 10 cm. Oxford, Ashmolean Museum 1948.104 and 1874.409.

5. Cretan relief pithos-amphora, from Arkhanes (?). ca. 675 B.C. Ht. 156 cm, diam. 87 cm. Paris, Louvre CA 4523.

6. Cooking pots and braziers used in Athens, from the Athenian Agora. Mid fifth to mid fourth century. Max. diam. ca. 23 cm. Athens, Agora Museum P 21948 on P 21958 and P 14655 on P 16521.

7. Public pots used in Athens, from the Athenian Agora: water clock (capacity 6400 cc), drinking cup, liquid measure (capacity 270 cc), and dry measure (capacity 1820 cc). Fifth and fourth centuries B.C. Athens, Agora Museum P 2084, P 5117 (diam. 13.7 cm), P 13429 (ht. 13.3 cm), P3559 (ht. 13.2 cm).

8. Attic red-figure kylix, from Vulci. ca. 500 B.C. Ht. of frieze 6.8 cm. London, British Museum E37. Painted and signed by Epiktetos (Beazley 1963, 72, no. 17).

9. Rhodian perfume pot in the shape of a swallow. ca. 600 B.C. Ht. 6.5 cm. London, British Museum GR 1860.4–4.32.

10. Drawn outlines of pots

 (a) amphorae (neck- and belly-)
 (b) alabastra, aryballoi and askos
 (c) chous and chytra
 (d) hydriai (shoulder and kalpis)
 (e) kados and kantharos
 (f) kraters (column and volute)
 (g) kraters (calyx and bell)
 (h) kylikes (lip and type B)
 (i) lebes and lekane
 (j) lekythoi (early, tall and squat)
 (k) lekanis, lydion and mug
 (l) oinochoai (trefoil and beaked) and olpe
 (m) pelike, psykter and pyxis
 (n) skyphos (Corinthian and Attic types)
 (o) stamnos, stemless and stemmed dish

V Decoration

1. Attic black-figure fragmentary amphora, Type A. ca. 540 B.C. Philadelphia, University Museum 4873. Painted by Exekias (Beazley 1956, 145, no. 16).

2. Attic white-ground fragmentary lekythos. ca. 440 B.C. London, British Museum GR 1907.7–10.10. Painted by the Bosanquet Painter (Beazley 1963, 1227, no. 10).

3. Sicilian polychrome fragmentary squat lekythos. ca. 350–325 B.C.

Ht. 13.2 cm. Malibu, The J. Paul Getty Museum 86.AE.399 (Bareiss Collection). The Lentini Group (attributed by von Bothmer).
4. Italian black plate with stamping and added colour ('Teano'). ca. 350–300 B.C. Diam. 26.2 cm. Baltimore, Walters Art Gallery 48.108.
5. Attic black stemless cup. ca. 450–440 B.C. Diam. 18 cm. London, British Museum GR 1864.10–7.1591 (Fikellura grave 39bis).
6. Apulian red-figure volute-krater. ca. 380–370 B.C. Ht. 68.8 cm. London, British Museum F 283. Painted by the Iliupersis Painter (Trendall and Cambitoglou 1978, 193, no. 7).
7. Attic hemispherical ('Megarian') bowl. ca. 200 B.C. Diam. 13.4 cm. Athens, Agora Museum P 590.
8. 'Exekias made and painted me' – a painted inscription on an Attic black-figure neck-amphora. ca. 550 B.C. Berlin, Staatliche Museen F 1720. Painted by Exekias (Beazley 1956, 143, no. 1).
9. Attic red-figure kylix. ca. 490 B.C. Diam. of bowl 22.5 cm. Basel, Antiken Museum BS 439. Painted by Onesimos (Beazley 1963, 323, no. 56).
10. Attic red-figure kylix. ca. 480 B.C. Diam of bowl 24.3 cm. Schwerin, Museum 725 (1307). Painted by Onesimos (Beazley 1963, 325, no. 73).
11. Corinthian black-figure kylix. ca. 580 B.C. Diam. of bowl 20.3 cm. Basel, Antiken Museum BS 1404. Painted by the Cavalcade Painter.
12. Attic red-figure kylix. ca. 490 B.C. Est. diam. of bowl 31.6 cm. Malibu, The J. Paul Getty Museum 86.AE.286 (Bareiss Collection). Painted by the Brygos Painter (Beazley 1971, 367, no. 1 bis addendum to Beazley 1963, 369).

VI Out of the shop

1. Graffito on underside of Attic skyphos. Sixth century B.C. Diam. 0.7 cm. Athens, Agora Museum P 17824 (Lang 1976, B 1).
2. Ostraka consisting of fragments of the wall of an Attic red-figure calyx-krater found in the Athenian Kerameikos, naming Megakles, son of Hippokrates. Early fifth century B.C. Athens, Kerameikos 4118. Painted by the Kleophrades Painter (Knigge 1970, pl. 1).
3. Graffito on underside of Attic red-figure pelike (from Johnston 1978, 222, Ill. 1). Late fifth century B.C. Ht. 37 cm. Naples, Museo Nazionale 1511600. Painted by the Nikias Painter.
4. Attic red-figure kylix. Ca. 500 B.C. Diam. of bowl 18.5 cm. Baltimore, Johns Hopkins University. Painted by Phintias (Beazley 1963, 25, no. 14).

LIST OF ABBREVIATIONS

AA	*Archäologischer Anzeiger*
AAA	*Athens Annals of Archaeology*
ABSA	*Annual of the British School at Athens*
ADelt	*Arkhaiologikon Deltion*
AJA	*American Journal of Archaeology*
AK	*Antike Kunst*
AM	*Athenische Mitteilungen*
Anat. Stud.	*Anatolian Studies*
AR	*Archaeological Reports*
Arch. News	*Archaeological News*
Arch. Class.	*Archeologia Classica*
AW	*Antike Welt*
BABesch.	*Bulletin Antieke Beschaving*
BAR	*British Archaeological Reports*
BCH	*Bulletin de Correspondance Hellénique*
BICS	*Bulletin of the Institute of Classical Studies*
CQ	*Classical Quarterly*
CR	*Classical Review*
CRAI	*Comptes Rendus de l'Académie des Inscriptions et Belles-Lettres*
EAA	*Enciclopedia dell'Arte Antica*
Expedition	*Expedition, Bulletin of the University Museum of the University Philadelphia*
Getty MJ	*The J. Paul Getty Museum Journal*
Greek Vases	*Greek Vases in the J. Paul Getty Museum* I-IV, *Occasional Papers on Antiquities* 1, 3, 2, 5 (1983, 1985, 1986, 1989)
GRBS	*Greek, Roman and Byzantine Studies*

ABBREVIATIONS

JBM	*Jahrbuch Berliner Museum*
JDAI	*Jahrbuch des Deutschen Archäologischen Instituts*
JHS	*Journal of Hellenic Studies*
JOAI	*Jahreshefte des Oesterreichischen Archäologischen Institutes*
MJBK	*Münchner Jahrbuch der Bildenden Kunst*
MMAB	*Metropolitan Museum of Art Bulletin*
MMJ	*Metropolitan Museum Journal*
NC	*Numismatic Chronicle*
OJA	*Oxford Journal of Archaeology*
PBA	*Proceedings of the British Academy*
PBSR	*Papers of the British School at Rome*
PCPS	*Proceedings of the Cambridge Philological Society*
Phil. Trans. R. Soc. Lond.	*Philological Transactions of the Royal Society London*
RA	*Revue Archéologique*
RM	*Römische Mitteilungen*
ZPE	*Zeitschrift für Papyrologie und Epigraphik*

PREFACE

This book arose out of a half-hour lecture given in two successive one-day conferences for teachers, organised jointly by The Joint Association of Classical Teachers and the British Museum Education Service and held in the British Museum some years ago. It is not a history of Greek pottery nor is it a study of Greek painting, nor again a picture book – all those are catered for elsewhere. I have organised it in a way that highlights various aspects and approaches, and it is hoped that it will prove useful to students of Classical Greek civilisation. I am grateful to the Manchester University Press for agreeing to publish it.

The museums named in the list of illustrations were very generous in furnishing photographs and in giving permission for the reproduction of material in their care. Mr Alan Burn, Head of the Cartographic Unit at the University of Southampton, had the figures specially drawn for this book; my thanks to him.

Financial assistance towards publication was very kindly provided by The Joint Association of Classical Teachers and the University of Southampton.

I have been fairly liberal with bibliographical references, not that I imagine that readers will have access to all the publications, rather that the references provide the evidence on which statements in the text are based and can be followed up in university or specialist libraries by the more industrious student. A word of warning: the references to Beazley 1956, 1963 and 1971, and to Carpenter 1989, are to lists of illustrations, not to the illustrations themselves.

The book is dedicated to my wife who has provided inspiration and support from start to finish.

I
INTRODUCTION

Archaeologists in general and students of ceramics in particular largely live in an ancient world of their own creation. (Casson 1938, 464)

To understand the important rôle clay and pottery played in the lives of the ancient Greeks, one need only consider the many and various objects in use today that are the equivalent of those earlier products, e.g. buckets, saucepans, light bulbs, clocks, jewel boxes, perfume sprays, wine bottles, tankards, toys, feeding bottles, roof tiles, beehives. Some today are still fashioned from clay, many are not, especially the finer wares which are now usually made of glass, china or plastic. There was a vast range of pottery production in antiquity, from heavy-duty storage jars and cooking ware to elegant wine cups and miniature perfume pots. Most social needs could be answered by the potter, and his rôle in the community was central and busy. There were few areas of life in which the potter failed to assist – anything that needed a container would usually find a ready answer at the potter's shop: water, wine, oil, honey, grain, brine, vinegar, fish, olives, etc.

For the Greeks, whether in Greece itself or in the other areas of the Mediterranean and beyond, where they settled, clay was usually readily available; it was a fundamental natural resource. When fired, it was porous, so if unglazed, it kept the contents cool by allowing evaporation; it was to a large extent waterproof, especially if glazed. It was malleable and thus could be formed into a great variety of shapes. Fashion ensured constant changes in shapes and details of shapes (foot, handles, lip, etc.) and in the decoration, whilst the differences in the geological base from which clays were dug led to differences in the fabric and finish. Hence the products are susceptible to study stylistically, chronologically and geographically.

The chapters that follow look at Greek pottery from a number of viewpoints and try to present a broad picture that gives some notion of their variety and importance. This is not a history of Greek vase-painting, though painted pottery has the largest part to play. The interest and high quality of Greek figured vases have tended to concentrate attention on those in particular, and often it has been the drawings on the vases that

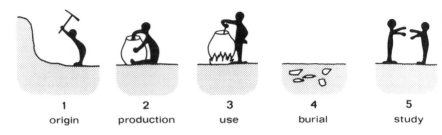

| 1 | 2 | 3 | 4 | 5 |
| origin | production | use | burial | study |

I.1 Stages in the history of a vase

have been made the focal point of Greek vase studies. This is natural, but such an approach tends to unbalance the study (as doubtless is the case here) and runs the risk of placing the vases in the category of art objects, to the exclusion of other considerations.

Greek pottery can be studied from many points of view (Fig. I.1): technique, period, place of production, function, shape, decoration, distribution, etc. The five chapters that follow deal with

(a) the techniques of forming, painting and firing with some attempt to sketch the organisation of potteries;

(b) the means used nowadays to date pottery, both relatively and absolutely;

(c) the shapes the potters created for the various needs of life and death, with a discussion of the names of potters and of shapes;

(d) the decoration that was applied to the shapes, whether incised, relief or painted, with a consideration of the different motifs, geometric, floral and figured, the last leading to a discussion of painters and subject matter;

(e) the later life of pottery: how much it cost, where, why and how it travelled, etc.

The types of evidence on which a study of this sort is based are:

(a) the pots themselves. They can be investigated singly for the techniques of making, shape and decoration, and for their petrological and chemical composition; they can be compared with others which share similarities in shape and so forth; and they can be studied in the contexts in which they were found, to help date them relatively or absolutely, to understand their function, and to see how far from their place of origin they may have been moved.

(b) the equipment of production. This can be the kiln evidence, workshop finds, trial pieces, etc.

(c) the references to pots and pottery production in written sources. There are some references in ancient authors and a few inscriptions that provide information, but the yield is not great. It has often been pointed

out that pottery, being a private, not a 'state' concern, is almost invisible in the literary record.

(d) the illustrations on painted pottery. A few show potters and painters at work; these are mainly to be found on Corinthian and Attic products and provide vital clues on technique and organisation.[1] Much more common are figured scenes with the pots in everyday use, and these are an unrivalled source of evidence.

(e) ethnography. Throughout antiquity the environment did not change: the summers were hot and dry, the winters cold and wet; the soil was mainly stony, the vegetation sparse. These conditions still obtain, and there has been much recent study of those potters in the eastern Mediterranean who continue to produce pottery by traditional methods. These may help towards creating a more vivid picture of ancient production.[2]

Ancient Greek pottery had a long development and a remarkable continuity; survival is abundant, and the areas of production are widespread, though evidence is not evenly balanced in time or place. The potters were businessmen, pot-making their livelihood. Their work was also a craft; some of them were high quality craftsmen, others, both in forming shapes and adding decoration, were poor at their job. The distinction does not tell us who were the better businessmen, that is a question of markets served and pots sold. The figured wares that carry complex and allusive stories argue a clientele that is literate and urban; such material is not a hallmark of the rural communities.

Study of the subject is constantly changing with new material and new approaches. The following paragraphs indicate the whereabouts of the actual material and some of the principal published sources of it.

Museums. The big national collections were mainly built up in the nineteenth century and contain material that was excavated in the manner of the time or that had been gathered into private collections earlier. The vases are therefore mainly isolated pieces, and the treasure aspect of them is hard to eradicate, though many museums now adopt a more didactic rôle (Figs. I.2 and 3). Some local museums in Greece, and in other countries where Greeks settled or with which they traded, house material excavated nearby and kept in the contexts in which they were found. There are also private collections, some open to the public, and these tend to contain pieces that have been acquired individually for their instrinsic art-historical interest. Catalogues of museum holdings are published from time to time, also annual bulletins of new, or studies of old, acquisitions.[3]

Exhibitions. On occasion material within a museum or borrowed from elsewhere is put on show in a special display which concentrates on e.g. a site, a centenary, a subject, an artist. A catalogue is usually produced to mark the exhibition and presents an up-to-date account of work in that

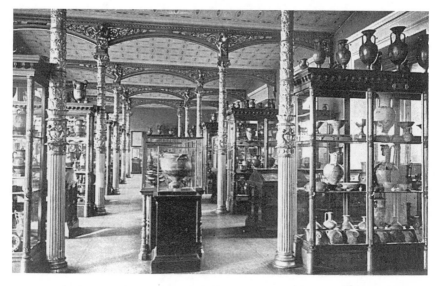

I.2 A vase gallery of the Berlin Museum ca. A.D. 1900

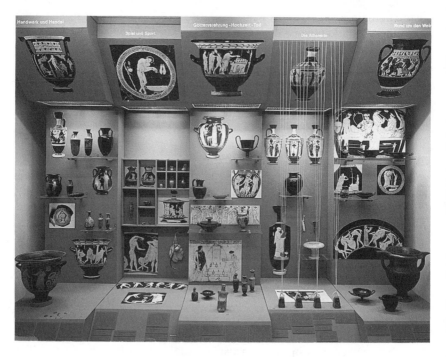

I.3 A modern museum display of Greek pottery, Bern

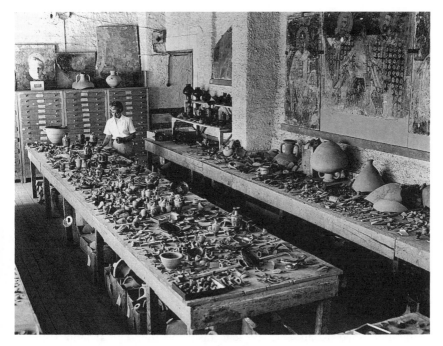

I.4 Pottery from a well in the Athenian Agora

particular field. So whereas an exhibition is temporary, the catalogue furnishes a permanent record of it.[4]

New finds. Excavations in territories bordering on the Mediterranean, and indeed in such areas as south Russia and the inland parts of European and Middle Eastern countries, and now increasingly in underwater contexts, reveal the presence of Greek pottery, often in abundance (Fig. I.4). The material may be whole (e.g. often in graves) or badly fragmented (e.g. on a town site); the condition usually depends on the type of site. Occasionally, a brief account of the finds is published within the year (e.g. in such publications as the annual *Archaeological Reports* of the Hellenic Society and the British School at Athens, or the annual *Chroniques* of the *Bulletin de Correspondance Hellénique*; for Greece there is the *Arkhaiologiki Ephemeris* and the *Arkhaiologikon Deltion*; and for Italy, *Notizie degli Scavi and Studi Etruschi* provide a similar service). With important, planned excavations, later, more detailed and definitive reports are published, either in archaeological periodicals, in single volumes, or in continuing series such as those of the American excavations in Athens and Corinth or the French at Delphi and Delos.[5]

Sale catalogues. Not all new material comes from controlled excavations. The art market, wherever based, whether Switzerland, London or New York, feeds the demands made by some museums and private collectors for new material. This material may be the contents of a private collection formed earlier that is being sold, or may consist of objects that have been illegally excavated and smuggled out of the country of discovery.[6]

Publications. As pottery can be studied from many different aspects, the range of publications is vast. Also, quite naturally, the publications serve different needs: to inform and interest scholar, student or lay person, archaeologist, historian or art-lover.

There is an international barrage of academic journals (such as *The Journal of Hellenic Studies, The American Journal of Archaeology, Revue Archéologique, Antike Kunst, Jahrbuch des Deutschen Archäologischen Instituts*) that contain articles of specific character. In these it is the expert speaking to his colleagues.[7] Other journals provide studies that are aimed at the beginner, but in most cases a general background knowledge of the subject is needed. As far as books are concerned, here too there is great variety, from the detailed monograph on a very specialised subject (e.g. a vase shape, imagery, religious use) to general histories of greater or lesser bulk and of varying emphasis (art, myth, trade). Keeping track of the work being published is an ever present task for the scholar and student; occasionally a resumé of recent work is published, with annotated bibliographies.[8]

Students are well served with histories of Greek vase-painting, in whole or part, and in some volumes the photographs are of high quality, whereas in others the emphasis is on the text, and the illustrations need supplementing from other picture books. Naturally, painted pottery bulks large in books concerned with Greek art, as indeed it does in those dealing with religion, social life, economics, etc.[9]

A special word may be said about the volumes in the *Corpus Vasorum Antiquorum* series, begun in 1923. They now comprise nearly 250 fascicules from 24 countries, and present vases from Bronze Age Cretan and Cypriot to Italiot black and relief painted, with a concentration on Attic black- and red-figured pottery. Not all are of usable quality, especially the earlier ones which tended to illustrate vases at a small scale and in poor photographs, but the more recent fascicules are of a high standard.[10]

Less attention has been paid in general publications to Greek coarse wares. Of the heavy-duty wares, the transport jars (amphorae), because of their usefulness in establishing trade relations, have been quite extensively studied and published.[11]

Congresses. Another way in which the study of pottery is advanced and promulgated is through the gathering of scholars to speak and discuss research work centring on chosen themes. The proceedings of these

congresses often provide the most up-to-date thinking on topics of interest.[12]

II

MAKING

'To make pottery': commonly said instead of 'to work hard' *The Souda* (tenth century A.D.)

The potteries

The areas of the Mediterranean and beyond in which the Greeks lived in antiquity were rich in clays: the Greek mainland, the islands, Asia Minor, Sicily and south Italy. However, not all clay deposits are equally suitable for the making of pottery or of any other clay object, as the geological make-up of the different regions varies and provides their own particular compositions of clay (Fig. II.1). For this reason, as well as for reasons of historical development, some areas were better able than others not only to produce pottery for local use but also to supply pots for others, whether as containers or as objects of value in themselves. Naturally, there were many pottery producers who had no outlets beyond a limited local area, and indeed no incentive to make more than they could sell in the immediate neighbourhood.[1]

The clays that prove useful in pottery production are those which are known as secondary or sedimentary clays: they are rocks which have been weathered and moved by erosion, and contain organic or mineral impurities such as iron, sand, stones and vegetable matter. The primary or residual clays which have not moved and are uncontaminated by foreign matter, are of less use. The fact that the composition of clays differs from region to region helps in tracking to its place of origin the pottery found scattered over the Greek world and beyond. Often the differences between the clay body of pots can be seen with the naked eye; one of the most easily discernible differences is that between the clay of Corinthian fine wares which is relatively pure and fires to a greenish yellow colour, and the less pure clay found in and around Athens which is rich in micas, feldspars and quartz, and fires to a strong red colour. But in many instances the eye is not enough, and there are differences that can be better or only understood by the use of such modern scientific techniques as optical emission spectroscopy and the thin sections of petrographic analysis (see pp. 26–7). Such analysis has shown, for instance, that some of the clay that was

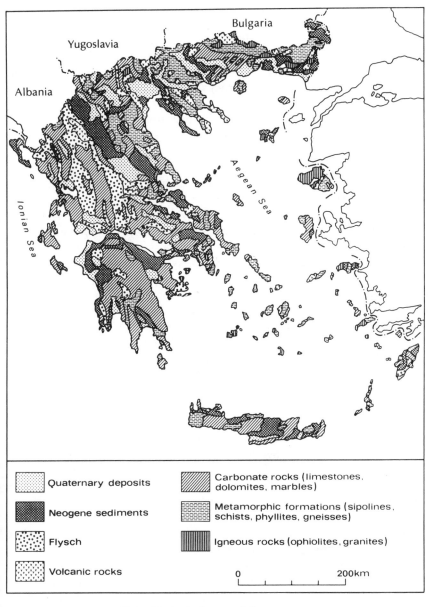

II.1 Geological map of Greece

worked near the Athenian Agora was brought in from Cape Kolias 15 km away.

The qualities which all clays share to a greater or lesser degree and which they must have if potters are to make use of them, are (a) pliability which renders the material malleable while it is being worked; (b) porosity which enables the moisture to evaporate in the drying and firing process; and (c) vitreousness which leads to hardening in the firing. Some clays are more suitable for the making of fine wares, whilst others, having a higher resistence to thermal shock, are more satisfactory for the production of cooking wares, such as the clay from the island of Aegina on the Saronic Gulf.

Greek pottery was produced in vast quantities and in many different places, but comparatively little is known of the layout of workshops and the establishments where pottery was made. Kilns have been excavated, and these give evidence for one aspect of the work involved in a pottery, but the wider picture is still relatively indistinct. Ethnological studies of modern workshop practices have suggested some methods of organisation that might have existed in classical Greek times.[2] Certainly, an effective method of work, once created, would be retained, as experimentation was likely to prove too costly. Family businesses must have been common. Plato (*Republic* 467A) has Socrates ask: 'Haven't you noticed how, in a craft like the potter's, children serve a long apprenticeship, watching how things are done, before they take a hand in the work themselves?' Sons (and maybe daughters) would follow their parents and gain experience from practical apprenticeship. Amongst the few names of potters and painters that have survived, there are some which show such relationships between father and son and other members of a family (see pp. 67, 112).

Not all production units would have worked the whole year round; the smaller, household-based industries in which the women of the family were likely to have played a major rôle in pottery production alongside the men, would have been carried on in the spring and summer, filling the gaps in the store of domestic crockery by mending the old and making new. A look at the agricultural and religious calendars shows that gaps in the farmer's year and dates for annual festivals would encourage seasonal working in the potteries. Nor would all potters have necessarily remained in one place to carry out their work; itinerant potters who served the needs of different villages by coming with their pack animal and their load of pots and/or wet clay and working among the local people, have been known in modern Greece and in other parts of the Mediterranean in recent times, and such 'strolling' potters are likely to have been in business in antiquity.[3] Some of these peripatetic concerns would also be unlikely to use a wheel; they would either use a turntable which, needing less force, might have been turned by the women, or would build up the pots on a fixed base, as has

been customary in areas of Greece and Cyprus until recently. Like wheels, kilns also were not indispensable items of equipment, as pots could (and can) be fired in surface bonfires.

Even the larger establishments have left little trace, but once again comparisons with modern traditional practices can be made. Potters may have been in business on their own, with a few assistants (perhaps members of their own family), and would seek to earn their livelihood from the making and selling of their own products. At the other end of the scale would be the groups of workshops situated in towns where wealth was concentrated, demand was high and work might continue all the year round, and where a wide variety of specialised wares would be produced, serving both local and distant demands. It is these workshops that we know best today, mainly from the study of their varied output, but it is doubtful if we should think in terms of really large businesses. Even for Athens, the most plentiful production centre of fine pottery in ancient Greece, one recent estimate suggests that the total number of people working in the potters' shops at any one time in fifth century B.C. is unlikely to have exceeded five hundred.[4] This is very much an estimated figure: for less well known centres and for the smaller outfits there is too little evidence even to hazard a guess. The potter's status is likely to have been low; some were immigrant workers, some slaves. Conditions would have been harsh, and punishment severe.

In the larger congregations of potteries work seems to have been carried out close together in a particular district, producing a social bond and intense rivalry. Athens and Corinth both had their 'potters' quarter' where it would seem that the greater proportion of the craftsmen carried out their work in fairly small individual workshops.[5] At Corinth it is suggested that the shops which were located on the fringes of the settlement, as near to the clay and fuel sources and the farmlands as to the centre of the town, were nucleated workshops with workers in separate establishments, whereas at Athens the shops were near the Agora and may have been manufactories (with the workers in one building) rather than nucleated arrangements. It has been shown that at Athens one painter might work for six different potters, and one potter serve as many as ten different painters, and this argues a more extended unit.

If we are to imagine what a potter's establishment looked like, we must envisage (Fig. II.2) an open yard with room for mounds of clay that have been brought in from the nearby clay pits, a good supply of water, and a generous store of wood needed for the firings. To one side of the yard would be the shed in which the potter's wheel, etc. was housed, and not far away would be the kiln itself, decked with small religious offerings to ensure a successful firing. Some area of the yard might be used for the building up of larger pots by hand in sections, and room would be needed

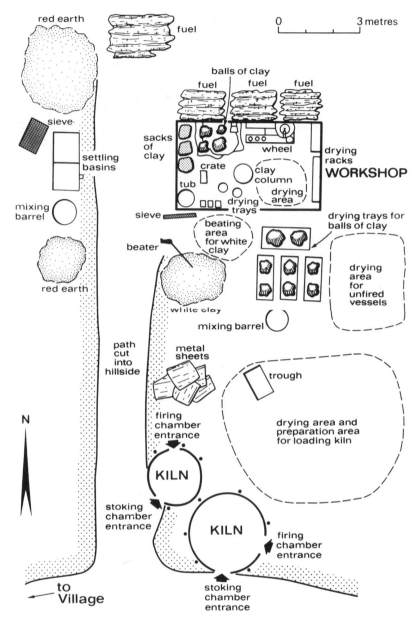

II.2 Plan of modern potter's traditional workshop in Crete

for the drying-out of the pots after they have been formed and before the firing.

The crude clays were first dug by open extraction from the clay pits and along with other materials were transferred to the potter's yard by pack animal. It is usually necessary to remove unwanted elements such as pebbles and roots, and the clay is mixed with water to form a slurry from which the impurities can be washed away. For the fine wares it is the purer clays that are wanted, whereas for the coarse, heavy-duty containers and for the larger architectural figures of terracotta, temper in the form of sand and crushed rock would have been added to give the finished article the required strength. The clay is then dried out in the yard and cut in squares, and left to weather for some months, being added to the older clays to form the mixture that the potter needs.

Let us now consider the three major stages in the making of a pot: forming, decorating and firing.

Forming

Within the potter's workroom, which may have been a fairly dark, enclosed building, the business of throwing the pots took place. The equipment in the shed would have varied. Not all pots were made on the wheel; indeed, we have already seen that some were made freehand, maybe with the help of a low-level turntable, which could be square and made of stone or wood, and was a slower process than the wheel, or maybe built up in the yard itself if they were big jars like the 'Ali Baba' pithoi that were formed in coils or slabs.[6] Some pots were made with a paddle and anvil, the paddle being struck against the emerging shape of the pot, the anvil held inside to provide a surface to receive the blows.[7] This process produced a thinness that was required for some of the shapes of cooking pots to enable them to be set on the fire and be heated without cracking. Some of the more elegant shapes were made in moulds, e.g. the perfume bottles formed in the shape of birds (Fig. IV.9), animals and humans, and vases in the shape of human and animal heads that were used as drinking cups; also mould-made were the very popular hemispherical bowls with relief decoration that are the major fine wares of the Hellenistic period (Fig. V.7) and are best known later from the shapes and patterns encountered in Roman red wares (see pp. 26, 110).

However, much the most important method was that which depended on the fast wheel. This demanded more constant, physical effort, and was most likely man's work. More standardised and livelier shapes were produced by this technique, and en masse, so not merely for one household. The invention of the fast wheel was certainly a fundamental advance in method.

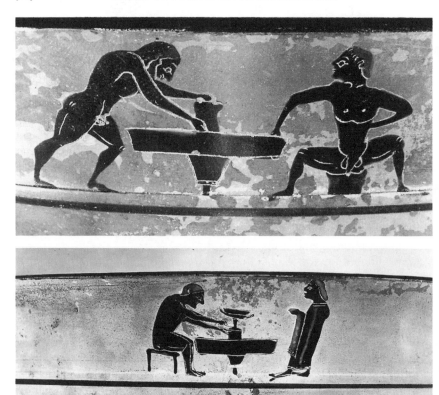

II.3 Making a cup on an Attic black-figure kylix, ca. 550 B.C.

Our evidence for making wheel-thrown pottery in Classical Greece derives mainly from the pots themselves or from illustrations of potters at work that decorate some Corinthian, Attic (Fig. II.3) and Boeotian vases.[8] Virtually no written evidence on the subject has survived, and what there is is slight and unhelpful. However, the picture that we can recreate is fairly full and consistent. The potter sat on a low stool, or squatted on his heels, with his knees almost at the level of the wheel itself which was set quite close to the ground. A spindle was fitted into a socket in a pit below the floor. The

wheel itself, which acted both as throwing plate and fly wheel, was most likely made of wood and seems to have been on average between half a metre and a metre wide.[9] There was no kick wheel which the potter could work with his foot; instead the potter had an assistant, a wheel-boy, who sat opposite him on a low block or cushion and spun the wheel with both hands, while the potter guided the clay from the heel of his hands to his fingers in a counterclockwise motion. Naturally there were times when the potter needed to stand at the wheel, e.g. to put his hand down into a deep jar, and times when he would spin the wheel himself, e.g. to gauge the evenness of a vase as he moved the wheel slowly.

At his side the potter needed to have ready the tools of his trade: plenty of water in a bowl to keep the clay malleable, his shaping and measuring implements, e.g. knives, scrapers, etc. of wood, metal or bone, callipers for measuring a section, a sponge for smoothing the surface of the pot, string for removing the pot from the wheel, and drying racks and trays. But his chief tools were his sure hands and quick fingers.

The process of throwing the pot was very similar to that adopted now:[10] kneading and working the clay to remove the bubbles and to give a smooth consistency, centring the lump of clay on the wheel, forming the hollow and drawing up the sides into a cylindrical shape (Fig. II.4). Some vases were made in one piece and needed only a sponge for smoothing the surface and a string for drawing under the pot to remove it from the rotating wheel. It would be few vases, however, that could be formed in one process; many were made in sections – neck, body, stem – and later luted together with wet clay slip. An expert potter would be able to produce a series of vases of the same shape with almost identical proportions without complicated and repeated measurements.[11] His eye and a stick, maybe a rule or callipers, would be sufficient tools, together with the experience he had acquired over the years. A potter's brains were in his hands.

When a pot is taken from the wheel, it is heavy with water and must be set aside to dry. The pots must be left until they are in a leather-hard condition, and during this time they will shrink slightly through evaporation. At this stage as at others later, accidents are likely to happen. Some of the potter's daily batch of pots may sag or crack, or the joining of the sections may prove unstable. Failures at this stage can be scrapped and the clay re-used; more serious problems occur during the processes of decorating and firing, by which time the damage cannot be so easily rectified.

Next day when the pots have dried out, they need attention again. The potter places his leather-hard pot upside down on the wheel and turns it, i.e. he shaves off the unwanted clay with a sharp knife and smooths and polishes the surface to make it ready to be placed directly in the kiln, or to

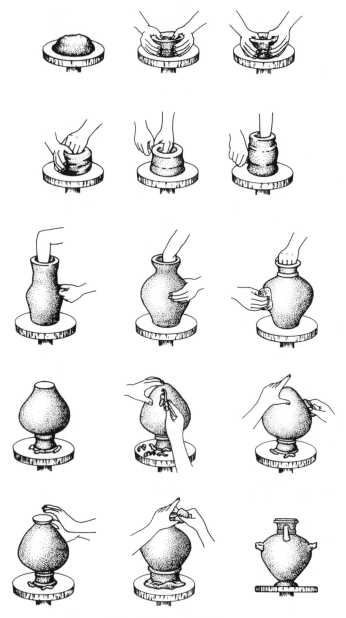

II.4 Making a hydria

receive the paint. Many pots will now need to have attachments added to them: handles, a foot, or even an appliqué in floral, animal or human form. After assembling the pot in this way, the potter turns it again. The pots are now set aside for the kiln or for decoration to be added.

Decorating

It was few pots that did not need or receive the application of decoration of some kind. Some large containers, as the transport amphorae (Fig. III.9), might receive a painted covering inside to seal the surface and render the clay less permeable, though even then it was not totally impervious to seepage. Many others were mainly left plain both inside and out but carried a small amount of decoration – stripes, wavy lines, circles; others were furnished with a complete covering of paint outside and in, which fired black – these were the cheaper forms of fine ware. The more costly products were elaborately painted with geometric, floral, animal and human compositions.

Instead of, or as well as, being painted, pots were decorated in other ways. The pithoi were often furnished with relief decoration; this could be in the form of raised strips that had patterns incised on them, or bands of figured decoration that were impressed on the wet surface with a roller (Fig. IV.5). On fine wares incised and impressed decoration was also covered with black gloss. Relief decoration is also found in conjunction with paint, and some pots have elaborate attachments added in the shape of snakes, animal and human heads, and floral details.

As for the nature of the paint used, recent practical investigations have shown that the paint is a special preparation that has as its basic ingredient the same clay as the vase.[12] To produce the 'gloss', the painters used the finer, more settled clay which had a more compact consistency than that from which the pot itself was formed. They added to it a deflocculating agent that hastened the separation process and ensured that the fine particles were suspended in the liquid. The agent used to activate the clay in this way could be rain water, potash (wood ash soaked in water) or iron-bearing sand.

When being applied, the liquid clay is deep red in colour and may not have been very different from the colour of the vase itself. Through evaporation the liquid has a creamy consistency. In some wares the surface was polished before and after the painting was done; this 'burnishing' was done with a pebble, a piece of bone or a wooden tool. Also a weak solution of clay might be washed over the whole surface of the pot as a base coat to enhance the colour.

The ways in which the clay solution was applied depended on the final appearance required. For the inside of a 'closed' pot which could not be

reached by hand, a rough swilling of the liquid might suffice. For the outside, a slapdash way of applying the paint was to pour it over the pot; another easy way was dipping, and the finger marks round the feet of many vases indicate that the potter or his assistant had plunged the pot into a bowl of liquid gloss. For more careful, but still quick painting, the vase could be set back on the wheel, perhaps on a small block, and the gloss applied with a brush as the wheel was rotated. This method could also be used for adding horizontal lines, and also for those parts of the more elaborately decorated vases that needed covering above and below the zones and panels (Fig. II.3).

For the actual painted decoration of the vases, more detailed and painstaking work was needed. Where extra special care was being taken, a preliminary mapping out of the composition might be done, and for some of the figured work a preliminary sketch with a stick of charcoal or lead was made, which guided the painter when he came to apply the gloss. This preliminary sketch was not always adhered to, and where a furrow had been made with the stick, the original sketch is sometimes visible.[13] Brushes were the most common tool for the application of the gloss. Sometimes for

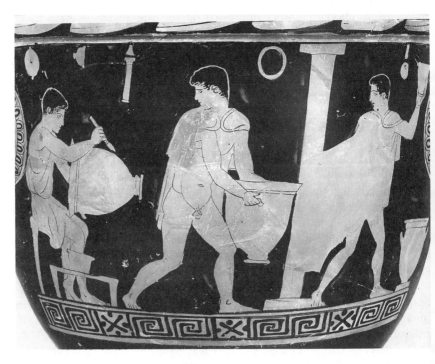

II.5 A potter's shop in Athens on an Attic red-figure bell-krater, ca. 430 B.C.

concentric patterns a number of brushes were fastened together to produce an evenly executed set of circles or semicircles, applied either freehand or with compasses.[14] When using the brush the painter would sometimes sit with the vase resting lightly on his thighs (Fig. II.5) or with it standing on the motionless wheel (Fig. II.3). The angle at which some tondos were set inside kylikes would suggest that some cups were set on a table and rested on their rim and handle while being painted. It was with a brush alone that the floral and geometric patterns were created, and in some periods and places the figure work also depended on nothing more than a brush.

The techniques that have attracted the most attention and that were some of the most elaborate in antiquity are the black-figure and red-figure techniques of Corinth, Athens and elsewhere. It is on pottery decorated in these ways that ornamentation rose to an art (e.g. Figs. V.9, 10, 12). Black-figure, which was first produced in Corinth ca. 700 B.C. and was then borrowed and used more extensively in Athens from ca. 630 B.C. onwards, enhanced the old technique of the brush with the addition of engraved lines and added colours (red and white) to enliven the compositions. The engraving must have been done with a sharp pointed instrument after the gloss had dried, and if we are to imagine what other objects the painter needed to have at his elbow, we should add paint pots for the gloss and for the added colours, his brushes, sticks, compasses and sponges (Fig. II.5).

The techniques of silhouette, outline and black-figure painting (e.g. Figs. II.3; III.1, 7; V.1), as the names suggest, produced figures and designs done in black gloss with the background left in the colour of the clay or slightly heightened by the application of a wash. The technique of red-figure (e.g. Figs. II.5, 6; III.4, 5, 6; IV.8; V.9, 10, 12; VI.4), which was invented in Athens ca. 530 B.C., reversed the colours: the figures were left in the background red, and the background to them was filled in with the gloss which fired black. The red-figure technique was mainly practised in Athens, but it was borrowed by some other centres, by Athens' neighbour, Boeotia, by Corinth, and most spectacularly in Sicily and south Italy, areas to which potters and painters can be shown to have emigrated from Athens in the second half of the fifth century.

As work in red-figure embraces most other methods, it is worth spending a little time seeing how much care might be taken with Attic red-figure vases to produce the elaborate compositions that represent the high mark of Greek painted pottery. First, a preliminary sketch was made, and this was followed by the lining-out of the figures with a broad band of paint, what is now usually called the 'eighth-of-an-inch' stripe (Figs. II.6 and 9). These painted lines would stand as the outside edge of the intended shape to produce the contour of the figures. Then the figures themselves would be filled in with the details of anatomy and clothing needed and with the

addition of washes of brown dilute for the less important details. The pattern and background would then be filled in, these perhaps being left to assistants or apprentices. When the paint had dried, added colours might be applied: white (usually for women's skin), red (for blood, for the lettering, etc.) and in some cases added clay with a covering of gilt (for wreaths, golden ornaments, etc.).

From the above resumé there has been omitted an important and controversial technique. Many Attic red-figure vases show painted lines that are raised from the surface of the vase, relief lines that emphasise the contours of the figures or inner details of anatomy and clothing. They catch the light and can be felt with the fingers. Instances of this technique are found on some black-figure vases where it was used on minor details; however, it was the red-figure painters who realised its effectiveness to the full. The implement which formed the relief lines must have held a good amount of gloss and was able to dispense it evenly for some distance. Much discussion has centred round the nature of this tool, and recent suggestions have attracted a good deal of interest. One suggestion is that a bag was attached to a quill head which enabled the solution to be squeezed out almost indefinitely without the quill being lifted from the surface of the vase, like a syringe. In a second suggestion a more basic implement has been postulated: a brush with a single hard bristle or a few flexible hairs loaded with gloss. Practical demonstrations with these tools have shown that they work, but many scholars still champion such tools as the quill or reed pen with a conical point and a thin brush inserted into the hollow to restrict the flow, or a metal tube pressed flat at one end and cut on the diagonal with the gloss filling the tube.[15]

Apart from the use of the gloss which fires black or red in reaction to the firing conditions, other techniques were employed, though none was so popular. The white which was used as a supplementary colour in black- and red-figure was on occasion used as a background slip for silhouette and outline figures. Another of the rarer techniques involved covering the surface of the vase completely in gloss and then adding different colours (such as white and red) over the gloss in the form of figures or floral designs. Polychrome was a rare technique in the use both of ceramic colours and of colours applied after firing. There are also some instances where by the application of different strengths of gloss the painter was able to produce both black and coral red at one firing. For all these, see Chapter V.

The success or failure of the painting would only appear after the vases had been fired, but, although some of the failures would be caused by mistakes in the kiln, others had already been made once the pot had been painted, and even a totally successful firing could do nothing to retrieve the mistakes. Some of the commonest mistakes in painting stem from such causes as the failure to mix the correct consistency of paint, the use of two

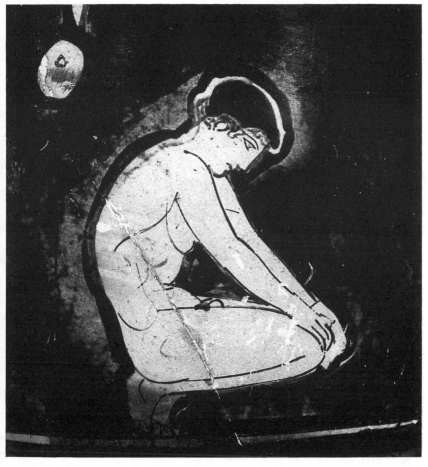

II.6 Glaze failure on an Attic mug, ca. 430–420 B.C.

different batches of paint (e.g. one for the background, one for the contours) that were affected in different ways in the kiln (Fig. II.6); less frequently we can see that a painter attempted to cover over a design he decided to change but failed to apply the gloss thickly enough to prevent the earlier drawing showing through the gloss once fired.[16]

Once the paint was dry, the pots were ready for the incisions and then for the kiln.

Firing

The firing of a batch of pottery – turning unbaked clay into terracotta – was, and still is, a tricky business. After all the previous stages in the

making of the pots – digging the clay, preparing it, forming it into useful shapes and decorating it – it was the final stage that was the most important, and it was the work at the kiln to control the heat that was crucial. A Greek poem, most likely composed in Athens in the sixth century B.C., gives a lively picture of the firing.[17] The poet has been asked for a song and expects to be paid:

If you pay me, potters, I will sing:
come here, Athena, and hold your hand over the kiln.
May the cups and bowls all turn out a good black,
may they be well fired, and fetch the price asked...
But if you turn shameless and deceitful,
then will I summon the ravagers of kilns...
Stamp on the stoking tunnel and chambers, and may the whole kiln
be thrown into confusion, while the potters cry aloud.
As a horse's jaw grinds, so may the kiln grind
to powder all the pots within it...
And if anyone bends over to look into the spy-hole, may his whole face
be scorched, so that all may learn to deal justly.

So care had to be taken in building the kiln, in storing the pottery in it for each firing and in arranging the firing itself from the heating to the cooling and the opening. Such troubles as those listed above would also apply to firing without a kiln, such as the surface bonfires when the pots were covered with wood, charcoal, twigs, etc. Indeed, all firings had an unpredictable outcome.

Kilns were built outside in the yard. Some examples of kilns survive in

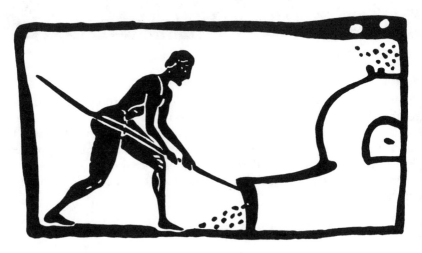

II.7 Kiln on Corintbian votive plaque, sixth century B.C.

fragmentary form from ancient Greece, and there are a number of painted representations of firings taking place that help in recreating their appearance (Fig. II.7).[18] The kilns, partly sunk in the ground to support the structure, to preserve the heat and to give easier access to the stoking and firing chambers, were made of mud and clay with the inclusion of stones and perhaps old fragments of pottery; they were usually in a round plan, though some were square.[19] By modern standards those found are small, some under 2 metres in diameter (modern traditional sizes range from 2 to 3 metres); there is no knowing to what size they may have been built in some of the larger establishments. All are of the cylindrical, updraught type with an arched stoking tunnel projecting from the side just below ground level, leading to the firing chamber which was furnished with a pierced floor above (Fig. II.8). Directly above this was the stacking chamber which had a dome-shaped roof with a vent at the top and a chimney; old pieces of broken pottery which would be lying around the yard could be used for the chimney. The permanent structures of actual ancient kilns are preserved only a little way above ground level, and the projecting edge is smooth; this suggests that the domed covering may not have been permanent. The painted illustrations of kilns (e.g. Fig. II.7) all seem to agree on the basic shape with domed top and chimney, and they also show a door to one side, perhaps for loading the pots into the firing chamber. The door may have had a spy-hole incorporated into it or set to one side of it. A lucky mascot would usually have been hung on the outside of the kiln, to ward off the

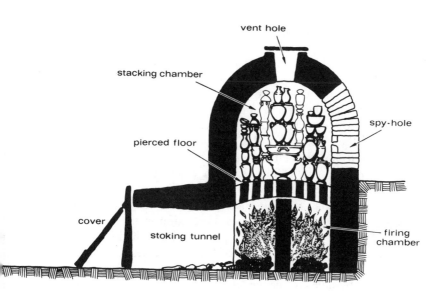

II.8 Modern reconstruction of ancient kiln

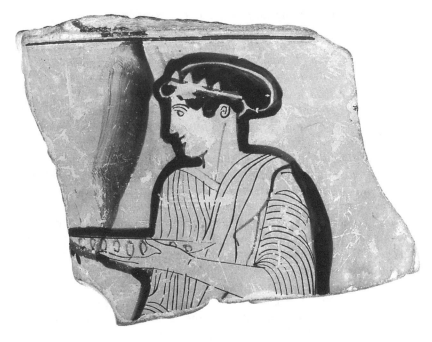

II.9 Unfinished Attic red-figure fragment used as test piece, ca. 460 B.C.

sorts of accidents to which the poet above referred. The dome, if a temporary structure, may have been made of plastered clay and brushwood that could easily be renewed for the next firing, and it is possible that the loading and stacking of the pots could have taken place before the dome was built above them.

As Greek gloss was never sticky either before or during firing, it was possible to stack the pots in and on one another. Hence there was no need for rings or saggers. Some illustrations give the impression that no care was taken with the stacking, but this may be artistic licence to enable the shapes to be drawn and seen. It is hard to believe that special pieces were not placed carefully in the kiln for such a precarious operation. However, accidents were inevitable. Some of the pots were squashed out of shape, and some of the glaze failures can be seen to derive from the methods of stacking where the different types of reaction in the firing had been held back from those vases and parts of vases which had been closely packed together or stacked inside one another, and the desired black has fired red or brown.[20] When the kiln was full, the firing chamber was closed, with only the spy-hole to gauge the colour of the flame and thus the temperature, and to enable the test pieces (Fig. II.9) to be withdrawn.[21]

The fuel for the kiln was wood, of various sorts, rarely good timber, more likely material unusable elsewhere, such as thorn bushes, olive prunings or the discard from olive pulping. It is unlikely that potters made extensive inroads into the tree-cover in antiquity.

To produce the contrast of black paint on a red ground, the firing was carried out in one process which involved three stages; the kiln was not cooled down and unloaded during this time. The whole cycle took some hours; indeed, if one includes the cooling down period at the end, the firing lasted a few days. The heat was gradually raised to about 800 degrees centigrade, and with the vent at the top open to allow oxygen to enter, the pottery was baked to a pinkish buff colour, the gloss becoming a brownish red. This is the first stage, in which the vases are baked in smokeless conditions. In the second, reducing stage, the vent was closed, as was the entrance to the stoking tunnel. Thus the air in the kiln was starved of oxygen. Water was also introduced into the stoking tunnel in the form of wet leaves, green wood, or damp sawdust or shavings. The chemical reaction that took place turned the porous body of the vase a greyish black, and the denser gloss became a sintered black which was able to resist oxidisation in the next stage. The temperature was now at its highest, about 950 degrees centigrade. In the third stage, which resembled the first, the temperature was allowed to drop a little, to about 900, with the vent and stoking tunnel open and the wet leaves, etc. raked out, so there was now only dry fuel and air once more in the kiln. This was the most crucial stage, and it was only by careful balance of temperature and atmosphere that the clay was made to revert to the reddish colour of the first stage and the paint to remain the black colour created in the second stage. In successful firings the gloss was well attached to the surface of the pot and densely compacted. It was by this three-stage process – oxidising, reducing, oxidising – that Greek black-gloss pottery was produced.

The kiln had to be allowed a day or so to cool before it could be opened and the results of the firing seen. Besides the mistakes that may have arisen from the actual painting and stacking, the firing process brought many others in its train. Pots may explode, shapes may warp and fuse in the fire. The colour of the clay and gloss will vary with the effect of the different stages: too little water will produce a poor black colour and texture, the black gloss may become reddish brown through being left too long in the heat or not being heated sufficiently high in the second stage or too high in the third stage. Stacking might shield parts of some pots from the correct atmosphere, and tell-tale marks will appear on the surfaces.[22] A perfect firing produced a sheen on the burnished clay and a bloom on the gloss through sintering; light was reflected from the surface, and the appearance of a more costly metal was imitated.

The kiln would be used again; cracks would be replastered and the dome

rebuilt. Most pots would be ready for use or sale; some would return to the workshop for the addition of further decoration or finishing. The frequency of the firings would obviously depend on the nature of the operation: every few days for a large establishment, once a week or month when working on a small scale or on one's own, seasonally if replenishing the family stock.

The three-stage firing was used for centuries by the Greeks; it seems to have been in operation already in the early second millennium B.C. However, in the Hellenistic period, when the black-on-red decoration of Greek pottery had ceased, and potters had turned to producing mould-made wares which were covered all over with gloss, a red gloss, fired under oxidising conditions only, was adopted in some areas. More importantly, when the Romans began to produce red-gloss table-wares (Arretine and others) based on the Hellenistic relief-mould vases, the potters also used oxidising firings, and the Roman red wares took over completely from the Greek black. The materials were the same, it was the processes of firing that produced the different colours.

Scientific approaches

In distinguishing the different clays and glosses of the various local pottery-producing centres, the eye is often not enough, and pottery is increasingly subjected to scientific analysis in order to investigate the make-up of the vases. Petrographic and chemical analyses enable pottery to be traced back to its clay source and to be grouped with others that share the same elements. Petrographic study seeks to find the origin of the raw materials that comprise a particular clay. By means of thin sections of pottery the mineral inclusions and rock fragments are identified under a polarising microscope (Fig. II.10) and may then be traced back to the geological area from which they originated (Fig. II.1). This method does not work well with fine wares which provide too few distinctive clues; it is used mainly on the coarse and semi-coarse material of such containers as transport amphorae. By contrast, chemical study treats pottery as pottery and seeks to determine the chemical composition of clays by distinguishing the different elements in their make-up. Nine elements are considered to be suggestive of similarities and differences in major groups, and charts are drawn in the form of dendrograms to express these relationships. The methods here include neutron activation analysis (NAA), optical emission spectroscopy (OES) and atomic absorption spectrophotometry (AAS). The study of glosses is also assisted by scientific testing.[23]

The methods proceed from the better known fabrics which may already have been fixed by non-scientific means (find spot, typology, style of decoration, stamps) to the less well known which are hard to place by sight

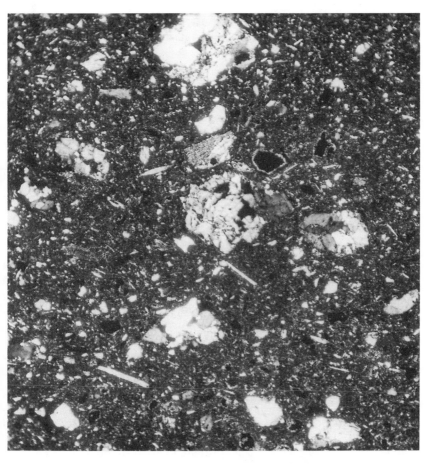

II.10 Thin section of Parian transport amphora

alone. The science is exact, but the results are still open to individual interpretation and hedged about by probabilities. Problems arise about how representative a sample might be, what effect on the raw clay the processing has had, etc. However, as more work is carried out by these methods, so more information is available for comparison, and a 'clay map' of the areas concerned is gradually being created. Thus new and independent approaches to the study of pottery production join the more traditional avenues of investigation and help to refine understanding of the subject.

III
DATING

Scratch is a position from which one can never start. (Lancaster 1947, 9)

Most museum labels in Greek galleries and books illustrating Greek pottery furnish dates for the material they present. For prehistoric periods a sequence date, e.g. Mycenaean III A 1, may be given in preference to, or as well as, a date expressed in the chronological terms we apply today. But for the Greek material of the first millennium B.C. a date in accordance with our present system is usually attempted. Sometimes such dates will be fairly precise, most will be qualified with 'about' or 'circa', or spread into a decade, a quarter century or more. How are such dates arrived at? How trustworthy are they? Why is it possible to be more precise for some pieces than for others?

Relative dates

There is of course in one sense no need to apply our form of dates to Greek pottery at all, even when such absolute dates can be calculated. The chronological relationship of one vase or group of vases to another can be devised on the basis of changes that the vases themselves underwent in shape, decoration or technique, or on the basis of association in an archaeological context, and in this way the history and development of pottery can be charted.

Most Greek vases were made to suit specific purposes, and this usually meant that their shapes persisted with small but perceptible alterations over the years. These changes could affect the contour of the body (broader or narrower, taller or shorter) or details such as the set and angle of the handles or the profile of the foot. Sometimes a shape produced in one area was borrowed by potters working elsewhere, and thus further changes were made and may now be traced. It is rare for the direction of development, whether chronological or geographical, to be misunderstood, as it is not usual for a student to be dependent on this type of evidence alone, but the time gap between pieces, whether produced in the same place or further

afield, is often difficult to assess, as it is unwise to assume a steady, uniform rate of development. Some shapes were enhanced by decoration, and so it is possible to add a second avenue of relative study. The decoration – whether geometric, floral or figured – can be placed in a stylistic progression, and thus another complementary sequence may be constructed. As with shapes, so with decoration, borrowing took place, and so the grid of connections can be extended in this way too. Naturally some of the figured decoration can be studied for its subject matter (see pp. 117–22), and this furnishes another possible avenue of approach to dating. In most centres that produced decorated pottery, the hand of individual craftsmen (sometimes even of the potters, more usually of painters) can now be recognised, and this in itself enables tentative conclusions to be drawn about the chronological span and order of a painter's career. In a few instances, the relationships of families in the pottery business (e.g. father, son, grandson) enable relative dates to be assigned to their work (see pp. 67, 122). In Attic pottery of the sixth and fifth centuries B.C. the precision of the study of vase-painters' work has enabled a grouping of shops, careers and borrowings to be traced so that in conjunction with other types of chronological evidence, a tight system of relative dating for pottery has been devised. The techniques used for the making and decorating of pottery may also be studied to give chronological clues, but these usually have less importance than shape or decoration. In all these approaches to relative dating there is inevitably a tendency to apply logic and consistency. But potters and painters individually worked at different rates of development, many were conservative and traditional in their work, a few more innovative. Also, some periods were more forward-looking than others, and thus change in general varied from time to time; this also applies to the different areas in which pottery was made. So chronology based solely on the relation of vase shapes, decoration and technique is likely to be both overprecise and imprecise at the same time.

A complementary opportunity to apply relative dating is provided by excavated contexts or stratified levels where pottery may be found in bulk, and conclusions about contemporaneity can be attempted. Such contexts may be habitation areas (public and private), shrines, wells, cisterns, pits and graves. The undisturbed embrace of a grave furnishes perhaps the simplest aggregation (Fig. III.1). As some of the vases were made for funerary purposes, they are often found whole and in good condition, and, as the dead were provided with a variety of offerings, the assemblage usually contains vases of different shapes and decoration and maybe of different techniques and origins. Here precision is again a problem, as it is often difficult to know what length of use non-funerary vases may have had before being consigned to the ground: heirlooms and precious possessions, whether larger vases or imported pieces, perhaps treated with more than

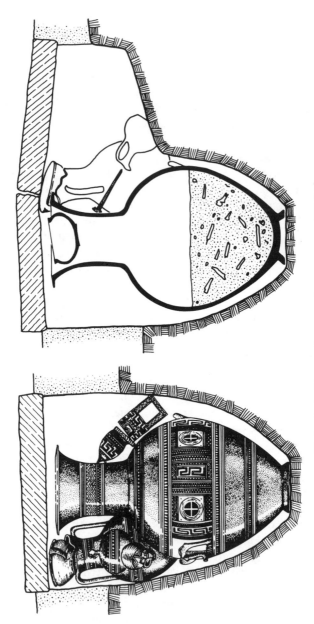

III.1 Attic Geometric cremation grave, ca. 850 B.C.

usual care, might be a generation or more older than the rest of the assemblages.[1] This problem of age is more serious when the discoveries are made in contexts of use, as the material is likely to have had a more varied active life. Shrines in which offerings were made generation after generation may furnish material going far back in time before the moment of destruction or abandonment, just as houses and public buildings will provide pottery that reflects the use of many years.

So a grid of relative dates can be established here and there, but what is needed is 'the measuring rod of absolute historical dates that may be applied to points in the relative sequence'.[2]

Absolute dates

No Greek vase of itself provides its own absolute date. However, there are various ways of arriving at absolute dates, and some of these cross one another, merge with relative dates and supply more secure fixed points by so doing. All absolute dates must be reached by a combination of different types of evidence: documentary, literary, archaeological. For much of their history the Greeks had no overall system of dating; individual states and kingdoms had their own local ways of marking the years such as annual officials or eras, and it is rare for our evidence to link these local dating systems together.[3] Thucydides, writing in the fifth century and wishing to fix the start of the Peloponnesian War (431 B.C.), shows how complex such punctiliousness could be (2.2):

The thirty years' truce which was entered into after the reconquest of Euboea lasted for fourteen years. In the fifteenth year, the forty-eighth year of Chrysis' priesthood at Argos, the year when Aenesias was ephor at Sparta, and two months before the end of the archonship of Pythodorus at Athens, six months after the battle of Potidaea, just at the beginning of spring, a Theban force . . . made an armed entry into Plataea.

Let us therefore consider some of the ways that have been adopted for combining historical dates and pottery. As Greek pottery did not make news and the association of datable historical events and vases is as a consequence accidental, assistance from the one to the other is usually tangential. But it is from such accidental associations that one can begin to sort out the relationships of pottery and specific dates and to gauge the chronological span from one batch of pottery to another. As the value of the dates that different associations provide varies, the following pages do not move in an orderly chronological progression from Geometric (to 700 B.C.) through Archaic (to 480 B.C.) and Classical (to 323 B.C.) to Hellenistic, but are arranged by categories of association: contexts, parallels with other, more easily datable works of art, subject matter,

inscriptions, etc. The examples given are heavily selected and are chosen to give an indication of the variety of contacts; some are not as important or as fixed as others. Many relate to Athens for which, as it was the most literate state, we have most detailed historical evidence.

Contexts

In excavations pottery is found in various types of site: settlement, sanctuary, cemetery. As we have seen, vases and fragments of vases can be dated in relation to one another. However, for some finds an external date is available, as the site or the building with which the pottery is connected, may be linked with a date or dates known from written sources. Literary and documentary evidence gives dates for foundations and destructions of settlements and shrines, and it is also possible to link certain graves with known historical events. It is rarely a straightforward procedure, nor do the results or even the premises always command agreement.

What follows is a selection of such items, beginning with the more easily intelligible category of graves.

Datable graves

There are a number of graves, mainly communal, which can be linked to historical events recorded in written sources. We know the dates of many battles that the Greeks fought against one another and against foreign powers. After some of the most famous campaigns communal graves (*polyandria*) were dug either at the site of the battle itself or back in the home town of the dead; some other graves can be associated with less prestigious battles or events. As it was the custom to bury the dead with grave goods that included pottery, material is available for study, and in such cases it is not the actual importance of the event but the fact that it is dated that makes it of interest to students of pottery.

(a) Perhaps the best known communal grave is that which the Athenians erected on the plain of Marathon to house the remains of those who died in the battle against the Persians in 490 B.C.[4] Herodotus (6.117) tells us that 192 Athenians died in the battle, and Thucydides (2.34.5) and Pausanias (1.29.4 and 1.32.3) give more circumstantial information. The mound with its brick platform and underlying graves has been only partially excavated, and there has been much controversy about the finds. However, orthodox opinion is that what has been found there represents the offerings made to the dead a little time after the battle. The material consists for the most part of Attic black-figure; one fragment of an Attic red-figure cup was found, and some vases that stylistically differ from the main finds are earlier or non-Attic. Altogether the ensemble is limited in the assistance it

III.2 Some of the contents from the grave of the Corcyrean ambassadors in Athens, ca. 433 B.C.

affords. More recently a second tomb furnished with contemporary material has been excavated about a mile west of the Athenian mound.[5] This has been identified as the tomb of the Plataeans, Boeotians and slaves that Pausanias mentions (1.32.3); they fell in the same battle. However, the connection of the tomb with the same historical event is not sure.

(b) A recent excavation in the main cemetery of ancient Athens, the Kerameikos ('Dipylon') cemetery to the north-west of the town, has furnished a small group of datable material.[6] An inscribed grave marker records the identity of the two men buried beneath: 'Here the earth received in burial Thersandros and Simylos, two men dear to their native Corcyra; they came as ambassadors and accidentally died, and the sons of the Athenians gave them public funeral honours.' It has been plausibly

suggested that the occasion of the embassy was that which took place in 433 B.C. on the eve of the Peloponnesian War and is described by Thucydides (1.31–54). Beneath the marker, to left and right, were two graves; one was empty, the other contained offerings which included a white-ground lekythos, black vases of various common shapes, a few household wares and a strigil (Fig. III.2). All the vases are useful in affording evidence of the stages in development reached by 433 B.C.

(c) A better known set of burials, but one which does not provide such a simple group of material, is the Rheneia Purification Pit.[7] Once again our chief contemporary source is Thucydides. In summarising what happened in the winter of 426/425 B.C. he refers to Athenian activity on Delos (3.104, cf. 1.8):

> The Athenians, no doubt because of some oracle, carried out ceremonies of purification on Delos. . . . The whole island was purified in the following way. All the tombs of those who had died on Delos were dug up, and it was proclaimed that in future no deaths or births were to be allowed in the island; those who were about to die or give birth were to be carried across to Rheneia.

The French excavators of Delos discovered a pit 20 m square within a paved enclosure 500 m square, and bones and funeral offerings beneath. As this was a haphazard collection of offerings, the material was mixed in date, some vases dating as early as Geometric. It is naturally the latest material that is important for dating, and the pit contained many Attic red-figure and black vases that provide a terminus ante quem for other material of similar type elsewhere. The equation of this excavated pit with that mentioned by Thucydides is not in doubt.

(d) During the first decade of the Peloponnesian War ('The Archidamian War') the Athenians under Hippokrates invaded north-east Boeotia, and in 424 B.C. a battle was fought at Delium (Thucydides 4.93–101); this was the first pitched battle of the war and in it, according to Plato (*Symposium* 221A–B, etc.), Socrates and Alcibiades both took part. The men of the nearby village of Thespiai fought on the Boeotian side and suffered heavy losses (Thucydides 4.96). When the battle was over and the Athenians had been defeated, the Thespian dead were conveyed back home and there furnished with a public burial.[8] The tumulus and enclosure (32 m × 13 m), with the remains of a large pedestal which carried a reclining lion in marble over 3 m long, were found in a cemetery to the east of Thespiai. Remains of the bones and the funeral pyre were unearthed together with a large number of offerings. There was a very small amount of Attic pottery, a little Euboean and Corinthian, and an enormous deposit of Boeotian including red-figure lekythoi which closely copy Attic, and much black and floral ware in a wide variety of shapes. There were also terracotta figurines and offerings in other materials. Much of the casualty list inscribed on

stone has also survived. The ensemble is of vital importance for the dating of Boeotian pottery.

(e) Some years ago the German excavators of the Kerameikos cemetery of Athens uncovered, on the south-west side of the main road (*dromos*) that runs through the ancient area known as the 'state burial ground', an 11 m long, walled rectangle that carried on it the names of the dead inscribed on a cornice block.[9] The monument stands over the grave of the Lacedaimonians who fell in 403 B.C. when, a year after defeating the Athenians in the long Peloponnesian War, troops had come to assist against the democratic insurgents in the Piraeus. Remains of thirteen bodies were found in three chambers, and the fragmentary inscriptions, from right to left, in Laconian lettering, give the start of the word La[kedaimonioi] and name three of the Spartan military leaders (*polemarchoi*): Chairon, Thibrakos [*sic*] and M[—. Two of the names are the very ones that the historian Xenophon gives (*Hellenica* 2.4.33): 'In this fighting [in the Piraeus] the colonels Chairon and Thibrachos [*sic*] were killed; also Lacrates, a winner at Olympia, and other Spartans who now lie buried in the Kerameikos outside the gates of Athens.' Unfortunately, the ceramic material found in association with the monument is very fragmentary.

(f) In the same cemetery as the graves of the Corcyrean ambassadors and the Spartan warriors, but away from the public area, is the famous relief marker of young Dexileos who fell as a cavalry officer in the fighting before Corinth in 394 B.C., as the base of his monument relates. The plot did not contain his remains, as he was buried with the other cavalrymen in the area of the state burial ground. However, his family acquired the corner plot at the time of Dexileos' death, and the red-figure vases which were discovered in that family grave and may have been deposited at the time of Dexileos' death, have been used to give some indication of the stage of development reached in Attic vase-painting at that time.[10] All five vases are oinochoai, and one of them carries the subject of the Tyrantslayers (see pp. 47–8).

This small selection of datable graves perhaps gives some idea of the helpfulness and the limitations of such evidence.

Foundation, destruction and reoccupation

It is more difficult to derive absolute dates from the foundation and destruction evidence of sites, even when seemingly helpful information is provided by written evidence.

The endemic nature of ancient warfare means that many settlements were destroyed and sacked, and then either abandoned or reoccupied, and these events are the sort that we find mentioned, not always dependably or clearly, in the writings of ancient historians. It is natural that in the present-day ruins of such sites, objects of daily use, particularly pottery, will be lodged. One of the hurdles to be overcome concerns the externally

datable destruction levels, as these cannot always be easily isolated. Also the type of site excavated will affect our attitudes to the material. If the site is part of a settlement and thus likely to provide pottery that was in use at the time of the destruction, the length of the period during which the pottery had been in use has to be considered. If the site is a sanctuary, then older material is likely to be encountered, the offerings of generations of the faithful. Also, destruction does not always mean total abandonment; survivors may return and make their living again on the same site. This means that pottery is used and thrown away once more, and hence the destruction level is not always clear-cut. Another difficulty is the inevitably less precise excavation and study made by earlier excavators. This is particularly unfortunate, as their investigations were guided by their reading of ancient literature, and so they were often led to those very sites that were externally datable. Even today, with more precise methods, excavators do not clear a complete site, and so the evidence on which to base general conclusions is only partial.

There follows a small selection of the more important sites at which the foundation or destruction is dated by external evidence and which scholars have felt to be of assistance in establishing a chronology for pottery. In many instances the amount of material found on which study can be carried out has been small, and the condition in which the vases were found – worn, smashed, burnt – has often been unhelpful. Some assistance in the earlier periods for the dating of Geometric pottery might be expected to come from Greek pottery found on non-Greek sites, the history of which is sometimes chronicled by non-Greek documentary evidence, but the danger of circularity in argument has recently been stressed. There is still room for discussion.[11]

(a) *Hama(th) on the Orontes, north Syria.*[12] A neo-Hittite site destroyed by the Assyrians under Sargon II. The date of the destruction is provided by Assyrian sources. Greek imports are few and fragmentary, the latest being Late Geometric. The usual date given is 720 B.C., but two points make the connection between date and pottery uncertain: the site was not deserted but colonised with more than six thousand Assyrians, and the destruction level may not have contained the latest fragments of pottery now known.

(b) *Aziris, Cyrenaica (Libya) (modern Wadi el Chalig).*[13] This was briefly occupied by the Therans on their way to the more long-lasting colony of Cyrene. Information comes from Herodotus (4.157.3; 4.169.1) and Eusebius who may give the foundation date of Cyrene as 632 B.C. (*Chron.* 96b). There was said to have been a six-year occupation of Aziris. Remains found included Protocorinthian pottery and East Greek bowls and banded cups.

(c) *Daphnae (Tell Defenneh), Egypt.*[14] A Greek-manned frontier post on the eastern border of Egypt, Daphnae was dismantled by the Persians when

they invaded in 525 B.C. (Herodotus 2.30). Doubts have been expressed about the identity of the ancient with the modern site, but orthodox opinion makes them one and the same. Greek pottery included Attic, Rhodian, Clazomenian, Fikellura, as well as situlae which may have been made by Greeks near the site, and a fragmentary Chian transport amphora sealed with a cartouche of the Egyptian pharaoh Amasis (568–526 B.C.)

(d) *Athens*.[15] The Persian occupation and destruction of Athens in 480/479 is well attested (Herodotus 8.52–4; 9.3–13), and much of the dating of Attic Archaic sculpture and architecture is dependent on recognising the material of the 'Perserschutt', especially on the Acropolis. The Attic black-figure and red-figure pottery found on the rock has also been put to use, but even now there is still much uncertainty about its help for the purposes of dating.

(e) *Motya, Sicily*.[16] Dionysius of Syracuse was responsible for the siege and sack of this Phoenician–Punic island site off the west coast of Sicily in 397 B.C. (Diodorus 14.47–53). The site was never rebuilt, though life on the island continued. The material connected with the sack includes Attic red-figure and black pottery.

(f) *Olynthus, Chalcidice, northern Greece*.[17] This Greek settlement on the Chalcidic peninsula was destroyed by Philip II of Macedon in 348 B.C. (Diodorus 16.53–4). A great amount of Attic red-figure and black as well as local pottery was excavated from the destroyed houses on the site. Part of the site was reoccupied until ca. 316 B.C.

(g) *Koroni, Attica*.[18] This site has been identified as one of the hastily built and short-lived fortified camps used by Ptolemaic forces in the Chremonidean War of 265–261 B.C. (Pausanias 1.1.1; 1.2.3; 3.6.4–6). The material includes black vases, cooking ware and transport amphorae.

(h) *Corinth*.[19] The Greek city was destroyed by the Romans under Mummius in 146 B.C. (Pausanias 7.16). It lay waste for a century and was refounded by Julius Caesar in 46 B.C. There is abundant ceramic material from the destruction level.

There are many other sites for which the foundation and/or destruction dates provided by written testimony have been thought to help the absolute dating of pottery, e.g. Old Smyrna, Tarsus, Massalia (Marseilles). None are without their problems.[20] Destruction levels, though complicated by the factors mentioned above, are definable within limits; foundations of settlements, particularly the early ones, are less substantial and more difficult to pinpoint. The first arrival of a group of people to a site was generally on a small scale, both in terms of numbers and in the nature of the structures they erected. That initial presence was soon overlaid and obliterated by the generations that lived after them on the same site. Hence, once again a potentially simple phenomenon is rendered complex when

studied closely, none more so than the settlements that the Greeks established in the West.

The Greek migration to the West, to south Italy and Sicily, that took place mainly in the eighth and seventh centuries B.C., has naturally engaged the attention of students of Greek pottery.[21] The reason that the sites in those areas have had a particular interest for chronological purposes is that the literary evidence for the foundations is reasonably full, and in particular the historian Thucydides devotes three paragraphs (6.3 – 5) to the phenomenon and gives a brief account of the Sicilian foundations. His general trustworthiness has predisposed scholars to pay close attention to his statements and, with the help of later evidence, to try to extract fairly exact dates. The sources of Thucydides' information are not known and need not be all equally reliable; however, what he says has been made to yield relative and absolute dates, and, armed with these, excavators have faced the masses of material that have been unearthed from these sites, particularly the imported pottery of Corinth, and have suggested absolute dates for the different wares. Study of the excavated evidence has led some to assume that Thucydides was correct in his relative dates; others have thrown doubt on the connection. The attempt to match the two sets of evidence has once more invited a charge of circularity in argument.

Although there is early material not connected with the establishment of colonies, no Greek colony in the West has produced pottery earlier than Late Geometric I (currently dated 750–725 B.C.). Pithecusa[22] and Cumae[23] off the bay of Naples have produced ceramic material that goes back to Late Geometric I and II, and the four Sicilian colonies (Naxos, Syracuse, Leontini, Megara Hyblaea) that Thucydides says were established first seem also to provide Late Geometric I as the earliest material.[24] Other sites with similar pottery are Sybaris[25] and Taras.[26]

There is still much uncertainty surrounding the dating of Geometric pottery, and the Western colonies are symptomatic of the difficulties for which radical and far-reaching new solutions are being proposed.

As with sites, so with individual buildings that are datable from written sources, the material found in them might be expected to receive outside assistance to help with the absolute dating. But once again the clear-cut evidence is hard to find.

Stylistic comparisons with other works

Let us now move from accidental context dates and look at a different avenue of approach. One method of trying to date figured vases is by comparing them stylistically with figures in other media, particularly sculpture, for which external dates are sometimes available. This procedure mainly involves architectural sculpture (metopes, friezes, pediments,

akroteria), as it is often the building carrying the sculpture that is dated, either by literary or documentary, particularly inscriptional, evidence. Relief sculpture and free-standing statuary are less useful, but there are possible parallels. Comparisons of this sort are at best approximate and subjective, and all depend for their validity on the assumption of parallel development in the different media. There are good reasons for thinking that this is a valid assumption, indeed much of our interpretation of Greek art is based on such an assumption, but it is doubtful how closely the analogy can be argued. Related problems concern the primacy of sculpture vis-à-vis painting, the speed of influence, both within a single community and from one community to another, and the fragmentary nature of the evidence at our disposal, especially the total loss of free painting. In most cases where comparisons are being made, it is the general style of the media that forms the connection; in fewer instances the subject matter may be relevant, and more rarely close copying of sculptural or other figures in vase-painting can be studied. It is also possible to compare vase shapes with similar shapes in materials other than terracotta, e.g. metal (gold, silver, bronze), glass, stone.

Besides comparison of figures, objects within the figured scenes can be compared: illustrated vase shapes, furniture, etc., with actual or carved pieces, and also the decoration in and around the painted scenes that may resemble the decoration found in carved ornament and such.

Architectural sculpture

There first follow some examples of works of architectural sculpture that have been considered useful chronological pegs on which to hang the work of vase-painters. All have their difficulties, and some recent studies have called in doubt the generally accepted bases of traditional theories.

(a) *The temple of Artemis at Ephesos.*[27] Herodotus, writing his history in the later fifth century B.C., has this to say of Croesus, the king of Lydia, whose reign ended in 546 B.C. (1.92): 'There are many other offerings of Croesus in Hellas besides those mentioned. In Thebes in Boeotia there is a golden tripod which he dedicated to Apollo Ismenios, and at Ephesos there are golden oxen and the greater part of the pillars.' Fragments of the vast sixth-century Ionic temple of Artemis have been unearthed, and on the column base of one of the drums King Croesus' name has been thought to be recoverable. If this is so, then Herodotus' 'pillars' come to mind. An unusual feature of some of the drums is that they carry life-size carved figures, and hence such details as splaying garment folds are compared with similar treatment found on vase-paintings.

As can be judged, the connection is not a tight one. It is not even certain that Herodotus is speaking of sculptured pillars; the two previous objects mentioned are of gold. Also, the fragmentary inscription can be made to

give a reading that eliminates both 'King' and 'Croesus'. Given that it could be the temple drums that he means, it is not easy to assess the length of time that the building of such a colossal temple would have taken. Pliny (*HN* 36.14) says it was 120 years in construction, and Macrobius (*Sat.* 5.22.5) mentions the dedication of an Artemis temple at Ephesus ca. 430 B.C. – the final completion date?

(b) *The Siphnian treasury, Delphi.*[28] Herodotus mentions another building that is preserved today. Though it is in a better state of preservation, in this instance the interpretation of his words is even less easy to unravel. At Delphi, as at other sanctuaries, the Greeks built a number of treasuries: small one-room structures, like simple temples, that contained costly offerings from various city-states. That erected by the people of the island of Siphnos was one of the most elaborate, and Herodotus mentions its construction (3.17.8): 'The Siphnians were at this time very prosperous and the richest of the islanders, as they had gold and silver mines on the island. So rich were they that from the tenth part of the revenues a treasury was dedicated at Delphi, equal to the most wealthy.' The occasion to which Herodotus refers by 'at this time' was when the Spartans were attacking Polycrates of Samos and when Samian opponents of the tyrant sailed from Samos, attacked Siphnos and sacked it. He links that episode with the invasion of Egypt by the Persian king Cambyses (3.39), which we date to 525 B.C. The gaps in time between various episodes are not securely given by Herodotus, but it is usually assumed that the treasury had not been long erected when the attack took place, hence in conventional dating it is placed ca. 530 B.C. If this date is secure, then it is extremely important, as the treasury has high-quality friezes with scenes which include the Trojan War and the Battle of the Gods against the Giants as well as ambitious compositions with three-quarter views and elaborate treatment of clothing. The nearest work in vase-painting is that done by the earliest red-figure vase-painters in Athens – indeed stylistic connections between some parts of the friezes and the work of the Andokides Painter are particularly close. It is on such connections that the dating of the beginning of Attic red-figure is partly based. Recently a suggestion has been made that the Siphnian treasury is dated too early, with obvious consequences for the history of vase-painting as well as of sculpture.[29]

(c) *The Apollo temple, Delphi.*[30] Also at Delphi, the temple of Apollo was rebuilt in the late sixth century B.C., and Herodotus once more (5.62) gives us some information. He connects the building with an historical occasion: the exile of the family of the Alcmaeonidae from Athens during the rule of the sons of Peisistratus there. The exiled family were ready to lavish their generosity on the Delphian sanctuary by providing the temple with an east front of marble in place of the usual tufa. Excavations have unearthed a set of marble and a set of tufa pedimental figures at the east and west ends respectively, thus drawing attention to that detail of

Herodotus' account. The exile of the Alcmaeonidae came to an end with the Spartan expulsion of Hippias from Athens in 510 B.C. The style of the figures from the temple has been felt to be sufficiently close to the work of Attic vase-painters of what is now termed the 'Pioneer Group' to establish a chronological connection for the late sixth century.

(d) *The Athenian treasury, Delphi.*[31] Yet again at Delphi, an instructive example of the difficulties of dating centres on the treasury of the Athenians. Pausanias (10.11.4) connects the occasion for the erection of the building with the Athenian success at the battle of Marathon: 'from the spoils of the landing of Datis at Marathon'. If this is correct, then the sculptural decoration – Herakles and Theseus – would date after 490 B.C. Modern scholars are divided on the question of date, and some dissociate the treasury from any connection with Marathon (there is an inscription near the building which mentions Marathon, and it is suggested that this was the basis for Pausanias' (erroneous) assumption) and date the building and its sculptures ten or more years earlier, i.e. to the late sixth century. This lack of agreement highlights the present uncertainty in the dating of sculpture, and hence the problems of drawing any conclusions about figure decoration on vases from comparison with it.

(e) *The Apollo temple, Eretria.*[32] In their first expedition against the Greeks the Persians destroyed the temple of Apollo at Eretria before moving over the channel to Marathon later in 490 B.C. (Herodotus 6.101). Fragments of figures from the pediment of a temple have come to light and are usually connected with the Archaic temple that the Persians destroyed, thus dating prior to 490 B.C. and affording comparisons with vase-painting. However, an upper date for the temple is not known, and indeed the Archaic dating of the material has been challenged, and the figures have now been linked by some with the rebuilding of the temple after the Persians had left.[33]

(f) *The Zeus temple, Olympia.*[34] The building of the temple of Zeus at Olympia can be dated within the second quarter of the fifth century, roughly 470–456 B.C. According to Pausanias (5.10.2), the building was financed from the booty 'when Elis and the local people who joined the rebellion captured Pisa', in 471 B.C. On the apex of the east pediment Pausanias saw the dedication of a shield by the Spartans for their victory at Tanagra (5.10.4), in 457 B.C. Thus the temple must have been all but complete at that time and certainly the metopes must have been in position, and the pedimental figures are likely to have been in place by that year. The inscription on the apex which Pausanias quotes for his evidence is still partly preserved. The sculptural decoration gives parallels for Athenian vase-painting of the 'severe' period, i.e. Early Classical, and helps to anchor the style in the second quarter of the fifth century. Comparisons of drapery and composition are particularly close.

(g) *The Parthenon, Athens.*[35] The Parthenon is securely dated by the

public inscriptions that record the building programme of Periclean Athens. It was begun in 447/446 B.C. and the cult statue of Athena Parthenos was dedicated in 438/437. The metopes (and perhaps the frieze) are likely to have been finished by that year, as the roof needed to be in place, and it is then that work on the pedimental figures is first recorded. The accounts were closed in 432 B.C. Comparisons in general and in particular have been made between Attic vase-paintings and figures from the temple – not only in style, but also in subject matter and individual figures. In one or two cases the architectural figures were copied or adapted by vase-painters (Figs. III.3–4), as were the figure and details of the Athena Parthenos statue (see p. 44).

After 400 B.C. there is little opportunity for comparison, as the vase-paintings are less amenable to testing and the fairly uniform thread of development seems to have become more complex.

Free-standing and relief sculpture

Apart from architectural sculpture, there are individual free-standing and relief sculptures that afford some stylistic help in dating as they themselves can be dated fairly closely. Of original free-standing sculpture that can be linked to absolute dates, the following have been considered some of the most useful:

(a) *Kallimachos' Victory, Athens.*[36] This was set up for Kallimachos on the Athenian Acropolis, a little after 490 B.C. It is too badly preserved to render more than marginal help, but the stacked folds of the skirt, the bent knee, the backward set of the wings can be compared with those found on vase-painting.

(b) *Agorakritos' Nemesis, Rhamnous.*[37] This is also a ruin. The statue and base were made for the temple of Nemesis ('Retribution') at Rhamnous in northern Attica by Agorakritos, a pupil of Pheidias (Pausanias, 1.33.2–3, says it was by Pheidias himself). A date around 430 B.C. seems to follow from the connection of the architecture of the temple with that of the Hephaisteion in Athens and the Poseidon temple at Sounion. The drapery provides parallels with details of the clothing seen on painted pottery.

(c) *Paionios' Victory, Olympia.*[38] This was set up at Olympia soon after 421 B.C., the sculptor being Paionios of Mende. Pausanias (5.26.1) saw it, and part of the inscription connecting it with Paionios still survives. The billowing dress and cloak provide parallels for Attic vase-painting.

Copies of free-standing statues obviously offer less reliable evidence. For style, they are almost useless; for subject matter, see pp. 43–4. The Tyrantslayers of 477/476 B.C.[39] show the looser drapery folds that one associates with the end of the late Archaic phase and the beginning of the early Classical. Late copies of such works as Myron's Discobolos and

Athena & Marsyas, Pheidias' Athena Parthenos, etc. provide negligible assistance, even when a precise date for the originals can be assigned.[40]

Non-architectural reliefs may be closely dated when the carved block forms the crowning member of an inscription which can itself be dated historically. The best known is Dexileos' funerary relief in the Kerameikos at Athens, dated to 394 B.C.[41] Recently, the supporting plinth of the acanthus-crowned column surmounted by three dancing caryatids at Delphi has been shown to carry an inscription that refers the occasion of its erection to the victory of Athens and her allies over Sparta at Alyzeia (Akarnania) in 375 B.C.[42] There is also a series of reliefs, of which the earliest extant is dated to 430/429 B.C. and which continue into the third century B.C., that crown inscriptions recording or documenting treaties, gifts, agreements, etc.[43] The reliefs are slight works of art but add their small contribution by their securely fixed dates.

Influences from works of art

There are some instances of vase-painters being so influenced by works of art that they set down on their vases slightly adapted versions of the original works. The best examples are to be seen in the relationship between Attic red-figure vase-paintings and sculpture. We know that vase-painters had an alert interest in sculpture and would on occasion represent a sculptor at work or show a statue within a composition (e.g. the Athena statue in the sack of Troy). So we should not be surprised if certain figures, whether shown as statues or as characters in a composition, closely resemble sculptured works. We cannot of course be certain in every case that the immediate source is sculpture; missing wall-paintings, which may themselves have influenced sculpture, loom tantalisingly in the background, but the following seem fairly sure. Where a sculpture can be accurately dated, it provides a useful *terminus post quem* for the vase-painting that is derived from it. Sometimes the gap between the two may not have been large, but for some, the interval between original and adaptation is so wide that the connection is useless for dating purposes.

(a) *Angelitos' Athena.*[44] A case has been made for a connection between a standing statue of Athena on a column, erected on the Athenian Acropolis ca. 480 B.C., and two Attic red-figure vases which show a very similar figure of Athena, one on a column, both dated on present chronology ca. 470–460 B.C.

(b) *The Tyrantslayers.*[45] Only copies exist of this group, but the stance and meaning of the pair make the influence on vase-paintings beyond doubt (see pp. 47–8).

(c) *Athena and Marsyas.*[46] The group made by Myron of which we have marble copies dates to the middle of the fifth century. A later fifth century Attic red-figure chous seems based upon it.

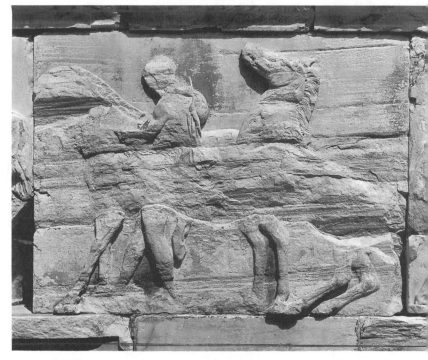

III.3　Detail of Parthenon frieze with horse and rider, ca. 440 B.C.

(d) *The Parthenon sculptures.*[47] The effect of the Parthenon sculptures, both those architectural sculptures on the outside of the building and the Parthenos herself and her decorated accoutrements, was strong. The Helen and Menelaus pair of metopes from the north side of the building is recalled on an Attic red-figure oinochoe. The cows of the south frieze seem to have inspired a number of artists, and some of the human figures are alluded to as well, particularly a young knight from the west frieze (Figs. III.3–4). The pediments, especially the west with the strife of Athena and Poseidon, can be seen reflected in works of the late fifth and fourth centuries; the central figures of the east pediment have recently been recognised on a late fifth century Attic bell-krater. The late fifth century also sees adaptations of the gold and ivory figure of the Parthenos herself, and much interest was shown by vase-painters in the subject matter and arrangement of the figures that decorated the shield and other surfaces (see p. 42).

(e) *Olympian Zeus.*[48] Pheidias' other gold and ivory statue did not arouse so much interest as the Parthenos, but it has recently been argued

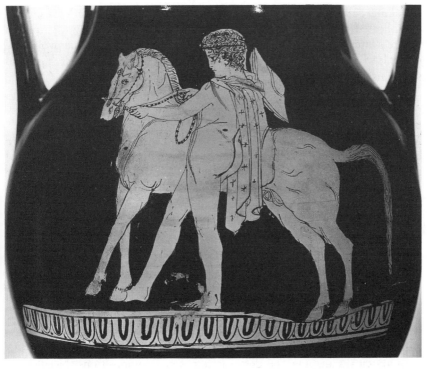

III.4 Attic red-figure pelike with horse and rider, ca. 430–420 B.C.

that his throne was adapted by one Attic vase-painter of the late fifth century in a composition that was a mélange of sculptural types.

Patterns

Besides the connections made between figures in sculpture and vase-painting, comparisons have been noted between the patterns that were used to decorate buildings, outside and in (whether carved, painted or mosaic), and those which formed the surround to many of the scenes on vases. Once again the dated buildings – treasuries, temples, tombs – afford a few fixed points. The complexity of the connections may be illustrated by reference to vase-painting and fourth century pebble mosaics. Pausias was a painter who worked in Sicyon in the second quarter of the fourth century B.C.; he was noted for his flower paintings. None of his own work survives, but his influence has been traced in pebble mosaics (e.g. from sites in Macedonia such as Pella and Aegae (Vergina), from Olynthus, and from Sicyon itself). The most outstanding elements of these designs are the female heads surrounded by flowers and tendrils, and the three-dimensional effect of

spiralling bell-like flowers with curling stems and scroll-like leaves. Such complicated effects are to be seen also on vases, particularly on Apulian volute-kraters and amphorae. Influence between artistic media would be difficult to deny, but the closeness of the connection is hard to establish and so the usefulness for dating purposes is impaired.[49]

History, myth and subject matter

Many of the more elaborate examples of Greek pottery carry figured compositions, and the subject matter of the scenes can sometimes be linked to historical persons or events and to literary works. Although the establishment of such connections has its pitfalls, attempts have been felt to be worthwhile, and some results can be obtained that may then be associated with others that have been reached by a different route to produce a satisfactory, if not totally precise, conclusion.

Historical figures

There are some rare instances where the compositions consist of or include historical figures.[50] It would be rash to assume that the paintings must be contemporary with the living characters or even follow closely on their deaths – indeed this is palpably not so in a number of instances, as with the Attic red-figure amphora depicting Croesus (see below) – but none the less chronological clues may be derived from some compositions. Needless to say, the figures are in no real sense portraits. Here is a selection of the more important examples.

(a) *Arkesilas*.[51] One of the best known vases that presents a named historical character is the Laconian black-figure cup with an elaborate scene on the interior of wool- or silphium-weighing in the presence of a seated figure with a sceptre, who is inscribed Arkesilas. He is to be identified with one of the kings of Cyrene, the Greek settlement in north Africa. There were four kings of that name, and this means that a choice must be made between them; thus the precise dating has to depend on other criteria. The fact that it has been said that the cup 'supports rather than establishes the chronology [of Laconian vase-painting]'[52] shows its unreliability. On present chronology it is King Arkesilas II, who reigned in the 560s B.C., who is thought to be depicted. The style of the painting is individual enough to enable other Laconian cups to be attributed to the same painter, and the shape of the cup can be linked with a similar shape produced in Athens (the 'Siana' cup) to suggest contemporary production, and other work by the Arkesilas Painter has been found in context with them.[53] Total certainty is not possible, and the fact that Arkesilas I ruled a little before and Arkesilas III in the 530s and 520s, offers other closely adjacent, though less likely, candidates.

(b) *Anakreon.*[54] The poet Anakreon was born at Teos in Ionia and after spending some time at the court of Polycrates of Samos, moved to Athens around 520 B.C. and died there in the 480s. Some early red-figure vases depict and name Anakreon, and a good number more present a similar composition to these scenes but without the name. Two of the named, and many of the unnamed, scenes depict a revel with men dressed in Ionian (Lydian) dress, with head-scarf or turban; some men wear earrings and/or soft leather boots, some carry a lyre and others a parasol. The three vases that bear the name of Anakreon are early in the series, and although individual items of dress are found earlier, the combination of items seems to belong to the late sixth century and to harmonise with Anakreon's arrival in Athens. The general assumption is that Anakreon's 'foreign' dress and ways were stressed by painters as a subject soon after his arrival.

(c) *Croesus.*[55] Croesus, king of Lydia in Asia Minor, was deposed in 546 B.C. by Cyrus of Persia. He had had contacts with the Greeks of the coast of Asia Minor and had given gifts to Delphi and elsewhere (see pp. 39–40). He soon became a semi-mythical figure for them, and Herodotus' account of his death (1.86–92) is well known. One Attic vase-painter, Myson, depicted the king on his funeral pyre on a red-figure amphora. It cannot be a contemporary painting nor one painted immediately after the event. On present chronology it belongs around the year 500 B.C., and a recent suggestion connects the choice of such a theme at this time with the revolt of the Ionian Greeks of Asia Minor from the Persians in 499 B.C.[56] As the other side of the amphora shows Theseus carrying off the Amazon queen Antiope, a Greek carrying off an Easterner, both sides may make allusion to the revolt that burned Croesus' old capital at Sardis and the Athenian assistance rendered to the Ionians against a foreign power. Such an interpretation might back up an already established chronology but would not be strong enough to create it.

(d) *The Tyrantslayers.*[57] In a similar way representations of Harmodios and Aristogeiton on Attic vases may have reference to events contemporary with the vase-paintings, not with the event that made the two famous. The Tyrantslayers received early recognition for their killing of the tyrant Hipparchus in 514 B.C. They were voted a bronze group of themselves, made by Antenor before the Persian sack of Athens, and when this group was taken to Persia at the time of the invasion of 480 B.C., another set was made in 477/476 B.C. (the archonship of Adeimantos, according to the Parian Marble). It is this latter group that is well known from later Roman copies in marble. However, there are also four vases which show the assassination in a composition adapted from this group, and on present chronology they should date between 475 and 460 B.C. They may be seen therefore as statements about Athenian democracy and its success against another tyrant who tried to dominate Athens. The heroes are also depicted

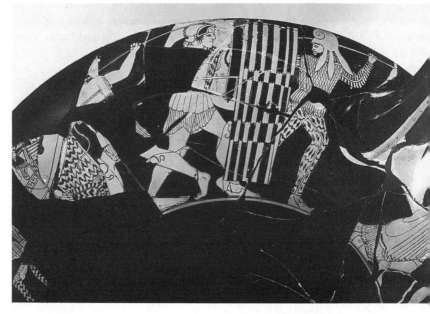

III.5 Attic red-figure kylix with Persians fighting Greeks, ca. 480 B.C.

on Attic vases of the later fifth and early fourth centuries. The choice of the pair as shield devices of Athena on black-figure Panathenaic prize amphorae, dated on other grounds to near the close of the fifth century, has been thought to reflect the newly regained democracy in 403 B.C. and thus date to that year or the next.[58] A red-figure chous which also depicts Harmodios and Aristogeiton in the same sculptural pose was found in the grave plot that adjoins the monument of Dexileos who died in 394 B.C. (see pp. 35, 43), and a reference to his defence of Athenian democracy may be likely.[59]

(c) *The Persians*.[60] After the Persians had come and gone in the early fifth century, painters of Attic vases depicted them in combat with their victorious Greek opponents (Fig. III.5). It is natural to assume that such scenes belong to the post-war years, whether post-490 or post-479 B.C., and thus a *terminus post quem* is provided. The popularity of such combats is to be found among painters of the generation after the invasion, 480–450 B.C., but one or two may date 490–480 B.C.

(f) *Pronomos*.[61] The famous Attic red-figure volute-krater in Naples with a dramatic company depicted across the front of the body presents actors, chorusmen dressed as satyrs, musicians and the poet, with Dionysos shown among his followers. Some of the figures are named, including

Demetrios the poet, Charinos the lyre-player and in the central place below, Pronomos the pipe-player after whom the vase receives its modern sobriquet of the Pronomos Vase. There was a Pronomos who taught Alcibiades to play the pipes and was said to have been no ordinary teacher; a Pronomos is also mentioned in Aristophanes' *Ecclesiazousae* (v. 102) of 392 B.C., and this may be same person. If the figure on the krater is to be equated with this historical character, a date in the late fifth or early fourth century would fit, but no precision is possible.

(g) *Alexander.*[62] There are some vases painted in Apulia in the red-figure technique that depict battles between Greeks and Persians. A leading figure on the Greek side may be Alexander himself, and the fact that he is shown with a beard when Alexander was clean-shaven is explained on the assumption that his appearance may not have been known in south Italy: his fame had preceded precise knowledge of his appearance. A date around 330 B.C. has been proposed.

Myths and heroes

Greek vase-painters only occasionally made overt references to contemporary events or historical characters, and the few just selected are unusual in this respect. Along with sculptors, vase-painters used mythological stories as paradigms of more recent events: their struggles with foreign foes were mirrored in such battles as the Greeks against the Trojans or the Amazons. It has therefore been suspected that reflections of historical events might be discovered in vase-paintings through the popularity of a particular myth or hero. In this way a rough *terminus post quem* might be suggested for the vases which carry such scenes. An approach of this kind has its obvious dangers and depends to a large extent on the ingenuity of students of the subject and on the existence of some chronological scheme that is already accepted: its validity is not autonomous. A simple example of this approach concerns the myth of Boreas, the North Wind, carrying off the Attic princess Oreithyia.[63] The episode only starts in Attic vase-painting after the Persian Wars, and its appearance has been connected with the wreck of the Persian fleet at Artemisium when Boreas was successfully beseeched and showed his favour to the Athenians. Recently the figures of Herakles and Theseus in Attic vase-painting have been studied for the light they might throw on the politics of Athens in the late sixth and early fifth centuries B.C., but this is a much more complex problem. Herakles has been seen as a figure used by the tyrant Peisistratus and his sons, and Theseus a little later as the hero of the developing democracy at Athens, as his range of stories is enlarged by novel episodes in the later sixth century, and he is promoted as a rival to Herakles. The return of Theseus' bones from Skyros to Athens by Cimon in 475 B.C., and the establishment in Athens of a sanctuary for him with

wall-paintings (now lost) showing stages of his career, heighten the popularity of the figure towards the mid century, and vase paintings of that time have in turn been seen to offer reflections of those lost wall paintings.[64]

Literary subjects

This last point introduces a further approach to dating that has been felt to have validity: the reflection of literary subjects and stories in vase-painting. Much has been made of the influence of literary works on vase-painting, though less so now than in the past, when it would seem that vase paintings were almost seen as 'book illustrations' and judged by their relation to literary models. Now the interdependence of the two is considered more cautiously.[65] It has been well said that ' "Illustrations" in vase painting are not, of course, straight transcriptions from poem or stage to the vase surface. They necessarily contaminate the literary images with stock motifs forming the artistic repertory of the period, because the artist had to move inside the framework of his trade and could not go free to create new compositions direct from a literary experience.'[66] So we must not expect close correspondence between word and picture, and this opens the door to speculation.

The two main points of contact have always been felt to be with the early epics, including the *Iliad* and the *Odyssey*, and with Athenian drama, especially tragedy.

As far as dating is concerned, the Homeric poems, and indeed the early epics in general, are themselves so difficult to place that there is great danger of circularity of argument. Also, the appearance of mythological stories in vase-painting at the end of the eighth-century or in the early seventh century, although often connected with literary works that are thought to have been emerging at this time, might instead be the response of the artists to the widespread oral stories, now that the technique and range of vase-painting were becoming more extensive. It has been pointed out that the very early scenes that might be linked to myths are rarely linked to the *Homeric* epics, and as two general propositions from which to start, it has been suggested that 'Homer probably never saw an Attic Geometric vase in his life' and that 'no Attic Geometric artist had ever read or heard recited a single line of Homer'.[67]

Much work has been done on the possible effects of Athenian drama on vase-painters. Many plays, both lost and extant, are firmly dated to the year of production, and the appearance of the same subject matter on vases, perhaps with tell-tale signs of a theatrical flavour (e.g. types of dress, background, masks), can sometimes be linked to datable plays.[68] It is of course a temptation to work from those plays that are extant and assume that *they* provide the particular influence, even though tragic themes were

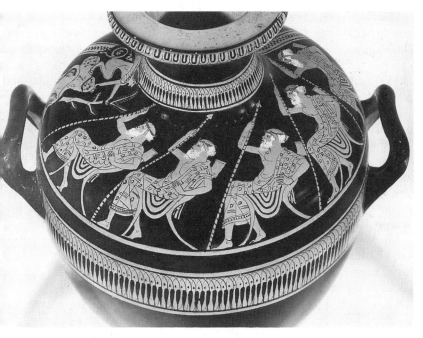

III.6 Attic red-figure hydria with chorus of satyrs, ca. 465 B.C.

repeated over and over again, and not only in drama. Let us take four examples, from tragedy, satyr-play and comedy.

(a) The tragedy of Agamemnon and Orestes' revenge is best known from the surviving trilogy of the *Oresteia* by Aeschylus produced in Athens in 458 B.C., and the appearance on an Attic red-figure calyx-krater of the murder of Agamemnon and the murder of Aegisthus seemed so close a parallel that influence from the trilogy to the vase-paintings initially appeared likely, especially as the connection of both murders on one art work is not known earlier than this example.[69] Current opinion, however, denies the connection, as conventional chronology for vase-painting places the calyx-krater earlier than 458 B.C., so in this promising instance chronology is not assisted.

(b) A more recently published case of a possible connection is perhaps more acceptable. Again the play is by Aeschylus, this time a lost satyr-play called *Sphinx* which was produced as the final play accompanying the Theban trilogy of which the third play, *Seven Against Thebes*, still survives. The date of 467 B.C. is certain, as a papyrus lists the plays and gives the archon for the year. The satyr-play burlesques the episode of the riddle set by the Sphinx to Oedipus and includes a chorus of satyrs. An Attic

red-figure hydria (Fig. III.6) carries a scene of a sphinx seated on a rock posing her riddle to satyrs elegantly seated in elaborate and uncharacteristic clothing, with diadems on their heads and holding sceptres.[70] Conventional chronology places the hydria in the 460s, and to find satyrs in such an unlikely setting argues influence from a specific source, of which the satyr play *Sphinx* is the likeliest.

(c) A second example involving a satyr-play shows how the dramatic productions initiated in Athens might be thought to influence painters elsewhere. Euripides wrote a satyr-play entitled *Cyclops*, variously dated in the last quarter of the fifth century. A red-figure calyx-krater, painted by an artist in Lucania, southern Italy, shows Odysseus preparing to blind the Cyclops with the help of satyrs.[71] Again, the unusual context for the satyr argues for the influence of a satyr-play, and Euripides' play has been accepted by some scholars as the catalyst.

(d) More recently, an Attic (?) red-figure calyx-krater with a pair of masked birds either side of a pipe-player has been thought to derive its inspiration either from Aristophanes' *Birds* (414 B.C.) or from the fighting cocks in the original production of his *Clouds* (423 B.C.).[72]

Close correspondence is not common, and although there are many theatre-based illustrations, particularly in south Italian vase-painting, they give little help with close dating, as they may draw their inspiration from earlier plays which were perhaps enjoying a revival, and in south Italian theatre no external dates exist to help in placing the performances.

Inscriptions

Many vases carry writing on them for one purpose or another. The letters may be painted in gloss, scratched or stamped and may be applied before or after firing; some, more rarely, may be written in ink. Thus the writer may be the painters of the pots, the potters or the shop-owners, merchants purchasers or passers-by who have picked up a piece of broken pottery in the street to scratch a message or impugn a rival (see pp. 124–5).

The study of letter forms is now advanced,[73] and as the shapes into which the letters were formed altered fairly rapidly over the years, it is possible to date those shapes with some precision. The existence of local scripts in different parts of the Greek world means that in many cases the letter forms can not only give a clue for dating but also help in locating the origin of the letterer. So even when the subject matter is itself of little or no assistance, the inscription can none the less be placed in a series which itself has firmly fixed points. As standardisation of writing spread in the fifth century, this useful approach is reduced in importance.

The type of inscription on a vase – painted, scratched, stamped or written in ink – will affect the usefulness of the dating. Any inscription or

stamp added before firing must date from the same time as the pot which carries it; scratched or painted letters added afterwards must be judged by other criteria and can give only a *terminus ante quem* for the pot or fragment.

Here are some examples of the ways in which inscriptions added before firing have been thought useful for dating pottery (for graffiti, see pp. 124–5):

(a) *'Kalos' names.*[74] For about a century (ca. 550–450 B.C.) it was a popular conceit for painters of Attic black-figure and red-figure pottery to add the names of Athenian aristocrats to the background of some of their figured scenes, with the addition of the predicative adjective 'kalos' = '(is) handsome'. About two hundred names are known from this source, and some of them are synonymous with names of Athenians known from other sources: Miltiades, Leagros, etc. For dating purposes, much reliance has been placed on the possible connections with known historical characters: some say that too much has been made of these connections.[75] Problems certainly stand in the way of precision here: the age-span to which the word 'kalos' may have been applicable, the lack of precision in the literary and documentary evidence on which the dating is to depend, the repetition of names in families (usually each alternate generation) – all such matters make for uncertainty. Nevertheless, although there is still much room for argument about the names, they may provide a possible support for other evidence.

(b) *'Signatures'.*[76] The name of the man who 'made' or painted a vase is sometimes to be found written on the vase itself (see pp. 65–8, and 110–12). The incidence of such 'signatures' and thus the reason for them is uncertain: pride, personal habit, fashion? The occurrence of a 'signature' on more than one vase, its combination with different names of colleagues, and the rarer but welcome appearance of patronymics can yield useful evidence for work over a period of time. Such 'signatures' are not of themselves likely to provide absolute dates but may give assistance when combined with other evidence. There are one or two Attic painters whose names can be connected with families of artists whose work we know from other media, especially sculpture (e.g. Euthymides, the son of Polias),[77] and a more firm date may be available that way.

(c) *Panathenaic prize amphorae.*[78] Here we have a much more precise means of dating, though with a restricted body of evidence. The archonship of Hippocleides (566/565 B.C.) seems to have been the first year of what was to be a regular festival at Athens, the Panathenaia, held every four years. With this date has been connected the provision of black-figure prize amphorae of oil which carry on one side a picture of an armed Athena and on the other an illustration of the event for which the prize was won. Also, on the side with Athena, an inscription was added before firing which

indicated that it was an official prize from those games: 'ton Athenethei athlon' = 'one of the prizes from Athens'. The well known 'Burgon' amphora in the British Museum, with Athena and a chariot race, is one of the earliest inscribed Panathenaic prize amphorae that survive; as early is fragmentary amphora from the Athenian Kerameikos cemetery which also carries a potter's name: Hyperides, son of Androgenes.[79] It cannot be known for sure that the Burgon amphora and the Kerameikos fragment date from the first year of the competition, but even if a little leeway is allowed, there is a fairly firm chronological anchor near the beginning of the series.

The production of Panathenaic prize amphorae continued as long as the Panathenaic festival was held; the technique of black-figure was retained but the appearance of the figures followed the taste of the times and the style of individual painters. At the beginning of the fourth century the traditional Athena and race were still being painted, together with the inscription, but soon afterwards, perhaps as early as 392/391 B.C. the name of the annual archon who gave his name to the year (*archon eponymos*), one of whose tasks was to see to the collection of the oil that was to go into the amphorae, was added to the right of the Athena (Fig. III.7). Twenty-six names, in whole or in part, are known, and some of the archons can be dated from other evidence. This enables the fourth-century series of Panathenaic prize amphorae to be arranged in order, based on combination of chronological and stylistic evidence, and the series run from 392/391 B.C. (?) to 312/311 B.C. Thus the changes in the shape of the amphorae and in the painting can be closely observed.[80] In the late fourth century, names of other officials began to be added or substituted *athlothetai* = 'commissioners of the games'; *tamiai* = 'treasurers of the military funds'; *agonothetai* = 'commissioners of the contests', and thus the dating can in some cases be continued, though in fact not many can be dated precisely.[81] However, the traditional nature of the Panathenaic prize amphorae, their retention of black-figure as their technique and their circumscribed subject matter make them less widespead in their usefulness than one could have hoped.

(d) '*Hadra*' *hydriai*.[82] A late series of water-jars (hydriai) was produced in Greek Alexandria (with white ground) and in Crete (with clay ground). The majority have been found in the urban cemetery of Hadra, east of Alexandria, from which their modern name derives; others come from the Eastern cemeteries of Chatby and Ibrahimieh and from the Western cemeteries. The vases were used as ash urns for distinguished foreigners who had died when in Alexandria. The shape is an old Greek one that has been in existence for centuries, but some of the clay-ground 'Hadra' hydriai carry datable inscriptions. Besides the modest decoration painted before firing (dots, palmettes, rosettes, fish, etc.), they also carry inscriptions

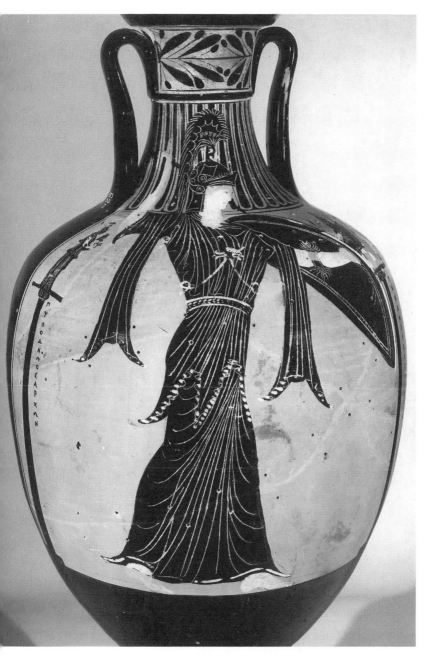

III.7 Attic Panathenaic prize amphora, 336–335 B.C.

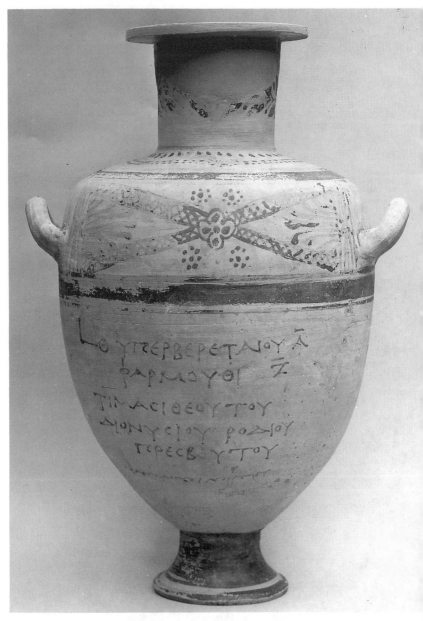

III.8 'Hadra' hydria from Hadra, Alexandria, dated 19 May 213 B.C.

added after firing, either in ink or incised. The information given usually includes the name of the dead man, the father's name, city or country of origin, and on some the date of death or burial is included, expressed by reference to the year of the reigning Ptolemy, together with the month of the Macedonian and/or Egyptian calendar, sometimes also the day (Fig. III.8). The name of the Ptolemy is sometimes omitted and has to be deduced. The name of the official who made the burial arrangements was also on occasion included in the inscription. A tight series has now been fixed from 271 to 209 B.C. and once again, as with the Panathenaic prize amphorae, development of shape and decoration within circumscribed limits can be plotted. Some of the hydriai have been found together with other tomb material, and thus there is help in dating vases of other shapes and decoration. However, as with the Panathenaics, the information won is once more restricted.

(e) *Ostraka.*[83] There are two meanings that we attach to this word: one refers to the voting sherds for the banishment of prominent citizens of Athens in the fifth century B.C., the other to fragments of pottery carrying letters written in ink; it is the first meaning of the word that is of interest here. Broken fragments of pottery, fine or coarse, were used as voting 'papers' when agreement had been reached in a particular year that a ballot for ostracism should be held. The procedure is confined to the fifth century B.C. in Athens, roughly 488/487–417 or 415 B.C. Many names are preserved on the sherds, including some prominent politicians such as Themistokles, Kimon, Megakles (Fig. VI.2), Perikles. We do not know all the occasions on which such a ballot was carried out, only some of those in which a famous figure was a candidate. It is obviously incorrect to assume, as used to be done, that every ostrakon that we have comes from the year(s) in which the named politician was exiled or is known to have been ballotted. Citizens might vote for the exile of any citizen in any year of ostracism; only the death or present exile of the person concerned is likely to have reduced the citizens' choice. This being so, once again the usefulness of the sherds is limited, particularly as the shape of the fragments is only likely to afford diagnostic help occasionally. Sometimes the name is inscribed on a fragment of figured pottery (Fig. VI.2), and hence the decoration must antedate the occasion of the voting, if that can be fixed. As with 'kalos' names, the repetition of family names may cause confusion.

(f) *Stamping.* Some of the large transport amphorae which were used as commercial containers for the transport of wine and other commodities and for their storage carry stamps on the tops of the two tall vertical handles.[84] Rhodian and Knidian stamps may carry two names, one of the manufacturer and one that indicates the official in whose term of office the wine was 'bottled' (Fig. III.9). This is also true of some jars from Sinope

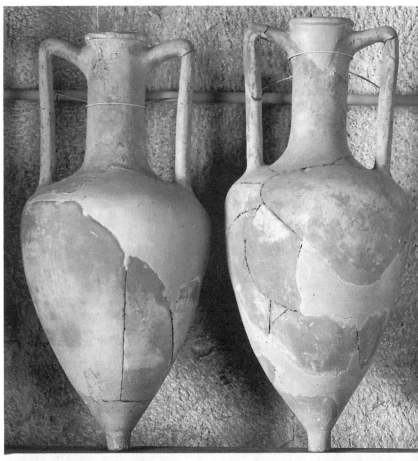

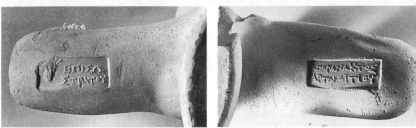

III.9 Rhodian transport amphorae and stamped handles, third century B.C.

and Thasos. The usefulness of these names is vitiated by the dearth of external dates for the officials named.

Some Chian wine jars have coins stamped on the handles in the wet clay, and the use of coins for decoration or marking is also to be seen in the centre of a class of black cups that go by the name of 'Arethusa cups', as the tondo is taken from Syracusan silver tetradrachms (398–380 B.C.) carrying the head of the local nymph. The coins of Heraclea are used on pottery in the same way. Once again the usefulness is somewhat restricted as the coins are not always easy to date, and are free objects that could be used any time after their date of minting.[85]

Scientific dating[86]

The use of scientific techniques for the dating of Greek pottery of the first millennium B.C. is still less precise than results reached by other methods. Thermoluminescence (TL), which relates to the firing of the clay and is the principal method of measuring absolute dates in relation to the age of pottery, has its uses in investigating forgeries (such as Tanagra terracotta statuettes) but is too imprecise to be of assistance in making the sort of chronological distinctions on which students of classical pottery have come to depend.

IV

SHAPES

It is, indeed, by an odd inversion of propriety that the word 'vase', with its modern connotation of ornamental un-usefulness, has attached itself to Greek pottery, and that as a result of antiquarian habit we can hardly think of this pottery outside a museum. (Lane 1971, 8)

Distinguishing functions

Most Greek pottery was shaped to serve a function or a variety of functions: for domestic tasks, for ceremonial, for leisure and pleasure. One shape might be used in a number of different contexts, and conversely some functions were served by more than one shape. In this chapter we shall be concerned with shapes and the functions that they were created to perform, and with the individuals who fashioned them.

Naturally, there are variations in the basic shapes in different areas of the Greek world: no two regions shaped a jug or a cup in precisely the same way. These variations are one of the ways that help us to assign to different sources the material found and to observe the influence of one area upon another. Similarly, shapes of pottery varied through time: they developed in certain ways, either radically or in details, and from time to time new shapes were introduced. Here again, the study of shape-changes enables a framework of relative chronology and influence to be erected. Fine wares changed more frequently and obviously than coarse wares; with the latter it is the much more recent social changes that have altered the long-standing traditional shapes.

Clay was readily available, cheap and malleable, hence it was the basic material for containers, and potters adhered to traditional shapes, unless persuaded that a change was an advantage – easier to form, more saleable, answering new needs.

How are we able to distinguish functions? Apart from the broad distinction of fabrics – such as coarse versus fine – which will indicate whether the objects were mainly used e.g. in the kitchen, garden or workshop, or in the dining room, for the sanctuary or at the grave side, there are five main ways in which the use can be determined.

(a) The shape of the object itself often declares its purpose, either in general or in particular. An open shape, e.g. a large bowl or cup, might suggest easy access for hands or implements, for ladling, for mixing,

dipping, drinking, whereas a closed shape with small mouth is likely to suggest sealing with wax or a stopper, or storage. One vertical handle and a spout or a shaped lip indicates pouring, two handles (vertical or horizontal) suggest carrying. A three-handled jar (hydria) – with one vertical and two horizontal handles – enabled the empty jar to be carried by the one vertical handle, the jar when full of water to be lifted to the head by the two horizontal handles. A small toe, on which no vase could stand, such as is found on transport amphorae, suggests storage in the earth or fixing in a stand, ease of lifting to pour out the contents (a sort of third handle) and neat stacking. A rolled rim was formed to enable a waxed or oiled cloth to be tied across the mouth to protect the contents, or for the attachment of a wooden cover or clay lid. Inner containers, whether large as in some storage amphorae or small as in some oil flasks, argue the need to keep the contents cool or perhaps contents too precious and expensive to fill the complete container.

(b) A second help towards understanding the function is the find spot: grave (Fig. III.1), sanctuary, house, etc. A straightforward example is the well, at the bottom of which broken or holed clay buckets with wide mouths, two handles and unpainted surface, declare their use readily.

(c) Much fine pottery carries figured scenes, and the illustrations shown provide valuable clues to the uses of a whole range of shapes. Naturally one must not assume that all vases depicted are painted fine ware, though occasionally some are decorated to indicate this, nor indeed must one assume that all the containers illustrated were of clay, though some are shown broken; many must be meant for metal, wood, stone, etc. However, even with this constraint, shapes may betray their purpose, no matter what their material.

The division often made between scenes of mythology and scenes of everyday life is a false one, especially when considered from the point of view of the pots illustrated, and the objects in the hands of legendary heroes rarely differ from those held by revellers and athletes. The contexts – symposium, libation at an altar, sports ground, well or fountain – reveal the functions of the vases held or set down: for example, the lekythoi shown on the steps of tombs on Attic white-ground lekythoi; the pots handled in fountain scenes; the varied jars, jugs and cups in use at drinking parties; oil bottles at athletic scenes or in scenes with women at home. Some of the mythological scenes provide help: the storage jar (pithos) in the tale of Herakles, Cerberus and Eurystheus; the drinking cup in the story of Odysseus and the Cyclops.

(d) Occasionally the lettering on a vase will assist in understanding its function. Some cups have mottoes written on them that urge the user to drink. More rarely, illustrated vases carry their names painted by their side ('hydria' by the side of a water pot; 'lebes' by a bowl on a tripod).[1]

(e) Greek literature also provides another source of evidence from which we can derive information on use. Almost unconsciously, writers on contemporary themes (Aristophanes the comic playwright; the orators of fourth century Athens) give help in understanding the objects in everyday use. However, the very fact that the words were living for them means that generally their usage is allusive. Later writers and those deliberately attempting to define old words in lexica have little more idea than we do but may be helpful in different ways. In any case, no language uses such words precisely, and our own 'saucer', 'pot', 'dish', 'bowl' etc. defy accurate visual description.[2]

The last item brings us to the difficult problem of the present bewildering names of vase-shapes that we find in modern studies of Greek pottery.

The game of the names

As Greek vases have been seriously studied since the eighteenth century and by scholars educated to an understanding of Greek and Latin literature, it has been inevitable that their knowledge of names for containers in ancient Greek and Latin literature and lexica should have been put to use in seeking to establish a nomenclature for the vases found and studied.[3] The vases then studied were mainly fine, decorated pottery, not coarse and plain wares, and so this established a bias from the start. The present chaotic system of vase names is the result of an historical accident, compounded by alterations and additions made during more recent study; however, the system, now international, would be impossible to jettison entirely. Students of both literature and ceramics suffer from the consequences, as readers of literature cannot look to the vase-shape terminology for a correct image of the word they have encountered nor can students of Greek vases necessarily derive from literature a correct idea of the name and uses of the vase they are studying, as it was named generations ago on a system that had no firm reasoning behind it. False images are raised on both sides.

Literary references to shapes need not always refer to fine wares nor even to objects made of clay. Also, the genres of literature had their own field of words, and tone and level of speech (vulgar, poetic, rhetorical) varied. Dialect and period also need to be considered. Some of the established names for shapes seem to 'work' correctly, some are partially right, some are totally wrong ('askos' was the word for a wine-skin but is conventionally used to designate a small oil-container; 'dinos', which has now been used of a form of mixing-bowl, was actually a word for cup). Also, study of Greek usage suggests that words were used generically, not specifically, and we are in innocence and error if we expect to find a one-to-one correspondence between literary references and a particular shape of vase.

Names of shapes are often encountered in inscriptional sources. Stone inscriptions such as temple inventories and the Attic stelai that listed the sale by the Athenian state of goods belonging to those accused of damaging the Herms in Athens and of profaning the Eleusinian Mysteries in 415 B.C., provide words by themselves and occasionally (by a more detailed description) supply a closer approximation to a specific shape.[4] Inscriptions on the pots may bring us nearer to naming the shape carrying the word, but the information won is still limited.[5] We have seen how occasionally a pot in a scene is given a name by the side of it; sometimes a painted inscription names the pot on which it is painted (e.g. 'kados' on an Attic black-figure amphora).[6] More commonly, the name appears in a graffito, scratched after the pot had been fired, declaring the ownership of the vase, e.g. 'I am the [cup] of [personal name], a pleasant drink'.[7] Some graffiti appear as trademarks under the foot, where they are usually abbreviated and are part of a batch list (see pp. 126–9). Here follow a few examples of such painted and incised vase-names; some provide added information on Greek social life.

(a) *Drinking cups*: the usual words painted before firing or scratched after it are 'kylix' and 'poterion'. To mark one's own drinking cup was perhaps a necessary precaution for a party, and laying claim to portable crockery was not uncommon. 'Kylix' is found (before firing) on a late seventh-century Chiot chalice ('Nikesermos made this kylix')[8] and (after firing) retrograde on a Rhodian subgeometric skyphos of ca. 700 B.C. ('I am the kylix of Korakos' – the conceit of the speaking pot is found early in ceramics)[9] and on an Attic cup-skyphos of ca. 400 B.C. ('Kephisophon's kylix. If anyone breaks it, he will pay a drachma, as it was a gift from Xenylos')[10] 'Poterion' is found (before firing) on a mid sixth-century Attic Siana cup ('I am the lovely poterion')[11] and (after firing) retrograde on a late eighth-century Rhodian Geometric skyphos from Ischia ('Of Nestor am I, a poterion pleasant to drink from. Whoever drinks from this poterion, a desire for Aphrodite of the beautiful crown will seize straightaway').[12] 'Kotylos' or 'kotylon' is found on a Boeotian mid. fifth-century black kantharos ('Mogea(s) gives a kotylos as a gift to his wife Eucharis, the daughter of Eutretiphantos, that she may drink her fill').[13]

(b) *Oil bottles*: the commonest word found is 'lekythos'. Again these were objects that were carried around and thus might need marking as a personal possession. 'Lekythos' is found (before firing) on an Attic early fifty-century red-figure aryballos ('Douris made. Asopodoros' lekythos')[14] and (after firing) retrograde on a Protocorinthian mid-seventh-century pointed aryballos (Fig. IV.1) ('I am Tataie's lekythos. Whoever steals me will go blind').[15] 'Olpe' is found (before firing) on a Corinthian early sixth-century black-figure round aryballos ('Polyterpos. Pyrrhias leading the chorus. The olpe is his very own').[16]

IV.1 Protocortinthian lekythos with graffito, ca. 675–650 B.C. (reproduced at approximately three times actual size)

(c) *Storage jars*: although we use the word 'amphora' as the general term for a shape with two vertical handles, the shape is designated by the word 'kados' painted on an Attic black-figure amphora of the late sixth century ('the kados is fine').[17] The same word 'kados' is incised on an unpainted coarse-ware bucket of the late fifth century ('I am a kados').[18]

As can be seen, we are likely to be confused if we expect any systematic ancient nomenclature. So modern names such as plate, bowl, mug tend to be adopted for new shapes being studied, with explanatory descriptions to subdivide them; sometimes a made-up name, such as one-handler, refers to the distinctive appearance of a type; occasionally, new names are invented to distinguish a shape, e.g. 'bolsal' for a shallow straight-sided drinking-cup, named from two Attic red-figure examples, one in Bol (ogna), one in Sal (onica).[19]

It would be more helpful if a systematic terminology could be devised, as for types of pottery more recently discovered or those belonging to a preliterate age, but this is unlikely.

Potters

For most of the period under study, pottery was largely formed by hands, and therefore it is natural to think in personal terms. It was mainly an anonymous craft, though study of details of shape, where enough are available and their idiosyncrasy is detectable (feet, handles, lip, contour), can lead to an understanding of an individual potter's work. So names have been invented to distinguish individuals, such as the Club-foot Potter and the Canoe Potter.[20] However, some vases carry painted (and scratched) inscriptions that indicate the men who 'made' them. These are painted in black on a clay background, or in purple on a black background where the painting is in red-figure; occasionally black was used on a black background, with a reserved outline round the lettering, or again inscriptions were incised on the black gloss, whether on black-figure or red-figure pottery. The inscription could be set on any part of the vase: body, neck, rim, foot, handle. A study of the handwriting reveals that the writer could be a 'letterer' charged with the task, not necessarily the man who 'made' the vase;[21] in some cases the letterer may be the painter who will thus finish off the work he has done, but this should not be presumed. So 'signature' is a dangerous word to use here. Letterers can't always spell correctly or consistently, but this may not mean that they do not know how to spell their own name.

There is only one instance where the verb used means 'potted', and this is on an Attic black-figure stemmed dish of the early fifth century, where the painted inscription says 'Oikopheles potted me and painted' ('ekerameusen eme Oikopheles kai egraphsen');[22] all other vases with this type of

inscription carry the more general word 'made' ('epoiesen'). This causes difficulty, as the general word 'made' may refer to the *actual* maker who threw the vase, but it could refer to the *proprietor* of the pottery shop within which the vase was made. There is scholarly disagreement here, and the solution is not simple.[23]

A 'maker's' name is first met ca. 700 B.C., i.e. not very long after the introduction of the alphabet to Greece and quite soon after its earliest use on pottery. The earliest known to us is to be found on a krater fragment from Pithecusa, Ischia ('—inos made me'), and it is written in a local script of Euboean style (the Greek settlers at Pithecusa were from Euboea).[24] Best known and clearest of the early makers' inscriptions is the Aristonothos inscription on a krater found at Caere in Etruria; it was made in Italy in the second quarter of the seventh century B.C. and shows a sea fight on one side and Odysseus and the Cyclops on the other.[25] Again the script is thought to be (colonial?) Euboean, though other suggestions have been made (Argive, Cumaean, Sicilian). There are very few 'maker's' inscriptions in the seventh century, but the habit seems to have been widespread, other examples coming from e.g. Smyrna, Chios and Ithaca.[26] One in Euboean script gives the father's name as well (Fig. IV.2): 'Pyrrhos, son of Agasileos made me'.[27] It is the letterer's home town that is betrayed by the script, and this need be neither that of the potter nor that of the painter. The practice becomes more common in the sixth and fifth centuries, mainly in Athens;[28] another centre that has provided makers' names in that period is Boeotia e.g. Teisias 'the Athenian' (scratched), Theodoros.[29] Most 'makers' (whether potters or proprietors) are nameless to us, and it is difficult to explain why a few should be commemorated in the way they are. There seems to be no consistency, no intelligible pattern. Some of the best quality

IV.2 Protocorinthian(?) aryballos with painted name of potter, ca. 650 B.C.

pieces carry no names of the makers, whilst some of the worst (e.g. that of Oikopheles, above) advertise the 'maker', so it is hard to believe that names were always added for quality of workmanship (see below for another solution, pp. 71, 149, n. 38).

Whether we accept the name of the man who 'made' the vase as the potter or the owner of the shop, there are certain consequences that flow from the names.

The names themselves tell us details about the men. Aristonothos (see p. 66), meaning 'Best bastard', suggests a nickname; Pyrrhos (Fig. IV.2) (see p. 66) may mean 'Redhead', another nickname, though his father's name, Agasileos, is straightforward. With names on Attic pottery, some inscriptions show that some 'makers' were also painters, e.g. Nearchos, Exekias (Fig. V.8), Euphronios (first as painter, then as 'maker'), Douris, Myson; some appear with the name of the painter, working in the same shop, e.g. Ergotimos the 'maker' and Kleitias the painter; Python the 'maker' and Douris the painter; Hieron the 'maker' and Makron the painter. Some names may reveal the origin of the men, e.g. Sikanos, from Sicily; Brygos, from Phrygia; Thrax, from Thrace; Syriskos, from Syria; some of these may be slaves, as also Epiktetos meaning 'Newly acquired'. Some add their ethnic origin, e.g. Teisias the Athenian, working in Boeotia (see above), Xenophantes the Athenian and Nikias, son of Hermokles, of Anaphlystos (a district of Attica). Amasis, a name shared with an Egyptian Pharaoh, has caused interest and discussion. Some, like Pyrrhos (see above), advertise their family connections: in Attic black-figure there are Tleson and Ergoteles, sons of Nearchos, the sons 'makers', the father both a 'maker' and a painter, and Ergotimos had a son Eucheiros and a grandson, both 'makers'; in Attic red-figure Kleophrades, who was the son of the 'maker' Amasis, was himself a 'maker'. Very occasionally, two are given as makers of one cup.[30]

It is interesting that we also have a 'maker's' name on a very early Panathenaic prize amphora, again with the father's name given (Hypereides, son of Androgenes).[31] As this public commission is likely to have been much sought after, it is remarkable that there are few instances with the 'maker's' name painted on them. A fourth-century instance of names added on Panathenaic prize amphorae has a bearing on the question of whether 'makers' were potters or proprietors. Some Panathenaic prize amphorae carry the names of Bakchios and Kittos, with the word 'made' (epoiesen) following them. One Bakchios amphora is dated by the archon name (Hippo[damosl]) to 375/374 B.C., the Kittos amphora to a decade later, perhaps to the year of the archon Polyzelos (367/366 B.C.).[32] A tombstone of ca. 330 B.C. found near Athens records in a verse inscription the name of a Bakchios, son of Amphis[———].[33] The accompanying set of verses tells us what trade he had followed: 'Of those who blend earth,

water, fire into one by art, Bakchios was judged by all Hellas first, for natural gifts; and in every contest appointed by the city he won the crown.' Towards the end of the fourth century an inscription set up in Ephesos records employment and political honours awarded to a Bakchios and a Kittos:[34] 'The council and people have agreed that Kittos and Bakchios, sons of Bakchios, Athenians, since they have undertaken to make the black pottery for the city, and the hydria for the goddess, at the price fixed by law, shall be citizens of Ephesos as long as they remain in the city ... ' The likeliest explanation would seem to suggest that the earlier Bakchios and Kittos ·were brothers, and that the sons of Bakchios, themselves named Bakchios and Kittos, followed their father and uncle in the pottery business and moved from Athens to Ephesos for work, perhaps after the death of the first Bakchios.[35] On this evidence, it would look as though these 'makers' did actually fashion the clay with their own hands, and that their work was highly esteemed.

That the word 'made' was also used by metalworkers on their shapes is known from the fact that some black relief phialai made in Cales (south Italy), the mould of which was taken directly from a metal, most likely silver, phiale, have the word 'epoiei' transferred along with the design (see below).[36]

Other materials

Before considering the variety of shapes in clay, it may be helpful to speak generally of the materials available that were fashioned into the shapes of containers to hold liquids and/or solids and used for storing, pouring, transporting, cooking, eating and drinking. As clay is such a malleable and virtually indestructible substance, other materials can be seen reflected in the ceramic vases, both in shape and in details of shape, even when the original objects have had no chance of survival.

Such a basic material as animal skin, so useful for clothing, could also be cut and sewn to act as a container: if large, as a wine-skin (askos); if small, as a purse which may be reflected in the small aryballoi that were hung from the wrists of athletes. Dried gourds make excellent containers, and the swollen shape may have given rise to certain clay forms such as the phormiskos. Reeds woven into baskets, large and small, provide the prototype for certain round clay boxes (pyxides) in which the plaited designs on the walls and the radial designs on the bottom are imitated in paint (Fig. IV.3); the actual raised form of the interwoven strands is occasionally to be found where the clay appears to have been pressed against a basket, and sometimes the long rope handles are closely imitated (Fig. IV.3). Wood must have served many purposes, perhaps mainly as platters, bowls and boxes, and the few remaining pieces that have survived

IV.3 Boeotian Geometric pyxis, ca. 700 B.C.

show us the beading and other decoration that we find on some clay vases; the knobs of clay lids also seem to imitate the shapes of turned wooden knobs. Occasionally, vases were moulded into the shape of nuts, shells, etc.[37]

Leather, reeds, wood, etc. are materials that need use no other processes than cutting, stitching, plaiting and carving. Though skill was needed in their making, they were technically uncomplicated and inexpensive products. Clay, similarly cheap, needed more complex production methods. Costlier materials needing even more advanced skills lie, as it were, at the other end of the spectrum. Stone (alabaster), horn (ivory, etc.) and metals (gold, silver, bronze) are less easily accessible materials than clay, and all have left their mark on the appearance of pottery. The Egyptian alabastron, a long narrow perfume pot, originally made of alabaster (hence the name), is copied in clay in East Greece and is later adopted in Athens; the surface of the clay alabastron is later covered with a white slip in imitation of the stone surface.[38] The rhyton, a horn-shaped drinking vessel, takes its shape from natural horn. Glass too, though more rarely, may have had influence.

With metals, the connection is much more complex and, it would appear, more all-pervading. Comparatively few metal vases have survived, their value was in the material of which they were made, and they could easily be melted down. What have survived would seem to suggest that many clay vases owed their inspiration, both in particular and in general, to metal originals (Fig. IV.4): the sharp edges, the acute angles, the thin walls, the precise articulation. It is also true of details such as imitation rivets, studs, discs, and of decoration such as ribbing, incising and

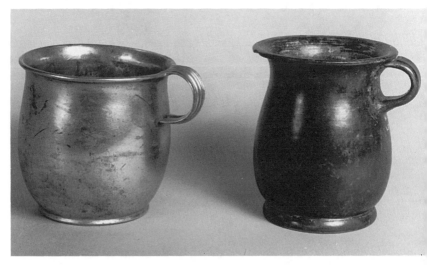

IV.4 Silver and black mugs from Dalboki, Bulgaria, ca. 400 B.C.

stamping. In some instances, impressed and applied reliefs can be seen to have been taken directly from metal originals, sometimes with the word 'made' transferred to the clay as well (see above p. 68). A recent theory would extend the influence of metal beyond the areas mentioned above and connect all the various colours of Greek pottery with metal and other original materials (see Chapter V). On this theory all such influence was from the more expensive materials to the clay, with important consequences for our understanding of both shapes and decoration, and in a wider context, of the social standing of the potters and their clients, and of the value and purpose of pottery.[39]

Besides the influence from other materials, Greek pottery borrowed and adapted shapes from traditions outside their own area. The Egyptian alabastron has been mentioned above; other such borrowings are the rhyton, a drinking horn with a hole in the base that owes its origin to Persia; the phiale, a drinking and offering dish also from Persia; the lydion, a small perfume container, that originated as the name suggests in Lydia (Asia Minor).[40] Nor was the influence always from East to West. Trade with the Etruscans found the bucchero amphora of their potting traditions copied by the Athenian potter Nikosthenes, given black-figure decoration and exported back to Etruria; the kyathos, a one-handled dipper, is also an example of a similar transference.[41]

Shapes and functions

There is no single, straightforward way in which to treat the different shapes in Greek pottery. There is overlap of function, variation in place and time, etc. A simple distinction to make, but one which immediately cuts across the morphology, is a division into varieties of ceramic material.

(a) There are the heavy-duty shapes. The best known perhaps are the big commercial transport amphorae (jars for storing, sealing and conveying wine, oil, fish, etc.) with long body, narrow neck, two vertical handles and small toe (Fig. III.9). The 'Ali Baba' pithoi, which were rarely moved once in position and could last for years, were also used for the storage of commodities such as oil and dry goods (Fig. IV.5). Other heavy-duty containers were big tubs, mortars for grinding and shallow basins on stands (louteria). Some of these were mould-made.[42]

(b) There are also the less well known coarse wares made with paddle and anvil (see p. 13) which were used in kitchen contexts: kettles (chytrai), two- or one-handled; buckets (kadoi) with two vertical handles at the neck to which a rope could be attached for letting down a well; water-jars (hydriai) with one vertical and two horizontal handles; jugs with a single handle for pouring; frying-pans, casseroles, gridirons, ovens (Fig. IV.6). The shapes are not so well articulated as those of the fine wares,

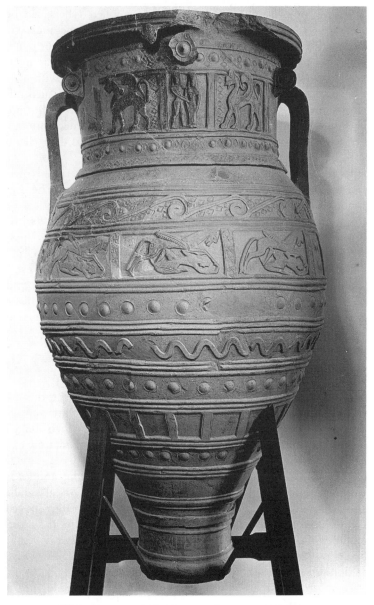

IV.5 Cretan relief-pithos amphora, ca. 675 B.C.

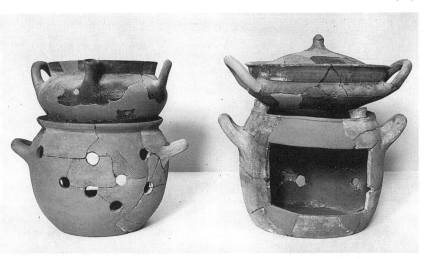

IV.6 Cooking pots and braziers from Athens, fifth and fourth centuries B.C.

perhaps because of the method of production or the absence of metal influence. Nor do the shapes change so rapidly and might be expected to last longer provided they didn't break or spring a leak.[43]

(c) Household wares were made by the same methods as fine wares but were left mainly in the colour of the clay, with perhaps a stripe or two across the body. Gloss was often applied to the foot, handles and rim, and the interior given a waterproof coating. The commonest shapes were open bowls (lekanai) with two horizontal handles, like kraters; lidded bins for storage; small narrow-necked jars for keeping food from going bad (eggs, olives); jugs and water-jars.[44]

(d) The range of wheel-made fine wares makes any all-embracing statement difficult. The distinction between them and the household wares is basically in the greater range and sophistication of the shapes, the amount of gloss and decoration they carry (black, patterns, figures), and the contexts in which they were used.

Occasions and contexts

Let us look at some of the most obvious occasions and contexts in which pottery was used, to get some idea of the range and variety of demands that the potters had to face.[45] We'll start with men and their life: politics, athletics, work, relaxation.

In the public life of the polis men needed the potter. In Athens, there were objects of clay specifically produced with public affairs in mind (Fig.

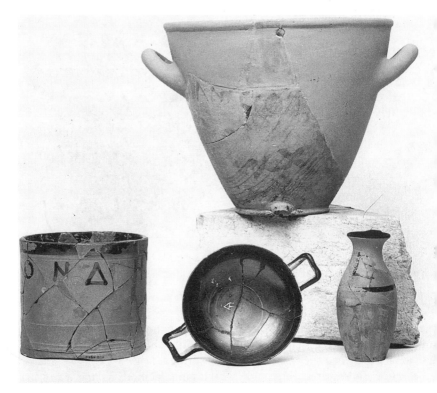

IV.7 Public pots used in Athens, fifth and fourth centuries B.C.

IV.7): liquid and dry measures, water-clocks for measuring the length o
the speeches in court, two-part voting tickets. Most were undecorated, and
some would carry the ligature ⋐, an abbreviation of *demosion* to indicat
that this was an officially recognised object. Often pottery needed fo
public life was the same sort as for other purposes, e.g. hydriai or kado
used in everyday life as water-jars and buckets doubled as voting-urns, and
the klepsydra or water-clock was adapted from the ordinary househol
bowl.[46]

In athletics, whether at practice or after an actual race, the men and boy
needed their personal oil bottle by whatever name we may now choose t
call it and whatever its precise shape might be, hanging from the wris
when not in use, or easily grasped in the hand when shaking out some o
the contents.[47] Prizes were awarded at games meetings, and these too migh
be made of clay. We know that tripods and cauldrons (lebetes) of bronz
were offered in earlier times, but there is enough evidence from Athens t
show that clay containers were common. Apart from the evidence o

amphorae and hydriai, the fullest material is the black-figure Panathenaic prize amphorae for the Great Panathenaea (see pp. 53–4). The city gave the commission for these on some basis that we do not comprehend ('one of the prizes from Athens' is painted on them), and the oil they contained came from the sacred olive groves of Attica. This must have been a lucrative commission for a workshop to win, as over 1400 would be needed every four years (cf. Bakchios and Kittos, pp. 67–8).[48]

What a soldier took to war apart from his weapons and his armour would have been small. Travellers would also have travelled light. A mug for drinking and a flask for carrying water (pilgrim flask) may have been all they needed.[49]

For the various trades and industries, clay vessels would have been vital: if a shoemaker, a bowl for softening leather in water; if a blacksmith, a jug for water; if an oil-seller, a container for oil and a funnel to direct the oil into the narrow neck of an alabastron or lekythos; if a wine-seller, amphorae, jugs and cups for tasting. Out of town, men had to collect and tread grapes; they needed a trough for the grapes, a bowl for the squeezed-out juice and a pithos for the storing of the juice. In big wine industries, the transport amphora was vital, and thousands have been discovered. If bees were kept, then the hive might be of pot. Storage jars would also be needed for keeping meat, olives, etc.[50] This is not the territory for elegant fine wares.

An area of male society that we know well is that of the festive symposium or drinking party, and the komos or revel. A great range of pottery was needed for drinking sessions. First, the wine itself had to be stored in large, coarse amphorae that would need to be broached – sometimes they were taken along by members of the party themselves. Access to water was needed for diluting the wine (two-fifths wine, three-fifths water), and there was no tap on hand. At the party itself (Fig. IV.8), deep, open mixing bowls of various shapes stood by the couches of the drinkers as they reclined: fine-ware amphorae with wide mouths, kraters of various types, lebetes on stands, stamnoi, pelikai. For the sophisticated party, a wine-cooler (psykter) might have been provided, to sit in the mixing-bowl.

To decant the wine from the mixing-bowl to the cup, a jug or ladle was on hand. The jug was one-handled, could have a trefoil mouth, and there were various shapes and sizes; ladles (kyathoi) or dippers served the same purpose but had longer handles. But it was in the variety of drinking cups that the ingenuity of the potters was most apparent. Many were large, to receive diluted wine, and many two-handled and shallow; it is doubtful how helpful such a shape was to the drinkers as they reclined. When not in use, they were hung from the wall. Some were taller and deeper, with one handle or two. Different pottery-producing centres issued their own

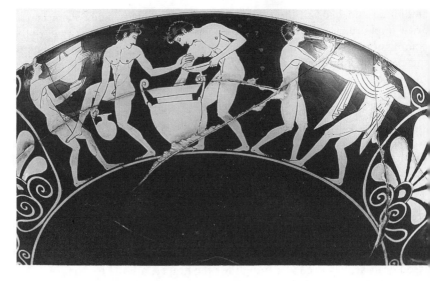

IV.8 A symposium in full swing on an Attic kylix, ca. 500 B.C.

versions: Chiot chalices, Laconian lakainai, Boeotian kantharoi, etc., and
there were less popular varieties: mastoi (shaped like breasts), rhyta
(shaped like a horn or an animal head), moulded tankards, phialai and so
forth. Later in the Hellenistic period the handleless hemispherical bowl (the
so-called 'Megarian' bowl) became the most popular drinking cup.[51]

Other objects to help the festivities were needed – besides wooden
platters for the food, perhaps stemmed plates of clay for fruit, plates for
fish, clay lamps to light the rooms in the evening; and also for those who
had taken too much to drink, a sick basin and/or chamber pot or jug (cf.
Fig. IV.8) were provided to afford much needed relief. The chamber pot
may have been something of a refinement, as the easiest move to make, if a
move was going to be made at all, was outside.[52]

What of the women? Their rôle centred on the house, the food and the
children. The house needed storage containers for the grain, for water,
olives, oil, wine. There would be a bucket for drawing water from the well
in the courtyard and a three-handled water-jar to take to the fountain
nearby. Much time would be devoted to the cooking, and the kitchen
equipment consisted of such items as kettles, frying-pans, ovens (Fig. IV.6),
gridirons – all made by the potter.[53] When not attending to the meals, the
mistress of the household spent time with the children and the weaving. For
the former, the potter's shop provided clay dolls and toys, baby feeders and
potty chairs, and perhaps dice for the older children; for the weaving, there
were clay loom weights, spindle whorls and a clay carding cover for the

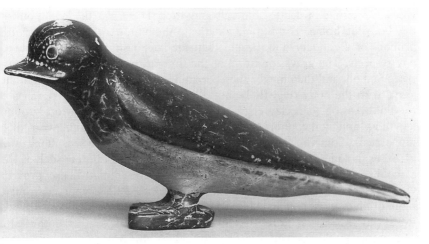

IV.9 Rhodian perfume pot in the shape of a swallow, ca. 600 B.C.

thigh over which to draw the unspun wool.[54] Clay lamps too were needed
for lighting. When there was time for the woman to attend to herself and
her appearance, the potter provided various lidded containers (lekanides)
for trinkets and also boxes (pyxides) for such cosmetics as powder, rouge,
pomade for the hair. She also had small bottles in which scent and perfume
were kept; these (such as alabastra and the various shapes of lekythos) had
narrow necks and stoppable mouths, the latter sometimes having a drip
ring at the neck. Other containers were lydia, amphoriskoi, 'askoi', gutti
and unguentaria.[55] Some of these containers declare their contents by
painted inscriptions: a lekythos in Athens carries the word HIPINON
painted on the top of its mouth: iris perfume.[56] Some perfume vases were
shaped in the form of heads, legs, birds (Fig. IV.9), etc. The exaleiptron,
because of its size, must have contained scented water, to be used on
special occasions such as weddings and visits to the tomb.[57]
 There were also special occasions in the life of the household that
demanded special pottery, occasions such as marriages, births, funerals and
times when, in public or private, the family took part in religious festivals.
For the marriage, there was a special range of shapes that were peculiar to
weddings: especially the loutrophoros in Athens, a tall ungainly shape that
provided water for the bridal bath, and the lebes gamikos, with either
attached stand or short foot, in which ceremonial water was kept. On such
an occasion, presents were brought for the bride, again furnished by the
potter: lekythoi, amphoriskoi, epinetra, pyxides, on many of which the
scenes of brides and home life link the object with a wedding.[58]
 Potters must also have answered a brisk, not to say urgent, demand for

vases at the time of deaths, funerals and after. There was the laying out of the body at home, the burial, whether inhumation or cremation (with primary or secondary burial), and then the later visits to the graveside to pay respects. The graveside ritual at the time of burial demanded vases of perfumed oil, and then maybe these, certainly similar, vases were laid in the grave with the body (Fig. III.1), not all new but some certainly purchased for the occasion (e.g. clay eggs, phormiskoi, and in Attica, white ground lekythoi, and loutrophoroi and lebetes gamikoi for those who died unmarried). Sometimes the need for a coffin was expressed, small and plain, or in some parts of the Greek world, large and elaborate such as the sarcophagi from Clazomenae; if the bodies were cremated, ash urns of various shapes (amphora, hydria, lebes) were needed, sometimes bronze more often clay. At certain stages of history, the grave location was marked by a clay vase as a grave monument, the best known being the Late Geometric amphorae and kraters, but others are not uncommon. Later visitors brought offerings to place on the steps of the tomb: lekythoi alabastra, oinochoai, with perhaps some objects of marble (pyxides, plemochoai).[59]

Religious occasions were an important element in Greek life, and once again the potter was in demand to provide the necessary physical expressions of their religious needs. There were specific days during the year when ritual worship of one deity or another demanded particular objects. Again, it is Athens and Attica that provide the best evidence: stamnoi for the Lenaea, choes and chytrai for the Anthesteria, kraterisko for Artemis, broken amphorae for Adonis. Throughout the year also, there were libations with jug and dish (oinochoe and phiale) at altars to the gods or for prayers at departure and return, and incense offered in the thurible (thymiaterion). Often the quality of production was poor: the ritual object were usually decayed versions e.g. votives, miniatures, of those shapes that had a proper life. By contrast, vases offered to a deity in a sanctuary were often of high quality (e.g. those from the Athenian Acropolis), and for some the vases offered were bespoke with the name of the deity and/or the dedicator on them.[60]

So one can see that there was no area of Greek life where the potter did not furnish the necessary materials.

Aesthetics of shape

Attention has been concentrated on the function of vases – they had a job to do, and their basic form was dictated by that function. However, this still left scope for variation within the individual shapes, both locally and chronologically, and for the particular preferences of individual potters The Greeks thought of their pots in human terms – handles were 'ears'

bases were 'feet', and we have continued this tradition by speaking of lip, neck, shoulder, body. 'In the hands of the potters, the vase is like a body being formed.'[61]

Modern aesthetic appreciation of vase-shapes must always be carried out with the practical purpose of the shape in mind: the object had to pour, stand, carry etc., but it cannot be denied that rhythm, formal balance, proportion, symmetry are factors that came into play. The visual attraction of the Greek shapes often depends on their tectonic and linear precision and proportion, and their similarity to sculptured figures has often been remarked upon. Attempts, not always accepted, have been made to connect the effect of the shapes with their relation to geometric figures, but even if agreed, this is likely to have been instinctive on the part of the potter, learnt by practical experience, not from mathematical theory.

Some shapes are obviously stereometric in their basic shape: the small spherical aryballos, the lebes and the hemispherical mould-made bowl, but many shapes are usually more complex. It has been suggested that, apart from such basic forms as those just mentioned, one might think in terms of the flexible/elastic shape where the form of the vase counterfeits the weight of the contents, i.e. such shapes as the pelike or the phormiskos in which the widest circumference is low down on the body of the vase, or in terms of the architectonic in which the structure of the form, e.g. the volute-krater (e.g. Fig. V.6), is built on architectural principles. 'The volute-krater is the vase-shape which has more of the temple in it than any other: not only do the handle-volutes recall the Ionic capital, but the designer of the upper part must have been thinking of epistyle, frieze and cornice, and the contrast of the ornamental architrave and plain shaft and capital may also have been at the back of his mind.'[62] There are also those shapes in which there is a flowing contour, more akin to classical sculpture.

Greek fine wares tend to be very disciplined in their exact shaping, precise contours, firm articulation. Certainly the effect of metal is felt in the fourth and fifth centuries (ribbing, sharp edges, plastic attachments). With the best examples, the decoration is planned to offset the shape, not to distract attention from it.[63] Kitchen ware does not so easily lend itself to this sort of treatment as fine wares. The shapes tend to be slacker, with less attention paid to refinements of feet, handles and lip. These were working shapes above all else.

Alphabetical list of vase names

The names included here are a selection of those most commonly in use today. The preponderance of them are Attic fine wares, though a few kitchen-ware names have been included. Not all are illustrated (Fig. 10.a–o). The scale is 1:7.

Alabastron (pl. Alabastra)	Based on alabaster prototype. Small vase for perfume or oil. Broad, flat mouth, narrow neck, thin bag-shaped body, sometimes with lugs, usually footless. Used for women's toilet and for cult. Contents extracted with dipstick.
Amis (pl. Amides)	A name used to signify a portable urinal. A Greek inscription indicates that one version was a wide-mouthed jug.
Amphora (pl. Amphorae)	Meaning 'carry on both sides'. Made in all fabrics. Two vertical handles, wide body, narrower neck. Some have broad foot, others a small toe. Some have lids. Size varies. For liquids and solids. The main types are: (a) Transport amphora – a large coarse-ware shape with long body, small toe and narrow mouth that can be stoppered. (b) Neck-amphora – many varieties in fine ware, all sharing an offset neck. Specially named variants are e.g. Nikosthenic, Nolan, Panathenaic, pointed. (c) Belly-amphora – body and neck in continuous curve. Forms of handles, mouths and feet differ. (d) Bail-amphora – handle reaches over the mouth. Used for storing and carrying wine, oil and other commodities, for serving wine at table, as an ash urn for the dead.
Amphoriskos (pl. Amphoriskoi)	Small version of the amphora, based on the pointed variant of neck-amphora or transport amphora. Some carry stamped designs. Used for perfumed oil.
Aryballos (pl. Aryballoi)	Conventional name for an ovoid or ball-shaped oil pot (with one or two handles). Footed or footless. Used by athletes. Some are in the shape of a head, animal or bird.
Askos (pl. Askoi)	Meaning 'wine-skin'. Conventionally (and erroneously) used for a small, flat vase, with narrow sloping spout and handle arching over body.
Bolsal	Invented name (Bol (ogna) – Sal (onica)) to designate a broad, shallow cup with short vertical sides and two horizontal handles below plain rim.

Bottle	A vase with a narrow neck, flaring lip, rounded body, and shallow foot. There is no handle.
Bowl	Word used to designate a plain, open shape without handles.
Chalice	Cup with conical foot, deep wall and horizontal handles at base of wall.
Chous (pl. Choes)	From verb 'to pour'. Broad-bodied jug, with low handle and trefoil mouth. Used in Anthesteria festival and as a measure fixed for participants in drinking bout (3.28 litres). Also small choes were used for children's day, when 3-year-olds received them.
Chytra (pl. Chytrai)	Footless cooking pot, with one or two small handles fixed at rim. Set on stand. Some versions have a lid.
Cup	General term for a two-handled container for drinking. See Kylix, Skyphos.
Dinos (pl. Dinoi)	Means 'drinking cup' but now wrongly used to designate the same shape as 'Lebes' (q.v.).
Epichysis (pl. Epichysides)	Literally 'a pouring on'. Used for a one-handled jug with long, narrow neck and reel-shaped body. Mainly south Italian.
Epinetron (pl. Epinetra) or Onos (pl. Onoi)	Long semi-circular cover for the knee and thigh, over which wool was drawn to remove dirt.
Eschara	Coarse-ware cooker.
Exaleiptron (pl. Exaleiptra)	From word 'to anoint'. Vase, usually lidded, on low or high foot (sometimes tripod-shaped). Broad, flat body. No handles. Deep mouth inside so that the liquid contents can be shaken without spilling. Used for perfumed oil in women's rooms or in grave cult. Other names which have been applied to it are Plemochoe and Kothon (see below).
Feeder	Small footed container with flat top and spout at side, for providing drinks to small children or invalids.
Fish-plate	Plate with low foot, overhanging rim, small depression in centre of floor (for sauce?). When figured, it is usually decorated with fish.

Guttus (pl. Gutti)	From Latin 'gutta' = 'a drop'. Latin name for a narrow-necked dipper. Conventionally applied to an oil pot with low body, ring handle, relief medallion and trumpet-shaped mouth at side. Some have a vertical mouth.
Hydria (pl. Hydriai)	From 'hydor' = 'water'. A water-pot for the fountain, with capacious oval body and two horizontal handles and one vertical handle. Manufactured in bronze and in coarse and fine wares. See also Kalpis.
Kados (pl. Kadoi)	A coarse-ware bucket for the well with two small vertical handles at sides and wide mouth.
Kalathos (pl. Kalathoi)	Means 'basket' for wool, etc. The shape in clay usually refers to a handleless conical vessel, quite small.
Kalpis (pl. Kalpides)	Conventional name for a shape of fine-ware Hydria (see above), with single contour from neck to foot.
Kantharos (pl. Kantharoi)	From the word for 'beetle'. Now used conventionally for a drinking cup with two vertical, usually high swung handles. The shape, most likely of metal originally, is often shown in the hands of Dionysos. There are various different forms.
Kernos (pl. Kernoi)	A cult vase, with large bowl on foot, small bowls attached to the rim.
Kothon (pl. Kothones)	Used of various different shapes. Some equate it (wrongly) with the shape noted above under Exaleiptron, others use it of a deep one-handled drinking cup, sometimes ribbed, carried by soldiers and travellers. It is also applied to the pilgrim flask shape.
Kotyle (pl. Kotylai)	Used as an alternative to Skyphos (see below) to designate a deep cup with two horizontal handles. No offset lip.
Krater (pl. Krateres)	From a word meaning 'mix'. A large, open bowl for mixing wine and water. There are four main types that carry modern distinctive names: (a) Column-krater from the shape of the columnar handles. (Ancient name 'Corinthian'.) (b) Volute-krater from the volutes that curl over the rim. (Ancient

name 'Laconian'.) The most elaborate type. (c) Calyx-krater from the shape of the body, perhaps invented by Exekias. Handles set low on body. (d) Bell-krater from the shape of the body. Other names derived from krater are 'krateriskos' to designate a small version, and 'kotyle-krater' for an early, seventh-century shape.

Kyathos (pl. Kyathoi) Used to indicate a deep ladle with cup-shaped container and long handle.

Kylix (pl. Kylikes) Large wine cup with shallow bowl, two horizontal handles and high stem above foot. Many types: Komast, Band Lip, Siana, A, B, etc.

Lagynos (pl. Lagynoi) Wine jug with low, bulging body, flat shoulder, tall neck and long vertical handle.

Lakaina (pl. Lakainai) Ancient description equates the name with a Laconian drinking cup, with deep body and two horizontal handles set near the base.

Lamp Classical lamps have small flat bodies, a round opening above and a spout with a hole for the wick. Some are provided with handles.

Lebes (pl. Lebetes) A mixing bowl with spherical body which sits on a stand. No handles, no foot. Often incorrectly called a 'dinos' (see above).

Lebes Gamikos (pl. Lebetes Gamikoi) A lebes for weddings. Shape as lebes but with two high vertical handles at shoulder, a lid, a marked neck and an attached stand or foot. Used for the bridal bath.

Lekane (pl. Lekanai) A large household-ware basin or bowl, with two horizontal handles. Used in the preparation of food and for many other purposes.

Lekanis (pl. Lekanides) Shallow lidded bowl with ring foot and two horizontal handles, for trinkets. Often given as a wedding gift.

Lekythos (pl. Lekythoi) A general word used to denote an oil bottle. Now conventionally used for tall and squat shape with a foot, a single vertical handle, narrow neck and small mouth. Sometimes the basic form is fashioned into fancy shapes such as an acorn or an almond, or into a

	human figure; some carry appliqué designs.
Lopas (pl. Lopades)	A shallow lidded cooking-pot, rather like a flattened version of the lidded Chytra (see above).
Louterion (pl. Louteria)	From a word meaning 'wash'. Used to denote a bowl with two handles and a spout.
Loutrophoros (pl. Loutrophoroi)	From 'carrying to the bath' for ritual cleansing. A tall version of the neck-amphora with two very long vertical handles. A slightly different version imitates the hydria with two horizontal and one vertical handle ('loutrophoros-hydria'). Scenes relate to weddings and funerals.
Lydion (pl. Lydia)	Named from the area of Lydia in Asia Minor. A fat, handleless perfume pot with outturned flat lip. For the Lydian *bakkaris* perfume.
Mastos (pl. Mastoi)	From the word 'mastos' = 'breast'. A shape of cup resembling a woman's breast. Usually furnished with one vertical and one horizontal handle, sometimes provided with a foot instead of a nipple.
Mortar	A grinding bowl of household or heavy-duty ware. Sometimes made of stone.
Mug	Used to designate a deep, one-handled drinking cup. See Kothon.
Nestoris (pl. Nestorides)	A wide-mouthed jar with two horizontal high-swung handles from shoulder to lip. South Italian, derived from a native, non-Greek shape.
Oinochoe (pl. Oinochoai)	Meaning 'wine-pourer'. The wine jug was fashioned in many varieties (conical, concave, convex) but was usually furnished with a single vertical handle. The mouth could be round, trefoil or beak-shaped.
Olpe (pl. Olpai)	A Greek word for 'jug', conventionally used of a slender shape of jug with no separate neck and usually a low handle.
One-handler	A modern name to denote a shallow bowl with one horizontal handle attached just below a broad rim.

Onos (pl. Onoi) See Epinetron.

Patera (pl. Paterai) A Latin word for 'dish', sometimes used to designate a dish like the Phiale (see below).

Pelike (pl. Pelikai) A conventional name for a type of amphora that has a wide mouth and the maximum width low down on the body, producing a pear-shaped outline.

Perirrhanterion (pl. Perirrhanteria) From 'sprinkling around'. A type of font: a shallow bowl on a high stem. Mostly of stone, some of clay.

Phiale (pl. Phialai) The shape, derived from eastern prototypes, is often found in metal. It is a flat, handleless libation bowl, sometimes with offset rim. In the centre of the floor is a raised navel (omphalos) which enables the finger to be inserted beneath when tipping the bowl. Clay phialai could be used at symposia.

Phormiskos (pl. Phormiskoi) From a Greek word for 'basket'. A bag- or gourd-shaped flask with narrow neck which is sometimes pierced. Used as a sprinkler in ritual.

Pinax (pl. Pinakes) A Greek word for 'Plate'. Usually now applied to a flat rectangular slab that was decorated and hung on tombs or in sanctuaries.

Pithos (pl. Pithoi) Large, heavy-duty storage jars (Ali Baba jars) for grain, etc.; used also for interments. Sometimes decorated with relief designs. Smaller versions go by the name of Pitharion (pl. Pitharia).

Plastic vases These are vases which have relief figures applied to the wall or are themselves in the shape of a figure: head, face, acorn, mussel shell, lobster claw. See also Rhyton.

Plate Not a common shape in clay, more likely to have been made of wood. Figured plates seem to have been made for religious dedication; black are more common.

Plemochoe (pl. Plemochoai) From 'full-pouring'. See Exaleiptron and Kothon.

Psykter (pl. Psykteres) From a word for 'cooling'. Used now to denote an Attic shape with broad, hollow stem, bulging, mushroom-shaped body, and

broad mouth. Sometimes furnished with lid
and pierced tubes for cord. The psykter was
filled with snow or cold water and set to
float in a krater full of wine.

Pyxis (pl. Pyxides)
A round lidded box, of various shapes and
sizes, for cosmetics, powder or jewellery.
Some were put in tombs. The term
'skyphoid-pyxis' is used to designate a shape
that became a Sicilian speciality with ovoid
body and lid, and two horizontal handles.

Rhyton (pl. Rhyta)
From a word for 'flow'. A drinking cup
originally made of horn, hence the shape.
The idea was borrowed from Persia. Used t
denote a one-handled cup that has the bowl
fashioned into the shape of an animal's hea
(sheep, donkey, etc.) or occasionally a more
complex creation (pygmy and crane, negro
and crocodile, mounted Amazon, camel and
driver).

Salt Cellar
A conventional name to designate a small
open bowl.

Situla (pl. Situlae)
From the Latin word meaning 'bucket'. A
deep bowl for wine, mainly south Italian.
The swung handle(s) suggest a derivation
from metal.

Skyphos (pl. Skyphoi)
A deep cup with two horizontal handles at
the rim (sometimes one horizontal and one
vertical). See also Kotyle. Hybrid names
such as 'cup-skyphoi' indicate hybrid forms

Stamnos (pl. Stamnoi)
Conventionally (and wrongly) used to
designate a storing and mixing bowl with
two small horizontal handles attached to a
compact, bulbous body, a short neck and a
lid.

Stemless (Cup)
A modern name to indicate a shape like a
Kylix (see above) but with a ring foot, not a
stem.

Stemmed Dish
Handleless bowl on stem. Most small, some
large.

Stemmed Plate
Shallow plate on stem, often with over-
hanging rim and central dip like the Fish
Plate (see above).

strainer	Perforated bowl for straining wine or in larger form for use in cooking.
Thymiaterion (pl. Thymiateria)	from a word meaning 'fume'. A censer or thurible for the house, tomb or sanctuary. A small bowl, sometimes on a tall stem. The lid is often perforated to let out the scent.

IV.10 Drawn outlines of pots
(*a*) amphorae (neck- and belly-)

(*b*) alabastra, aryballoi and askos

(*c*) chous and chytra

(*d*) hydriai (shoulder and kalpis)

(*e*) kados and kantharos

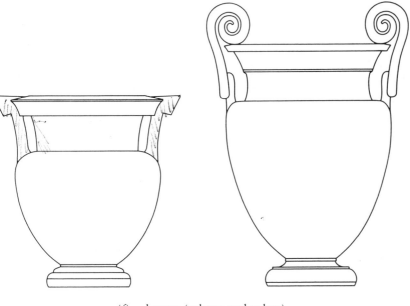

(f) kraters (column and volute)

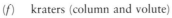
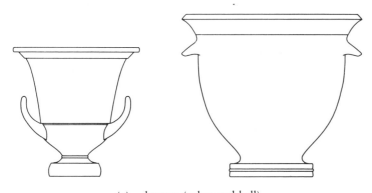

(g) kraters (calyx and bell)

(h) kylikes (lip and type B)

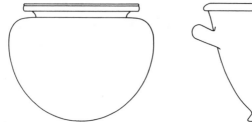

(*i*) lebes and lekane

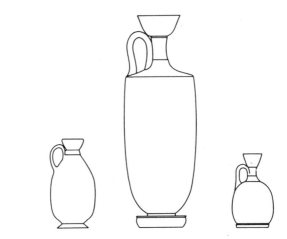

(*j*) lekythoi (early, tall and squat)

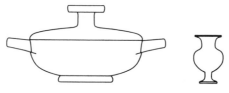

(*k*) lekanis, lydion and mug

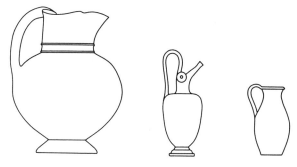

(*l*) oinochoai (trefoil and beaked) and olpe

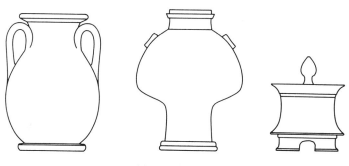

(*m*) pelike, psykter and pyxis

(*n*) skyphos (Corinthian and Attic types)

(*o*) stamnos, stemless and stemmed dish

V

DECORATION

Greek painted vases, looked at with detachment, are a very curious phenomenon.
(Robertson 1951, 151)

The study of Greek vases has concentrated on, indeed has been felt to be synonymous with, painted pottery with elaborate figured scenes. It is this painting that has attracted the interest of professionals and laymen alike, and the fascination of it cannot be denied. However, it needs to be seen in perspective. The vast majority of Greek pottery was plain or only slightly daubed, and the figured fine wares represent only a small percentage of the total output. Decoration was not indispensable for the function of a vase, though it was obviously felt to be an attractive addition to it. It would be a mistake to imagine the Greeks using figure-decorated pottery in any and every task in their lives; in fact, such pottery was an urban phenomenon, rural areas made do with plainer products.

There were basically two ways in which the shape of a vase was enhanced with decoration – (a) by raising, puncturing, incising or stamping the surface and (b) by adding paint to the surface. These techniques were used both separately and together. Occasionally three-dimensional additions were applied (florals, heads, figures) or the vase was shaped in the form of a head or figure, human or animal (cf. Fig. IV.9).

The kitchen wares were usually left, as one would expect, undecorated, as they were for domestic chores only.[1] Similarly, the transport amphorae rarely carried decoration, either incised or painted, except for the control stamps. Some unpainted heavy-duty shapes (such as pithoi that were made in the Cyclades, Rhodes, Boeotia and Laconia) were decorated with various patterns that were produced by incision (combing), stamps (geometric, floral or figured designs) and by raised reliefs which carried simple designs or complex arrangements of mythological stories and mythical beasts, e.g. Fig. IV.5. Some freehand shapes, similarly unpainted, carried incised and impressed patterns.[2]

Monochrome

Application of a coat of paint to a surface could be functional: applied internally to delay seepage of the contents, applied externally to provide a

smooth surface for the touch. The functional can, however, soon become decorative, and bands and stripes may be placed in such a way that they emphasise and articulate a shape and enhance an otherwise plain surface. Monochrome painting, without any help from other colours or from incision, was widespread in time and space, and for many potters this was the only way in which they chose to enhance their pots: a single flourish might distinguish hand or shop. The colour was mainly brown or black, depending on the composition of the gloss applied and on the firing. The outstanding examples of this use of one colour are to be found in the Geometric period (ca. 900–700 B.C.): it is the designs on the pottery that have given this historical period its name (e.g. Fig. III.1). During this time the plainer monochrome patterning that had preceded it (Protogeometric: ca. 1050–900 B.C.) was elaborated and made more various.[3] The compass-drawn circles and semicircles of Protogeometric were extended by more complex designs of tongues, triangles, cross-hatching, meander and other Geometric shapes; some of these were most likely derived from basketry and textiles. Eventually fauna appeared: animals (goats, deer, horses, birds) and by the mid eighth century figures and narrative scenes, mainly funerary (laying out of the dead, laments, processions), suitable for the funerary purposes for which many of the vases were made.

The figures, conceptually treated, were mainly in silhouette, with a little outline that helped to isolate and highlight inner details, presented in a diagnostic view that harmonised with the pattern set all around. The designs, both patterns and figures, were well fitted to the shape on which they were placed, and in the more careful pieces there is an admirable discipline and economy of line. Athenian potters and painters led the way, and their work was copied, adapted and handed on by craftsmen in Corinth, Euboea, Argos, Boeotia (Fig. IV.3), the Cyclades, Asia Minor and the Greek West. The regional styles of all these areas have been distinguished, and it is in the ambitious compositions of the eighth century that the individuality of painters becomes particularly marked.

Monochrome decoration did not die with the end of Geometric. If a 'progressive' history of vase-painting were being traced, then it would be usual to move directly from monochrome to chart the rise of the black-figure technique (see below), etc., as though the break was complete. However, monochrome painting continued and is to be found in many areas, even in those where some craftsmen had begun to add other colours and make surface incisions to enhance the drawing. It takes a less important rôle in many centres, but many types of simple pottery still carried quasi-functional bands, small floral designs and indeed sometimes figured scenes in monochrome, for which perhaps lack of initiative and contact is to be stressed as much as lack of ability. Simple decoration was far commoner than the more elaborate.

Black-figure

Towards the end of the Geometric period (late eighth century), when the patient application of the patterns was becoming less careful, monochrome painting began to be enhanced in two main ways: by the addition of colour and by incision. Colour was sometimes used without incision: for instance, lines and areas of colour (usually red/purple, yellow/white) were added to island and East Greek designs, where in mainland wares incision would now generally be expected as well. However, colour is often found together with incision, and from the late eighth century onwards this combination of black/brown gloss silhouette, of incision made through the paint for inner structure, and of added colours (white, yellow, purple) is what characterises the 'progressive' development of vase-painting and which affects other less advanced centres to a large or small extent (casual incision, etc.). Thus the flat monochrome figures and patterns began to be enlivened, and this seems to have started tentatively around 700 B.C. on small vases such as containers for perfumed oil in Corinth, where there were imports of eastern metal work and ivory in which the technique of incising played a large part. Corinth, being an important centre, imported goods from the Near East (via Syria), and it was the influence of these, and maybe of immigrant craftsmen, on Corinthian work that drew these techniques to the fore. It was certainly not the importation of foreign pottery that brought this about, as there is little sign that such decoration was characteristic of Near Eastern pottery, nor was that pottery of any interest to the Corinthians.[4] Incision was used from now on to mark inner punctures and outlines whether of bodies, legs, heads or of floral patterns. The colours came to be used to heighten details, such as purple for cloaks, nipples, etc., white for women's skin.

In the seventh century, the subject matter of vase-painting was enlarged in some centres by the increasing prominence given to mythological scenes (such as Herakles, Perseus, Odysseus, etc.), and also by the introduction of animals and monsters not seen previously in Geometric painting (lions, sphinxes, chimaera) and of genre scenes such as hare hunts. Animal friezes became a very popular way of covering the pot surface and were relatively more frequent than figured scenes. Some of these new images were borrowed as a result of the more extensive connections with the Near East, as also were the technique and the new floral elements in chains or single blossoms (palmette bushes, the tree of life, lotus, etc.). After centuries of controlled lines, whether straight or circular, the seventh century saw more natural, if unbotanical, curves; Geometric patterning had given way to controlled floral designs.

The black-figure technique continued at Corinth into the sixth century (Fig. V.11) and was adopted and adapted by other centres: Laconia,

Boeotia and so forth.[5] Some borrowed directly from Corinthian ideas, others took their inspiration from the one centre that improved on the Corinthian technique: Athens. The gloss the Athenian workshops produced became shinier, it adhered better to the clay, and the contrast between the orange and the black was more definite than the Corinthian pale yellow clay and the creamy brown gloss. Gradually, the quality of Athenian work improved until in the sixth century Corinth was lagging behind and even tried to ape the orange clay colour of Attic pottery by adding an orange/red slip of its own. More importantly, Athens further enlarged the repertoire of subjects, with more emphasis on humans; the floral designs began to take a subsidiary rôle.[6]

Athens' adoption of the black-figure technique was not sudden. For a while in the seventh century the outline technique was popular there and elsewhere with a heavy use of white and less dependence on incision, but eventually it gave way to the clearer silhouette figures enlivened by colour and incision. Indeed, outline never had more than a subsidiary role to play in the history of vase-painting; it was more important in panel-painting. During the sixth century Athenian black-figure was for the most part sharp and precise (e.g. Fig. V.1). It continued in the fifth century but was less important and less competent then; indeed it ceased to attract good painters. It was retained for the special commission of the Panathenaic prize amphorae (Fig. III.7) which continued into Roman times (see pp. 53–4), and is also found for a generation or so on the small, cheap funerary lekythoi. Outside Attica, it is found in Boeotia in the late fifth and fourth centuries when it is used on the idiosyncratic Cabeiric vases at the sanctuary near Thebes.[7]

Red-figure

A reverse technique that left the figures and patterns in the background colour of the clay (sometimes improved with a dilute wash and polishing) and filled in the surrounding areas with black, is now known as red-figure. Whereas black-figure had set silhouette figures in an open space against the light, with red-figure the effect was like a spotlight isolating figures against a black background (e.g. Figs. II.5; III.6; IV.8; V.9–10, 12; VI.4). It was invented in Athens, perhaps ca. 530 B.C., and a number of reasons have been given for this reversal of the old scheme. Some scholars see the change already heralded in black-figure in the work of the Amasis Painter, others look elsewhere beyond vase-painting. Painted bas-relief sculpture in which the background colour is usually blue has been thought by some to have had a strong influence, and as usual, panel-painting has also been considered to have been an influence. More recently, a controversial theory has suggested that both black- and red-figure owe their appearance to their

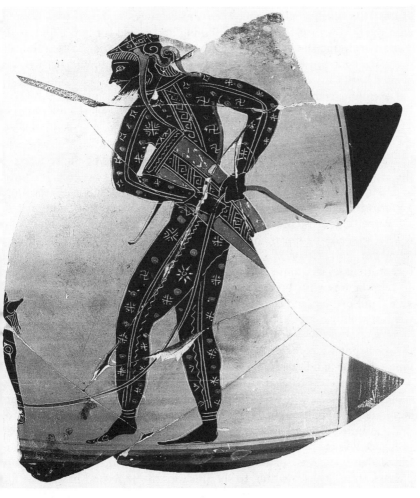

V.1 Attic black-figure amphora, ca. 540 B.C. Archer grazing horse.

mitation of the silver and gold of metal vases, and that red-figure mirrors
he changeover of metals.[9] It is impossible to name the inventor(s) of the
ew technique with any certainty. Possible contenders are thought to be the
Andokides Painter, Psiax and Nikosthenes.[10] There are vases on which
both techniques are used ('bilinguals'), but close study of them shows that
hey are not to be considered intermediate stepping stones from the one
echnique to the other. Some completely red-figure vases antedate them,
and the 'bilinguals' may have been display pieces, for customers who had
come to the shops to place an order. The reversed figures, with their inner
markings now indicated in gloss paint, make a strong and bold effect

against the black background, their musculature is shown to advantage with the flexible brush, and their clothing has gained substance and depth. Variations in the slip enabled gradations of tone to appear: with a thin slip there are light brown or golden lines, with a thicker slip a relief line was created with a special pen (see p. 20).

Development in drawing moves from what was initially a reversed black-figure picture through an experimental period when the potentialities of the new technique gradually began to be realised (the so-called Pioneers) to the Late Archaic generation of painters (ca. 500–480 B.C.), who used the technique to its fullest and best, not only in composing the scenes to fit the space available, but also in maintaining the nature of vase decoration (e.g. Figs. V.9–10, 12). Strong and simple forms unite with the floral patterns to fit the available area. Later this balance was lost and under the influence of panel-painting[11] with its freedom of space and illusion of reality, the vase painters, hampered by their blank, black wall, tried ideas that did not fit their ceramic medium, e.g. lack of groundline, foreshortening, etc., until by the end of the fifth century we are faced with sketchy figures with broken lines, shading and perspective, three-quarter views and overlapping elements. In earlier red-figure the added colours are used sparingly; later, clay relief lines enhanced with gilding became a feature, and in the fourth century the so-called 'Kerch' vases (named from the find-spot of many in south Russia) have a wide variety of colours, white, yellow, gold, blue, green.[12]

Other centres borrowed the red-figure technique that the Athenians had pioneered. In Greece itself the borrowing was only slight, and the products were mainly popular on a local basis; Boeotia (mid fifth century onwards) and Corinth (425–350 B.C.) were poor imitators.[13] The most important influence was exerted amongst the Greeks of Sicily and south Italy, and we know that Attic vase-painters emigrated there, to such places as Thurii, Metapontum and Tarentum, to set up shops in the second half of the fifth century.[14] Attic ideas were transferred and developed further away, and the results are sometimes ornate in the extreme (Fig. V.6). Also, there was red-figure produced in the fifth and fourth centuries in Etruria and Latium, where other modifications were made.[15] There were few centres that were producing red-figure after 300 B.C.

White-figure and white-ground

We have referred to white as an added colour for black-figure (women's skin, etc.) and for red-figure, though used to a lesser extent there, and it is also found as a minor element in decoration in other periods and places, sometimes directly on the clay, more usually added on the top of the black paint. It was also used in other ways: for whole figures and as a background slip, or priming coat, to receive the designs.

The less important and more restricted technique is that of 'white-figure' painted on a black background (conventionally known as 'Six technique' from the scholar, Jan Six, who studied it).[16] Here the figures, male and female, skin and clothes, were applied in white over black, and then the inner details were either incised through the white to reveal the black beneath or added in red; some outlines were also incised. It seems to have been one of the experimental techniques that were tried in Athens at the same time as the introduction of red-figure, and the names usually connected with its invention or at least its initial use are Nikosthenes and Psiax. It was never more than a side-line, and, though other black-figure painters continued the tradition, the quality deteriorated during the fifth century, and Athenian painters abandoned the technique before the mid-century. It was confined to a few special shapes such as the phiale and the lekythos. More important and widespread was the technique of covering the clay colour with a (yellowish) white slip. The practice became quite common from the middle of the eighth century and was used to cover rather poor quality, coarse and dark clays, giving a clearer surface for decoration. In the seventh and sixth centuries it is to be seen on a number of fabrics such as Laconian and East Greek, and particularly on vases made on the island of Chios where groups of dedicatory vases (chalices, kantharoi) also carry customers' inscriptions painted on the surface.[17]

In the early years Athenian painters adopted the technique less than others, perhaps they had less call to do so, but after the middle of the sixth century 'white-ground' gains in popularity there.[18] Painters painted black silhouette figures on a white ground, as a subspecies of black-figure. This then gave way to black outline figures on white. During the fifth century experiments and refinements were made by the red-figure painters, or perhaps it is more likely the potters who had the larger say. The second quarter of the fifth century saw the black relief lines diluted into lines of golden brown, with other colours added (two shades of red and a second 'whiter' white for the female figures), then in the third quarter, areas of matt colours (red, yellow, brown) were popular. Finally in the late fifth century, pale matt contour lines were applied over the white with much extra colour: greens, blues, mauves, together with a gold effect and shading, producing a much more polychrome appearance with a softening of the lines and less precise contours. The technique died out in the early fourth century. As the white slip did not adhere closely to the clay during the firing, vases decorated in this way were not suitable for everyday usage, and we find the technique confined to special purpose shapes: there were 'white-ground' cups in the second quarter of the fifth century which are thought to have been special orders (for dedications or gifts), but apart from a few other shapes (oinochoai, kraters) the main output from the mid fifth century was in funerary lekythoi which were consigned directly to the tomb (Fig. V.2). The influence of panel-painting has been seen to lie behind

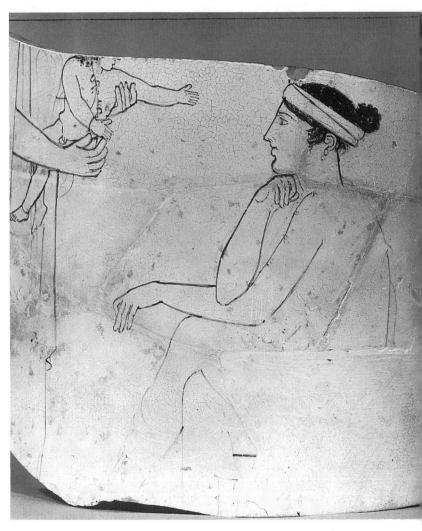

V.2 Attic white-ground lekythos, ca. 440 B.C. Mother and child.

this technique, though the funerary iconography was a deliberate
restriction of subject.

Later some other centres of vase production made use of a (yellowish)
white slip for covering the surface. Two types from the Hellenistic period
are the so-called 'Hadra' hydriai (see pp. 54–7), mainly made and found
in Egypt, and the lagynoi, some of which were most likely made in
Pergamum. Both carry decoration in brown or black applied on top of the
white.[19]

Polychrome

In some areas and periods vase-painters used an unusually wide variety of colours on their pottery, sometimes directly on the clay, sometimes on the black gloss or on the white slip (see above pp. 98–100), sometimes on the already fired clay. Such an approach, however, is never common and fairly isolated, and the motives for doing so are thought by some to derive from influences outside the workshops of the vase-painters, such as panel-painting. This connection can on occasion be seen in the choice of colours: brown with black outline for males, white with red outline for females – these are the conventions known to apply to panel-painting, etc.[20]

There are a number of instances of polychromy on vases in the seventh century. From early seventh-century Knossos on Crete a group of cremation pithoi have matt red and indigo on a white slip, and some have received a second coat over the ordinary painting, after firing. Later in the century there are the examples from Corinth, of which the Chigi olpe in the Macmillan Group (680–650 B.C.) is the best known, and later still some Protoattic (seventh-century Athenian) with red, yellow, brown and blue. Some other centres in the archaic period show an interest in varied colouring, such as Argos, Chios, Melos, Thasos; and in the sixth century there are the Caeretan hydriai from Etruria. Some seventh- and sixth-century polychrome was also applied over the black, found in Corinth and the areas influenced from there, in Chios and on the so-called 'Vroulian' cups from the island of Rhodes.[21]

In the fifth century a group of small vases made in Athens, the St Valentin group, was decorated with a more varied palette than usual. There is also a very strange group of late fifth-century coarse-ware jugs from the Athenian Agora that carry scenes of comic caricature applied directly to the unglazed surface of the pots in red outline, filled with such colours as pink, white, blue and green; the reason for this decoration and for its use on coarse pottery has never been satisfactorily explained. We have already seen that the white-ground lekythoi can display a wide variety of colours. Also Attic, but with adaptations produced elsewhere, is a series of vases, such as lekythoi and oinochoai, that carry relief scenes applied to their walls enhanced by polychromy; the major period of production is the fourth century.[22] Also in the fourth century the south Italian and Sicilian red-figure painters show a propensity for lavish colours (red, yellow, white) that match their more elaborately ornate compositions (Figs. V.3 & 6).[23]

In the Hellenistic period there is polychromy on some 'Hadra' vases, mostly made and found in Alexandria, and here the colours have been added on a white ground after firing. The practice of adding colours after firing is also to be seen in Sicily and south Italy. Some of the most outstanding are those from Canosa in Apulia and from Centuripe in Sicily. The colours are varied: blue, pink, white, red, yellow, black with some

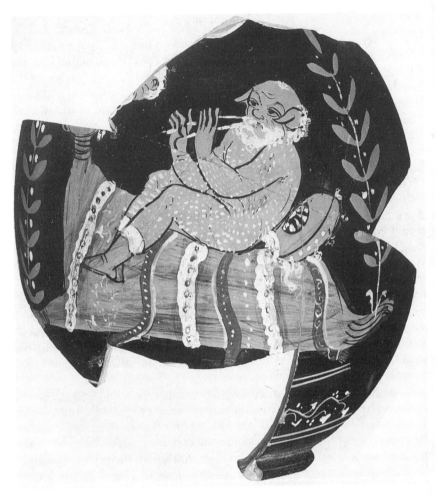

V.3 Sicilian polychrome squat lekythos, ca. 350–325 B.C. Piping satyr.

gilding. Such vases were never made for use in everyday life and must have
had funerary or religious significance. With the end of red-figure decoration
it is not surprising that potters and painters turned to white-over-black (see
pp. 104–6) and to colours added after firing, to enliven the appearance of
their products.[24]

Coral red

Brief mention may be made here of a rare and difficult technique that was
developed during the century from 550–450 B.C. as a background to Attic

lack-figure and as a subsidiary element in red-figure. The process used imed to produce two colours of background gloss: the standard black nd, beside and around it and applied after it, a brilliant coral red. The red loss, perhaps of a different composition from the gloss that fired black, lid not adhere well and has tended to flake. The red was used to enhance ome plain black shapes: cups, aryballoi, pyxides; or it served in subsidiary reas on figured shapes: a zone round the tondo inside cups, on the outside f cups below the figures or on the lip; occasionally it was carefully applied ound the edges of black-figure designs, as on the famous cup by Exekias vith Dionysos sailing on a coral-red sea. The technique may indeed have een invented by Exekias, at least it is first found on the cup mentioned. As vith white-ground, the planning is more likely to have been the potter's han the painter's. Such a difficult process that would need special firing onditions cannot have been practised in more than a few workshops. Most shapes so treated are small, though one volute-krater combines a ed-figured rim with a coral-red neck and body. The ingenious and delicate ieces that issued from the workshop of the potter Sotades in the middle of he fifth century, are the most startling in that some combine black, coral ed and white; they are also the last.[25]

Black gloss

t is usual to equate Greek fine wares with the figured vases that are ertainly the most distinctive products of the Greek workshops. But these ame workshops also produced less expensive wares, often in the same hapes but with no figured work on the surface, merely a covering of black. uch plain decoration can be found before the sixth century but it was in he sixth century that black-gloss pottery emerged as a distinctive line.[26]

A main early producer of black-gloss pottery was Athens. Other centres vere issuing black vases (with a little decoration) as early, but in numbers ind variety of output, in quality of potting and firing, in the added lecoration and in distribution, no other centre approached Athens. This lominance lasted until ca. 400 B.C. when the other, mainly south Italian, vorkshops which had copied and adapted Attic red-figure ware began to urn out black-gloss pots as well, once again mainly using Attic pieces as prototypes. Although black continues to be made in the Greek areas of the eastern Mediterranean until about 100 B.C., it is eventually superseded by ed wares such as 'Pergamene'. In the Western Greek areas the production of black is strong and continues for a generation or so longer, and is then replaced by the red wares such as Arretine.

Attic craftsmen who painted the black pottery were usually careful with the actual painting and reserving of such areas as the handle-panels and undersides, quite often creating on the latter a variety of circles, wide and

narrow, executed with great precision and sometimes associated wit
moulded undersides. The fact that the gloss was added as the vase turne
on the wheel gave it an even spread. Less good work was dipped an
consequently gives an altogether more lackadaisical impression. The shape
that were painted black were often closely similar to those decorated in th
black- and red-figure techniques, and this all-black work was undoubted
mainly produced in the same workshops. The tendency was to avoid th
more delicate and sophisticated shapes and to concentrate on the sturdi
and simpler forms. As time went on, there was a change in the appearanc
of the gloss. After control over the firing process had enabled a deep, ric
black to be produced, Attic potters, in the late sixth and for most of th
fifth century, issued shapes that were covered with a brilliant blue-blac
gloss. From the second half of the fifth century onwards the black becam
more metallic in appearance, more silvery in effect. Certainly, the effect c
metalwork was making itself more felt, and this can be seen also in th
thinness of the walls, as well as in the ribbing, incising and stamping tha
became features of the black ware at this time (see below, pp. 106–7).

The black pottery produced in other centres is for the most pa
distinguishable from Attic in clay colour, gloss and shapes. Sometimes Att
shapes were borrowed and adapted more or less closely, otherwise loc
ideas asserted themselves. On the Greek mainland there were centres c
black in Corinth, Boeotia, the West Peloponnese, Laconia – in fact th
distribution of such workshops is likely to have been very widespread, an
the islands and coastal areas of Asia Minor produced their own variation
Apulia, Campania and Etruria (both Greek residents and natives) wer
some of the Italian centres of production.

Many shapes were simply covered with a black gloss which wa
sometimes enlivened by the addition of a purple line or two and by thos
areas that were left in the colour of the clay. Some however had decoratio
to enhance the effect of the black: colour added on top of the black ((a
below), designs incised or stamped into the still damp clay before th
application of the gloss (b), relief either added separately to the vase befor
the painting (c) or created in a vase mould (d).

(a) We have met the use of colour painted on the top of the black in cor
nection with 'white figure' and polychrome (see pp. 98–9, 101–2). The us
of white to enhance the plain black vases, sometimes with thin trails of adde
clay topped with gilding, is mainly found from the fourth century onwarc
and may be said to be the late companion and successor to red-figure. Th
ware goes under the name of West Slope from the examples found in th
slopes of the Acropolis at Athens. The decoration consists of yellow an
white flora (wreaths, festoons, myrtle, ivy, etc.) and objects (ribbon:
musical instruments), and on occasion there are inscriptions. The period c
production seems to stretch from the third century onwards; the ware wa

made in Athens and in other centres. More important is the Gnathia
technique (named from the site in Apulia where examples have been
found), that was a popular line in south Italian workshops. It was issued by
a number of centres (mainly in Apulia, but also in Campania, Latium,
Etruria and Sicily) and had a vogue for about a century (ca. 360–250
B.C.). Initially the colours applied were orange, brown, pink and green,
then the main emphasis narrowed to white, yellow and red. The designs
might consist of single figures or heads (e.g. Eros or Victory) or maybe
figured scenes, but more often the choice was limited to objects and florals
in complex patterns. The shapes decorated in the Gnathia technique were
mainly small, and ribbing was occasionally a feature. Some workshops

7.4 Italian black plate with stamping and added colour ('Teano'), ca. 350–300
B.C.

combined the added colour(s) with incised motifs, stamping and rouletting (Fig. V.4).[27]

(b) Besides the paint applied over the black, incision, stamping and rouletting were important methods of decoration. These were applied before the gloss was added and are to be distinguished from the incision that accompanies the black- and red-figure painting.

The technique of incision on the black, no doubt borrowed from metal designs, is first found on Attic vases of the middle of the fifth century B.C. The early designs covered the interior of stemless cups and consist of rosettes, radiating lines and arcs – a laborious procedure that produced some excellent results when carefully carried through. The technique seems to have been initiated in workshops that produced red-figure cups, as some of the earliest examples share the decoration with red-figure scenes on the outside.

The use of incised patterns by themselves is short-lived, as it was obviously a time-consuming and expensive process. Results could be achieved more quickly by the use of stamps, and the history of incising and stamping is one of decline for the former and rise for the latter. Once again it is found first on shapes alongside red-figure scenes, towards the end of

V.5 Attic black stemless cup with stamping, ca. 450–440 B.C.

he fifth century, and there is evidence that it was also used with white-
ground. The stamps or poinçons, which could presumably have been made
of clay, metal, bone or such, must have been small with a single design at
he end: ivy, palmette (e.g. Fig. V.5), lotus, rosette, circle, ovule, but
occasionally there were larger examples that carried figures or parts of
figures (heads, limbs, wings, columns) and may indicate a wider and more
elaborate usage than the main body of our present evidence suggests.[28]

The range of shapes that carry stamped decoration widens: as well as
open shapes which carry the designs on the interior wall (e.g. stemless cups
e.g. Fig. V.5), phialai, bolsals), stamped designs are also found on the
outside of closed shapes (e.g. lekythoi, amphoriskoi, mugs). The more usual
exterior decoration was ribbing, another influence from metal. This could
un horizontally (on phialai, mugs, etc.) but the more popular version is the
vertical which is either scored or moulded, wide or narrow, sometimes
mixed with and edged by stamping. The shapes so treated are small mugs,
oinochoai and various shapes of cups and kantharoi, and the massive
fourth-century calyx-kraters, amphorae and hydriai.

The incising and stamping techniques are found in other centres, not
only in Greece but also, more importantly, in the West, in different areas of
taly. The individual stamping continues, though not always, as in Attic,
following the circular shape of the cup floor. It is sometimes found in
conjunction with overpainting (see pp. 105–6 and Fig. V.4) and can
become very elaborate. It is in the Western factories that we find numerous
instances of human figures (e.g. Herakles), animals (e.g. a dolphin) and
objects (e.g. a club) that have been pressed in the wet clay, perhaps with
tamps but maybe using signet rings or cut gemstones. A special category
consists of those designs which were impressed with coins, either directly or
from an intermediate mould, the best known of which are those late
fourth-century cups, some silvered, that carry the head of Arethusa from a
ate fifth-century Syracusan decadrachm signed by Euainetos.[29]

(c) A further method of adding decoration to a pot was by the
application of clay fashioned into figured or floral shapes. A vase could
usually function without these appliqué designs: they were ornamental
additions, some with symbolic meaning. The appliqués were made
separately and then attached to the vase with wet clay. Such attachments
were popular in all types of pottery and in many different areas, e.g. snakes
were set along the rims and handles of seventh-century Attic funerary
vases, heads were fixed to top and bottom of handles, leaves served as
thumb rests, animal paws and knuckle-bones as feet. Early production was
by hand (like fashioning terracotta figurines, e.g. the horse handles on
Geometric pyxides and the mourning women on amphora rims); later the
plaques were made in moulds which allowed for easy repetition. When
applied to black gloss pottery, the reliefs might themselves be highly
coloured or be varnished with the same gloss as the background. Mention

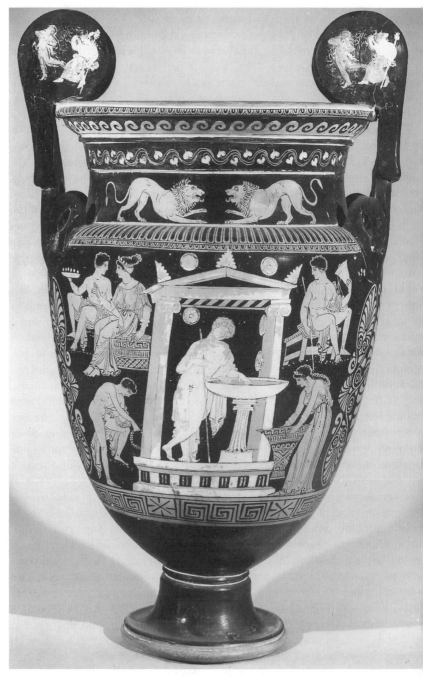

V.6 Apulian red-figure volute krater, ca. 380–370 B.C. Funerary scene.

has already been made of the Attic oinochoai and lekythoi that have polychrome appliqué figures (see p. 101), some others have figures covered with a white slip. In Hellenistic Cretan pottery there was a vogue for attached plaques (sometimes with added colour), and the so-called 'Plakettenvasen', which carry applied medallions with scenes from myth or religion that are covered with black gloss, may have been made there or in Alexandria. Appliqué designs are found fitted to horizontal tops of small askoi, made in Athens and South Italy, where a face or figured scene may be set. Mention might also be made of the placing of round plaques in the volutes of south Italian (Apulian) volute-kraters – mascaroon handles (Fig. V.6).[30]

(d) Mould-made vases were not uncommon, examples of them being found in many periods of Greek vase production and decorated in various techniques. Perfume pots from the seventh century onwards were shaped as

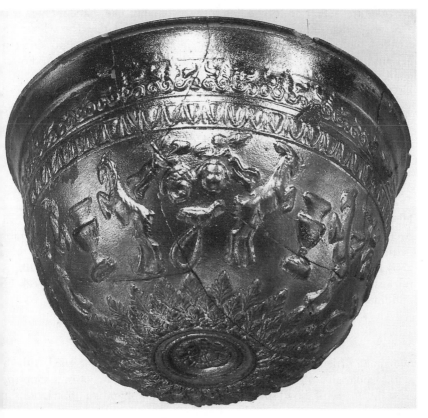

V.7 Attic 'Megarian' bowl, ca. 200 B.C.

heads, legs, birds (Fig. IV.9), etc., and drinking cups and jugs took on th appearance of human heads, sphinxes, etc. The rhyta which had the lowe half of their container in the shape of an animal head were quite a popula line. All these are usually enhanced with painted details to express th elements of the shape and/or have red-figured painting added. The hea vases were treated in the same way, with lifelike faces topped by a vase neck that carries figured decoration.[31]

The use of the mould for shaping vases increased in popularity in th Hellenistic period, and the moulds were usually elaborated with decorativ designs. Some of the most ornate are the flat, open phialai that were base on metal originals; their whole shape and decoration were transferred fron the silver prototype and the surface of the clay covered with a gloss tha fired a silvery black in imitation of the metal effect. More popular were th so-called 'Megarian' bowls which were made in many different centre from the late third century onwards. They too derived their inspiratio from metal originals which in the early years of production most likel provided the actual prototypes, as with the phialai. The shape was made i a hemispherical mould with the plain rim attached later. The whole wa covered with gloss. The wall of the mould was shaped into differen designs: ribs, floral patterns, individual figures (Herakles, Pan, Erotes goats, birds, e.g. Fig. V.7), myth and genre scenes.[32]

The 'Megarian' bowls were fired to produce a gloss that was black, wit a metallic sheen imitating the metal originals on which they were based Sometimes the firing accidentally produced a red, brown or mottled effec and this is to be observed on other Hellenistic pottery shapes. Eventuall with influences from traditions outside the Greek orbit, red became th colour consciously aimed at, and the way forward to the red-gloss potter of the Roman world was open.

Having surveyed some of the different ways in which Greek pottery wa decorated, let us now turn to some specific topics that have been uppermos in the study of the Greek vase-painting. These topics have usually bee chosen for investigation because of the quality of the work, its bulk, it intrinsic interest, and the light it throws on various aspects of Greek lif and imagination.

Inscriptions

We spoke of lettering in the chapter on shapes, when concerned with th word 'epoiesen', whether indicating the potter or the owner of a shop (p 65–6). We shall now speak of painters' names and of inscriptions i general.[33]

The work 'epoiesen' = 'made' may have initially covered both th

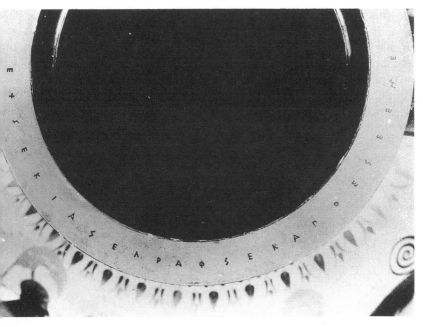

V.8 A painted inscription on an Attic neck-amphora: 'Exekias made and painted
me', ca. 550 B.C.

potting and the painting; certainly the work 'egrapsen' = 'painted' is found
later and less frequently, the earliest being a Naxian fragment of ca. 620
B.C. where the name of the painter is unfortunately missing.[34] In the sixth
century the convention is more common and is found on Corinthian
pottery (e.g. Timonidas, etc., ca. 580 B.C.) and Attic (Sophilos, Exekias,
Fig. V.8, etc.); in the late sixth and fifth century the evidence comes wholly
from Attic black-figure and red-figure.[35] Some names are followed by both
'made' and 'painted' (e.g. Fig. V.8). Names of painters are rare elsewhere,
but are found on Paestan pottery (Asteas and Python) and on a 'Hadra'
vase made in Crete (Pylon).[36] In the main the names, set on different parts
of the vase, were painted in black, purple or added white, or incised. The
names may be the autographs of painters who may also have added the
potter's names where these occur, or it may have been that some literate
associate wrote for both painter and potter.[37]

The names of painters are not essential for knowledge of the style of a
man's work, but they may provide helpful ancillary information. The sorts
of help they can give are: origin (Lydos = 'Lydian'; Sikelos = 'Sicilian';
Skythes = 'Skythian'), status (Lydos ho doulos = 'the slave'; Epiktetos =
'newly acquired'), nicknames (Smikros and Makron = 'Little' and 'Large';

Onesimos = 'Useful'); identity with the 'maker' (Exekias, Fig. V.8
Nearchos, Myson, Douris, Euphronios), relation by blood (Timonidas, son
of Bias; Tleson and Ergoteles, sons of Nearchos, the father both a potter
and a painter, the sons only potters); workshop connections between potter
and painter (Ergotimos and Kleitias; Hieron and Makron) (see also
Chapter IV pp. 66–7). There has been no satisfactory theory yet proposed
to explain the appearance of names on vases: it seems to have been
random choice with no necessary relation to the quality of the painting (see
also Chapter IV pp. 65–8).[38]

Other lettering found on pottery, some of it adding to the effect of the
decoration, some spoiling a good design, can be presented in brief form (for
graffiti added after firing, see Chapter VI pp. 124–5). Letterers may have
started to write on pottery as soon as the alphabet was being used by
Greeks; some of the earliest inscriptions were written retrograde, as with
inscriptions on stone and metal. Captions sometimes make reference to
what is illustrated, e.g. characters (usually mythological), objects ('lyre'
'cauldron', 'seat', 'spring'), the scene itself ('the games for Patroklos').[39] On
occasion words uttered by the characters are set beside them ("Look, here
is a swallow", "Yes, by Herakles, spring has come" "Here it is" ").[40] The
painter may wish to send greetings to the user ('hail and drink well").
Names are added to indicate either the owner ('Asopodoros' lekythos
therefore a bespoke piece), or of a deity (also then bespoke, as on Chiot
chalices of the early sixth century, some of which have the name of the
dedicator as well).[41] Sometimes a painter makes a comment about
colleague or rival ('as never Euphronios').[42] A rare use of lettering is to be
found on some Attic red-figure vases which show papyrus rolls with a small
sample of the text, always an extract from verse, fitted into the space
available.[43] The appearance of 'kalos' names which mention specific
individuals (e.g. 'Leagros kalos' = 'Leagros is handsome') has been
mentioned in the chapter on Dating (p. 53); they are in the main an
Athenian peculiarity and stretch from the mid sixth century to the late
fifth.[44] Also mentioned under Dating (pp. 53–5) were the Panathenaic
prize amphorae. These had begun before the mid sixth century with the
inscription 'one of the prizes from Athens' and in the fourth century had
begun to carry the names of Athenian archons as well.[45]

Some inscriptions were never intended to mean anything, either they
simply filled a space or they were poor copying by an illiterate in the
workshop. General questions of literacy are raised by these instances and
by the numerous mis-spellings that abound. Accuracy seems to have been
hit-and-miss affair, dependent on pronunciation. Not all centres of
production added inscriptions: most literate was Athens; others were
Corinth, Chios, Laconia, Boeotia, Etruria, south Italy.[46]

The actual lettering (dialectal spelling, shapes of letters) helps to pin

down the origin of the letterers, e.g. the lettering on the mid-sixth-century
pottery that we now know as 'Chalcidian', for which the find-spots would
indicate an origin in south Italy, possibly Rhegium, is connected with that
of Chalcis in Euboea and suggests that the ware was made by emigrés from
Chalcis. Some letterers have a fairer hand than others, and individual
enough to be recognised.[47] It is also possible to speak of periods of
handwriting: in Attic work the late seventh and early sixth centuries have
been characterised as 'subrustic', one thinks of Sophilos; the letterers of the
mid sixth century were careful and neat, such as Kleitias and the cup
painters of his time and going down to Exekias (Fig. V.8); later in the sixth
century the lettering became swifter, more frequent and less epigraphic.[48]

Painters and names

A painter's name is not essential to an understanding of his work, provided
that his style is distinctive enough to be individually recognisable. The
ancient names of painters, as we have seen, are useful for the incidental
assistance they might give, but it is study of the actual handiwork of the
artist that reveals his identity: details such as ears, ankles and shoulder
blades, drapery, and overall conception and composition (Figs. V.9 & 10).
Such an approach is linked to the name of Morelli who applied the method
to Renaissance painting. However, it was the scholar Sir John Beazley who
carried out the fundamental research on the same lines in the study of
Greek vases. 'The essence of the Morellian method is careful scrutiny of
details, especially those which an artist reproduces so regularly that they
can be considered as characteristic of his hand as his handwriting.' Nor is
the approach limited to figures only. 'Furthermore, subtleties of shape offer
additional information, as does subsidiary pattern-work, which can be
abstract, floral, or figural. The shapes of vases and their patterns are
reliable guides to attribution; their connoisseurship, therefore, combines
Morellian analysis of draughtsmanship with observations of potter-work
and pattern-work.'[49] This century much research has been devoted to the
differentiation of painters and groups, and not only in those times and
techniques in which ancient names are known, nor has the research been
confined to painting of quality. Although much vase-painting is still
unattributed to individual hands, our present understanding of the history
of Greek vase-painting, its workshops, the interconnections between
painters and potters, etc. has been enormously enlarged by this type of
investigation.[50]

This identification of painters has meant that in the various centres of
production (Corinth, Athens, Boeotia, Laconia, south Italy, etc.), an overall
view of the ceramic industry is available at different periods of time.
Specific connections between centres in techniques, shapes, styles and

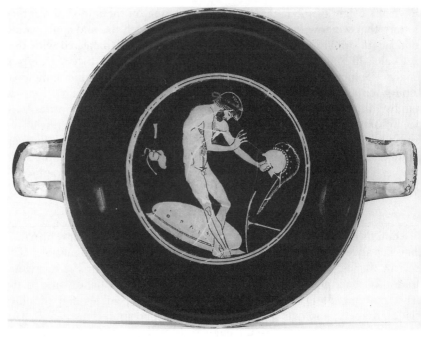

V.9 Attic red-figure kylix by Onesimos, ca. 490 B.C. Warrior.

subjects, recognised from general stylistic similarities, are also possible to plot more closely, e.g. Athens, Boeotia and Corinth in the sixth century also in the sixth century East Greece and the West to which artists emigrated in the face of the Persian advance; Corinth and Athens in the fifth (the Suessula Painter of the late fifth century did most of his work in Athens, but his hand has been recognised in work on Corinthian clay, technique and shape); Attica and south Italy also in the fifth century (examples of painters moving from Athens to south Italy and from Sicily to Campania).[51]

The plethora of modern names given to painters whose ancient names are unknown, but whose work has been recognised from their individual styles of drawing and painting, can look, and indeed can be, confusing. Listed below are some of the main types of name that are used:[52]

(a) The painter is given his modern name from the potter whose work he has decorated and whose name is known, e.g. the Amasis Painter, the Brygos Painter, the Kleophrades Painter, where Amasis, Brygos and Kleophrades are known names of potters. The decoration of many

V.10 Attic red-figure kylix by Onesimos, ca. 480 B.C. Youth.

ometimes all, of their vases can be shown by stylistic study to have been
ainted by one individual artist.

(b) The painter is named from a subject: the Nausikaa Painter, the
isyphus Painter, the Darius Painter.

(c) The painter is named from a 'kalos' name, such as the Antiphon
ainter, the Kleophon Painter.

(d) The name may be taken from a find-spot of one or more of the
ases: the Dipylon Painter, the Eretria Painter, the Agrigento Painter.

(e) The present whereabouts (museum or private collection) of one or
nore vases by a painter may give the name: the Berlin Painter, the
Honolulu Painter.

(f) The shape of one of the vases an artist decorated may provide a
ame: the Dinos Painter, and sometimes (e) and (f) may be combined as in
ne Painter of the Berlin Dinos to isolate another painter.

(g) Sometimes a memorable nickname has been thought to be
ppropriate: the Affecter, the Worst Painter, Elbows Out.

Attribution of vase decoration to painters, most of whom have had to be
iven invented names like those above, has been the main thrust of research

in this century, particularly in the sphere of Attic vase-painting. Th
method of careful scrutiny of every line a painter drew, of h
compositional preferences, of his choice of subject, of his whole approac
to the task, of the development of his style during his career (Figs. V.9 a
10), of the connection between workshops where he plied his craft – a
these facets have been patiently constructed into a synthesis of livin
communities of craftsmen. However, both the method and particularly th
continuing emphasis being placed on it in present-day research hav
recently been called into question. The method has its difficulties: how
characteristic must a painter's style be, to be his own? how tightly must w
set the parameters? how far can a painter's talent be allowed to deca
before he becomes another painter with a different sobriquet? These ar
vital problems for any connoisseur but do not affect the central core of th
attributions. It may be however that too much emphasis is being placed c
connoisseurship at the expense of other avenues of research, as the return
are now smaller than they used to be.[53]

Patterns

In the general history of Greek vase-painting, decorative pattern yielded i
position of primacy to figured composition. On Protogeometric and earli
Geometric pottery, pattern was all – concentric circles and semicircle
meander, triangles, lozenge, all placed to enhance the effect of the shap
(Fig. III.1). In later Geometric, when figured designs had begun to appea
the patterns started to retreat to the edges of the composition, below
above, at the sides, on the neck. In the early stages the figures themselv
were drawn as an animated pattern, and one of the most momento
developments in the history of vase-painting was the gradual emergence
the figures from their decorative chrysalis. By the seventh century th
patterns had become freer under influences that came from the arts
non-Greek areas rather than from a direct observation of nature itself, an
the severe precision of geometric designs gave way to forms based c
artistic flora: palmettes, lotus, spiralling tendrils, rosettes, pomegranate
and different leaves, buds and petals. In some fabrics these were fine
drawn and precisely placed, in others they were slapdash and ungainly,
if released from constraint without a guiding hand. Concentration on th
finest examples of the craft should not disguise the fact that much of th
work was poorly executed.

Floral patterns in Greek vase decoration were never entirely natural.[54]
some centres, painters presented a more luscious and freer treatment of th
flora (e.g. on Caeretan hydriai),[55] often in areas that were themselves
East Greece or influenced from it. But usually the designs, though based c
natural shapes at whatever remove, were unbotanical in their final form

irmly controlled and conceptualised. With black- and red-figure of the sixth and fifth centuries the floral element was, as it were, tamed, was rarely intrusive, and served to enhance both the shape and the figured composition, often providing a link between the two. The development in he variety and association of floral shapes can be traced in some detail. The rise and fall of the popular rosette design at Corinth is well known, from the detailed and painstaking treatment in the seventh century down to he scratched blob of the sixth. The palmette also shows many transformations: broad, narrow, angular, slanting, single or double, alternating with the lotus, circumscribed by tendrils, etc. The base rays derive from the leaves round the stalks of plants. Time, tradition, personal preference and ability dictated the appearance and popularity of individual patterns.[56] Some floral elements such as ivy, vine and laurel seem not to have excited the designer to any great extent, and indeed by their very shape lent themselves less to elaboration. Even in the fifth century, some geometric patterns, e.g. meander, saltire square and St. Andrew's cross, were combined in various ways to provide the base line for the figures or to act as the surround of a cup tondo (Figs. V.10 & 12). Occasionally and usually for humorous reasons, some of the figures took notice of the floral pattern by swinging on it or handling it in some way.

In the fourth century the floral patterns became more elaborate, and on some of the south Italian vases, particularly Apulian, the flora burgeoned at the expense of the figures, in fancy, and in some cases extremely intricate, designs (Fig. V.6).

Compositions and subjects

t is natural that the figured scenes on Greek pottery should have attracted great interest. In the development of the drawing, one sees artists coming to grips with the fundamental problems of creating scenes on a two-dimensional surface. The fact that the surface was usually curving and its outline dictated by the form of the vase meant that to succeed in their effect, compositions had to be shaped to fit the space available. The decoration veers away and approaches as the object is turned in the hands. A vase is not a canvas, and the modern drawings that flatten out the designs do less than justice to the original. The vase-painters were first decorating a curved surface; only later did they conceive themselves as creating a window on a world that lay behind.

For the figured scenes the characters are set, as it were, on a narrow edge (Fig. V.11) or later arranged on different levels (Fig. V.6). The silhouette stands out boldly from the curving wall; where outline was used, the effect was thinner and more insubstantial, and the figures appear to be blown across the receding surface. Most compositions were enclosed in a

tall, narrow space that allowed room for only a few figures, or in a broad low space that reduced the height of the figures but made room for a large cast. On the interiors of cups the difficult circular space was treated in variety of ways: as a porthole on a passing scene, with a horizontal line to act as the floor for the figures, or with no verticals or horizontals indicate and the figures carefully composed to fit the circular frame (Figs. V.9, 10, 12 There is little setting or background, and the figures are generally contained within their own space, with little hint of spatial depth in the Archaic period but in the fifth century, under the influence of panel-painting, give more corporeality. Black-figure painting gives the effect of figures sho against the light; red-figure compositions seem to be bathed in their ow spotlights (see earlier p. 96).[57]

Narrative compositions were introduced into Greek vase decoration i the eighth century B.C. and from that time onwards played an increasir rôle in the decoration of the fine wares of many pottery-producing centre From scenes of death, mourning and funerals which enhanced some of th funerary vases of the eighth century, the range of subjects increased. Figur decorated pottery was popular, both at home and abroad, and continue so for over four hundred years. As with the funerary scenes on La Geometric pottery, later one finds certain subjects related to shap fountain scenes on the water-pots of later Attic black-figure, Panathena events on the amphorae that were prizes in the games, and the continue choice of funerary subjects (e.g. laying out of the dead, mourning, visit t the grave, Charon, Sleep and Death) for vases destined for the grave. Bu for many scenes the reason for the choice is not so apparent. The grea number of vases that carry figured decoration argues that they must hav had mass appeal, it was popular culture, even though it is still difficult t say for whom precisely they were intended.

Although the division of subject matter between myth and real life oversimple, it is none the less helpful. The real-life scenes centred on suc fundamental aspects of life as fighting and hunting, seafaring, athletic music and dancing, theatre, home life (weddings, children, educatio spinning and weaving, the fetching of water), religious occasions, wor partygoing and lovemaking, death and the life beyond. Most of the scen are based on life in the city, and many of them reflect the life of the upp classes. The Attic vases that carry scenes of the symposium or komos, son with overt expressions of drunkenness, brawling and sex, may have bee ordered especially for parties, just as those with weddings (whether real c mythological), children and home life may have been made as weddi presents for a specific occasion.[58]

The other major category of subject matter is that which relates to myt The stories of the gods and heroes bulk large in the literature of ancie Greece, and this interest is also reflected in vase-paintings.[59] The ma

ppeal of the stories means that the majority are presented in a
traightforward way, often with the names (for those who could read) and
ttributes of the characters included, to make the meaning plain (Zeus and
is thunderbolt, Herakles and his club and lion skin). Subjects attracted an
:onography whereby the same incident was presented with the figures and
ubsidiary elements fixed in a stock arrangement. This meant that an
xcerpt could be recognised and related to the full story; it also means that
cholars can now connect even small fragments of larger compositions with
pecific myths. Some vases show myths that are not preserved in literature
r show them centuries earlier than their preserved literary versions.
Naturally, new iconographic arrangements were invented with changes in
roupings: tradition absorbed innovation. It is also natural that over the
our centuries and more during which illustrations of these stories were
roduced, specific myths and incidents from myth should vary in
opularity and in the ways in which they were understood, presented and
nterpreted. For instance, we have a scene of Orestes leading Aegisthus to
is death on a seventh century Protoattic krater, no similar scene for the
ext 150 years and then a surge of interest from the late sixth century for
he next fifty years. Is this to be set down to the vagaries of survival or is
here some deeper explanation?[60]
 Scenes on vases of the Archaic period were usually presented in a
traightforward manner, and the emphasis was on action. Painters,
nowing the development of the story they were drawing, tended to
ombine successive episodes into one single (synoptic) composition,[61] e.g.
 scene depicting Odysseus and his companions blinding the Cyclops might
how the limbs of an already dead companion that the giant has started to
at, the cup that caused the giant's drunkenness, and the stake being thrust
nto his eye. As one moves into the fifth century, especially in Athens, it can
e seen that some artists were capable of deepening the meaning of a story,
.g. Ajax who in most earlier versions of his suicide was shown dead on his
word (Corinthian: Fig. V.11) is later shown planting it in the ground (as
n Exekias' amphora)[62] or discovered by Tecmessa (Attic: Fig. V.12), thus
nvolving the emotions of another in what had earlier been represented as an
solated act. The fifth-century artists tended to dramatise the episodes from
nyth, but some of the serious and majestic stories of the sixth century such
s the Judgement of Paris were trivialised and made hollow, and by the late
fth century myth was valued more for the spectacle it afforded than for
he story it embodied – the figures pose and the narrative wilts.[63]
 Myths on vases may give us a clearer understanding of the popular
ersions of myths than the literary versions that we know through epic,
rama and such. Certainly, no treatment of Greek mythology can be
onsidered complete that does not take into account the preferences shown
y the vase painters and their customers. Whether the stories are well

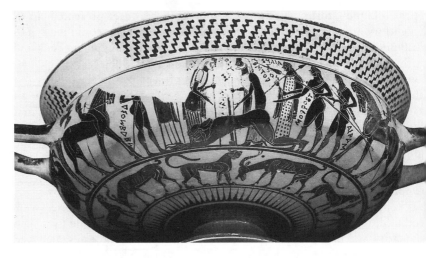

V.11 Corinthian black-figure kylix, ca. 580 B.C. Ajax dead.

known from the extant literature or not, the evidence from vases can act a a control, corrective and supplement to the literary sources. Many of th major figures and stories from mythology are known to us only from late reworkings in literature or from lexica and summaries of the Roma period; an account based on a conflation of these various versions is goin to differ strongly from an account built up solely of early literary sources i combination with the evidence of vase paintings and of the other artist media such as sculpture, bronze reliefs, etc.[64]

It is inevitable that in seeking to understand a myth as shown on a vas painting, recourse should be had to the literary versions, and these may b seen to harmonise or differ. However, the intelligence of a vase-painter ma need to be questioned when we are presented with an aberration that i hard to accept – often the name of one of the participants in an episod may differ from what we might expect or may be applied to the wron character. It is good to be reminded 'that vase-painters were neithe theologians nor philosophers – not literary critics nor art historians – bu that they were artisans who surely intended the imagery of their picture (when they thought about it at all) to be accessible to potential buyers'.[6] None the less, a high level of 'mythological literacy' was often demande by the choice of subject. It would be foolish to treat the vase-painters a unfailing sources of true wisdom. Indeed, the present trend in the study c myth would deny the validity of a view that sought to sift the true fror the false. A given myth, it is claimed, is made up of all its variants; th narrative sequence and content of the episodes is largely irrelevant; it i

V.12 Attic red-figure kylix, ca. 490 B.C. Ajax dead, with Tecmessa.

the structure of the myth that is important. The essential elements in the Cyclops story are the barbaric cannibalism of the giant and the blinding that is his retribution, with his drunkenness as an enabling element between the two; other elements are all equally acceptable, provided that the essential structure of the myth is preserved. The Structuralist school has provided some exciting new views on the subjects of vase-paintings, and not only in the field of myth – sacrifice, hunting, animals have been 'decoded' in terms of the anthropological themes they embody.[66] 'No figurative system is created as the simple illustration of a story, oral or written, nor as the straight photographic reproduction of reality. Imagery is a construction, not a tracing; it is a work of culture, the creation of a language, which, like any other language, introduces an essential element of choice.'[67]

The word 'iconology' is coming to the fore as a contrast to 'iconograph' with which students of vase-painting have been concerned for some year 'Iconography' represents the positive, objective, descriptive, specif approach, arguing a conscious, intellectual rationale behind the choice of images. 'Iconology' stands for the general, interpretative, symbol approach, seeking for unconscious attitudes and 'irrational' content. As or can see, the former accords with the classicist's credo; the latter takes into the world of the anthropologist.

Influences

Borrowing and influence naturally occurred within the world of the vas painters themselves, and we have had cause to mention the ways in whic the younger men learned their craft from their more experienced colleague on the bench and how ideas and craftsmen moved from one centre t another (Corinth to Athens, Boeotia and Laconia, East Greece to Attic Athens to the West). But vase-painters did not live in a cultural vacuun and it is natural that their paintings, both in technique and in choice of subject matter, should have been influenced by what was happening aroun them. We have already seen that, for their subject matter, the life of the cit in all its facets became a general source of interest and inspiration. It ma be possible, however, to recognise other influences at work. Some schola have felt that there was a close connection between literature and th subjects on vase-paintings,[68] so much so that direct influence has bee thought discernible, i.e. that the recitation of a particular epic[69] or th performance of a play may have inspired the painter to interpret the stor he has just heard and seen (cf. Fig. III.6). Certainly there would be no tex available; all literature was oral. Some such influence may be possible t detect in certain instances, but an all-pervading literary influence has fewe adherents today than earlier, now that it is felt that stories told i childhood and passing in general circulation are more likely to lie at th basis. We have seen earlier (see pp. 50–2) that the direct inspiration o the theatre may be traced in Athens, and the immense popularity of th stage in south Italy and Sicily accounts for scores of vase paintings tha present theatrical scenes.[70] Other literary connections do not always carr conviction. History in terms of specific figures and events has been seen t have had its effect, and in a more general way the choice of Persia combats can be seen to derive its source from the Persian Wars of the earl fifth century (Fig. III.5, p. 48). Politics and the use of mythologica figures in vase-paintings to make allusions to contemporary political view have had a vogue recently in the study of Attic vase-painting of the lat sixth and earlier fifth centuries.[71]

Influences from other arts may also be seen at work. These influence

may concern techniques and choice of decoration. As we have seen, incision itself seems to have come from the observation of goods (metalwork and ivory) imported from the East in the eighth century, along with patterns and subjects (see below). The influence of 'free' painting also can sometimes be detected in polychrome decoration (brown with a black outline for men, white with a red outline for women),[72] and mention has already been made of the possible influence of the colours on marble relief sculpture on the appearance of red-figure in Athens (see pp. 96–7).

Patterns and subject matter can also be seen to derive on occasion from other artistic media. Textile and basketwork may have provided some basic patterns, and at times a close similarity can be seen between architectural decoration and vase-painting. As far as subject matter is concerned, sculpture and 'free' painting can be seen to have inspired (if that is the correct word) vase-painters to adapt their compositions. This is most clearly observed in Athens after the erection of the Parthenon (see e.g. Figs. II.3–4, pp. 41–2), but also individual figures were introduced into vase-paintings either as statues or as actual figures within a scene (see pp. 4–5). In view of the patchy evidence, in the survival both of sculpture and of vase-paintings, this practice may have been more common than we realise.[73] The almost complete absence of 'free' painting on panels in the sixth and fifth centuries makes agreed statements about the source of influence on vases more than usually difficult. Pausanias' famous descriptions of Polygnotan panel-paintings in Athens (1.17–18) and particularly Delphi (10.25–31) can be related to certain novelties in Attic vase-painting of the mid fifth century and to the popularity of themes that Pausanias details in his descriptions (Amazons, Theseus, etc.).[74]

A different type of influence on subject matter may have been exerted by market forces. Not all subjects would have appealed to all customers, and certain subjects would have been more acceptable at home than away, and vice versa. It has been noted that subjects with Persian connections were favoured in Persian areas, that Aeneas was popular in the West, and that Amazonomachies and the story of Arimaspians fighting griffins in the north-east were popular in the Greek cities on the north of the Black Sea in the fourth century.[75] It is debatable to what extent such instances of local preferences can be ascribed to deliberate demand.

VI

OUT OF THE SHOP

Whatever the amount of pottery produced, its appearance on the market will hav
had but a limited impact – no shares rose or fell, no banks failed or prospered as
result. (Burford 1972, 60)

This chapter looks at various aspects of Greek (mainly painted) potter
once it was finished and ready for sale. There are more questions tha
answers.

Before considering 'trade' in pottery, we'll look at some evidence on th
pots themselves for their daily use. Many vases give signs of a useful lif
everyday wear and tear: rubbed rims, mending with lead rivets, eve
patching with fragments of other vases.[1] Even when irretrievably broken,
vase could be put to secondary uses: as a door knocker, as a stopper, as
counter in a game, as 'scrap paper' on which to scratch a message, practis
the alphabet, etc. (see below).

Graffiti and dipinti

The propensity of owners and others to scratch words on pots wa
widespread, whether the pot was whole or broken. Many of these graffi
spoil the effect created by the decorators of fine wares; the need to scratc
the message must in many cases have been paramount, or the purpos
malign. Here follow some of the more usual types of graffito added t
whole pots while still in use (for 'trademarks', usually set out of the wa
under the foot, see below pp. 126–9).

 (a) It was not unusual for an owner to mark a pot with his own nam
(in the possessive case, 'of . . . '). Small, portable objects were easily lost c
stolen, and so it was perhaps prudent to establish one's claim (se
p. 63), e.g. an Attic black mug found at Olympia carries the simpl
statement 'I belong to Pheidias'. Or maybe the object was engraved fc
someone else, as the Attic black-figure kylix found at Taranto, whic
carries the message, scratched under the foot in Western Greek letter form
'I am the prize of Melosa. She beat the girls at carding.' Sometim
abbreviations or monograms of individuals are incised, and the Athenia
community (demos) marked some of its public property with the ligatu
(joined letters) Æ for 'demosion' = 'public' (cf. Fig. IV.7).[2]

(b) On occasion the inscriber named the pot itself (see Fig. IV.1 and pp. 63–5 where a good selection is given).

(c) A message might be incised without the name of the owner or the shape, as the Attic Dipylon jug of the later eighth century, which seems to have been given as a prize in a dancing competition held perhaps at a drinking party, and written when the party was well under way: 'Whoever dances most saucily, will receive me . . . [the rest is unintelligible and almost illegible]'. Other messages may be toasts, invocations or insults, sometimes naming sexual proclivities.[3]

(d) Some inscriptions were added when the pot was about to be dedicated in a sanctuary. Thus we may learn the name of the deity worshipped; sometimes the dedicator also added his own name. Famous names are found but do not necessarily belong to the figures who made them famous, e.g. the name of Herodotus has been found scratched on two dedications at Naukratis, but neither should be linked to the historian.[4] The words *hieros* = 'sacred possession of' and *anetheke(n)* = 'dedicated' are often added. Even broken vases were sometimes dedicated.

(e) for capacity, for home use when measuring or for taking to the market to fill.

(f) tare, i.e. weight when empty.[5]

When vases were broken, the fragments might furnish small surfaces for scribbled notes:

(g) for practising the alphabet;[6]

(h) for messages such as expressions of love, errands or instructions, e.g. 'Put the saw under the threshold of the garden gate' (Fig. VI.1);[7]

(i) for accounts and lists of names or objects, e.g. the complex list of names on a fourth-century Attic black plate that seems to refer to the employment of slaves in Athenian potteries;[8]

(j) for voting ballots in a case of ostracism at Athens (see p. 57). This is now perhaps the best known use to which vase fragments were put. The sherds usually carried the name of the man being voted for ostracism, his father's name and the name of his deme (district) (Fig. VI.2).[9]

Epigraphers can assist in elucidating graffiti by fixing the approximate date on the basis of the letter forms, and pinpointing the origin of the letterer by the spelling, the dialect and the letter forms, e.g. the graffito on (f) above is written in the Megarian script, so we must assume that a man from Megara was seeking to borrow, or asking for the return of, a saw from a neighbour in Athens where the sherd was found. Similarity of lettering on ostraka sometimes shows that the voting sherds had been prepared beforehand for distribution to those citizens who could not write.

Painted letters that were added in red after firing (dipinti), easily became worn and are thus less common now than graffiti. They seem to have been used mainly in commercial transactions, by or for the ultimate purchaser.[10]

VI.1 Graffito on underside of Attic skyphos, sixth century B.C.

Trademarks[11]

There is a specific category of marks that concerns commercial transaction in pottery. These marks were scratched (graffiti) or more rarely painte (dipinti), usually under the feet of decorated pottery. They would not hav been visible during ordinary use, and it is generally agreed that they wer marks made by the potters or dealers, some before, but the majority short after, firing. The study and interpretation of the marks is a comple business, and words like 'inscrutable', 'cryptic', 'intractable' an 'uninspiring' have been used in reference to them. All dealers like to cloa their transactions in secrecy, so the present ambiguity of the marks woul no doubt delight the original parties concerned.

The marks, mainly to be found on Attic pottery in the late sixth and th fifth centuries, usually vary from single letters and non-alphabetic signs t

VI.2 *opposite* Ostraka with Megakles, son of Hippokrates, marked for ostracism early fifth century B.C.

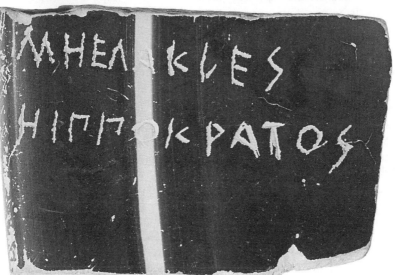

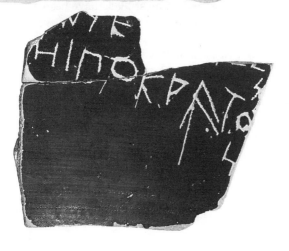

two-letter abbreviations and monograms or ligatures; more rarely as many as five lines of text were scratched. In the main, the substance of the graffiti relates to one or more of the following:

(a) numerals that note the number of pots in a batch. For numbers the letters of the alphabet were earlier used to denote the digits, later they were acrophonic (e.g. delta for 'deka' = 10).

(b) vase-names, abbreviated (Σ or ΣTA for 'stamnos' or 'stamnion') or in full ('krateres', 'lakythia', 'oxides', 'oxybapha'), some referring to the vase carrying the graffito, others giving a list of names that includes smaller vases that travelled in the same consignment as the large, inscribed vase. The 'trademark' names present some that are well known but also show that in some instances present nomenclature is misapplied or applied too strictly (stamnos/stamnion refers to amphorae and pelikai), or they are little known or unknown names that may be special to the trade.

(c) prices (see below).

Occasionally other information is added, e.g. 'p(oi)' for 'poikiloi/ai' = 'decorated', 'mik' for 'mikra' = 'small', 'en' for 'enthemata' = 'contents' (of a batch, not of a vase).[12] There seems to have been no unified system, not surprisingly given the nature of Greek society and trading, and of merchants' varied jargon.

Some graffiti seem to have been added before the pots were fired, by the personnel in the potter's shop, so presumably ordered on sight (or even earlier) by the trader, but the marks were more usually added after the firing. The largest amount of evidence derives from Attic pottery (some from Corinthian and East Greek), and where the graffito is in the dialect of the originating centre, one must assume that the marks were added at source. It is also possible that the Attic vases that carry graffiti in Ionic script, were marked in Athens by Ionian merchants; where a graffito on an Attic vase is in Doric and the vase in question is found in e.g. Doric speaking Sicily, the marks would most likely have been added at the end of the route[13] Certainly no graffiti were added in transit whilst the pottery was stored on shipboard.

The majority of vases inscribed with trademarks have been found away from the place of manufacture. Some small shapes of Attic pottery have been found in Greece, but the big shapes (e.g. kraters and hydriai) that carry the marks went to Etruria (the largest number have been found at Vulci) and Campania, with some to Sicily (especially Gela).

Here is an example (Fig. VI.3) of one of the longer texts with an explanation and expansion of the substance.[14] The vase is an Attic red figure pelike by the Nikias Painter, dating to the late fifth century, and was found in a tomb in Naples. The letters are in Ionic script. The listed batch was a mixed one, with table ware and oil containers.

There is a mark on the left side which runs across the foot and was made

VI.3 Trademark on underside of Attic red-figure pelike, late fifth century B.C.

after the lettering – it has been interpreted as an indication that the transaction had been completed and the batch was ready to leave port. The lettering will thus have been added in Athens where the order was made up.

Line 1 stamnoi 3, price 3 drachmas 3 obols [i.e. 7 obols per stamnos] one stamnos is the 'pelike' carrying the graffito.
'TI' is short for 'time' = 'price'.
⊢ is the sign for a drachma, – for an obol (6 obols = 1 drachma).
Line 2 oxides 11, 1½ obols.
the shape of an oxis is uncertain, maybe a small bowl.
Δ for 'deka' = 'ten'. ⊃ = ½ (?).
Line 3 lekythia small 50, 3 obols.
small oil pots were very cheaply made.
'MIK' is short for 'mikra' = 'small', lekythia is already a diminutive.
Line 4 lekythoi guaranteed 6, price 3 obols.
these oil pots were larger.
Π for 'pente' = 'five'. The two dots are punctuation.
'MIK' (line 3) and 'DIK' (line 4) may be a popular jingle. 'DIK' may mean 'honest', 'guaranteed', i.e. capacity matches appearance.
Line 5 oxybapha 13, 1 obol.
oxybapha, like oxides, may be small bowls, 80 for a drachma.

Prices[15]

It is not easy to speak of vase prices with any confidence. Evidence for prices of any goods is lamentably thin, and the evidence for vases is beset with many difficulties. Once again, only Athens provides any usable information, much of it won from the trademark graffiti, and it is patchily

bunched in time, mainly in the fifth and fourth centuries. In general, fo
prices to make any sense, the cost of living needs to be known. In lat
fifth-century Athens a mason could earn a drachma a day, as could a sailoɪ
a juror received up to 3 obols (half a drachma) for a day's work.[16] All thes
were jobs paid by the state. We also know the price of some articles at tha
time: a ladder cost 2–8 drachmas, wheat 2–4 drachmas a bushel, olive
1½ drachmas a bushel, a shield 20 drachmas, a cloak 20 drachmas.

As for the evidence concerned with pottery, that from trademarks undɐ
the feet of vases is complex and difficult to interpret. Questions abounɕ
Who was charging the quoted price: the potter or the merchant? Was th
sum an asking price or an agreed figure? What was the charge for: the pɕ
itself or the pot including contents (where there were any)? How many poɪ
would a potter expect or be able to make in a day?[17] How do the price
scratched on the pots relate to the amount asked at the far end of a trad
route? What profit could be expected for the potter or for the merchanɪ
Sometimes a pot price is given in a graffito on the body of a vase, e.ɡ
Kephisophon's 'kylix' quoted on p. 63 where the charge for breaking it
given as a drachma. To what extent this is a true figure and to what exteɪ
inflated to recompense the man for the loss of a cup that was a gift, is nɕ
known. Literary references to pot prices are rare, the best known is thɐ
in Aristophanes' Frogs v. 1236 (produced in 405 B.C.): 'you will gɕ
it [a lekythion – cf. p. 63] for an obol, and it's very fine and good
Again, as with Kephisophon's kylix, the precise interpretation is hard ɫ
disentangle.[18] Another major source for prices is the inscription recordiɲ
the sale by the state, of goods belonging to the men convicted of damagiɲ
the Herm statues in Athens and of profaning the Eleusinian Mysteries ɪ
415 B.C.; here it must be remembered that the goods were second-hanɕ
e.g. the Panathenaic amphorae fetched between 2 and 4 obols each at tl
sale.[19]

The following is a selected list of those shapes and prices that seeɪ
generally agreed to be correct (6 obols = 1 drachma). Quotation marl
indicate those names that are found in the batch list, not the names of tl
actual shape.

early fifth century	belly amphora	5–7 obols	decorated
	hydria	7 obols	decorated
	lekythos	⅔ obol	decorated
mid fifth century	hydria	12–18 obols	decorated
	column-krater	10 obols	decorated
	bell-krater	9 obols	black
	lekythos	6 obols	decorated
	'lekythis'	1/120 obol	–
late fifth century	neck-amphora	6 obols	decorated

pelike (see above)	7 obols	decorated
bell-krater	3–4½ obols	decorated
'lekythos'	½ obol	–
'lekythion'	¾ obol	–
skyphos	½ obol	decorated
bolsal	½ obol	black

Size, difficulty of potting, presence of decoration, complexity of decoration, etc. no doubt affected the prices, though it is interesting to note that there have been differences of opinion on some of these matters. One may contrast the statement 'Utility, then, must have been the main factor in determining ancient prices for pottery, and we should be mistaken if we thought that the usual painted decoration of vases was prized very highly'[20] with 'a considerable premium was put on the painted decoration'.[21]

Distribution

In any study of goods traded, pottery must be seen in the context of all commodities. The subject is complex, because the nature of the operation was diverse, and the evidence is faulty and tilted to certain places and periods. Ideas change rapidly with new evidence and new perspectives.[22]

The important cargoes consisted above all of grain, and of metals such as iron, copper, lead, silver, of timber[23] and stone,[24] with worked objects in various materials, including coin; live cargoes, such as slaves and horses, should also be noted. Certain important commodities needed clay containers, above all wine, which would be carried in the plain large transport amphorae (roughly 60–80 cm. high, 30 cm in diameter, with a capacity of 23 litres) (Fig. III.9).[25] This was the standard carrier, shaped for ease of stacking, and was used also for other liquids such as oil[26] and for such foodstuffs as olives and fish. Research on the amphorae (shapes, stamps, petrological and chemical make-up) has enabled many local varieties to be distinguished: Chiot, Thasian, Rhodian, etc., and they provide an incomparable source of evidence for trade routes. It is the transport amphorae above all other pottery shapes and fabrics that assist towards an understanding of economic history. The shipwrecks[27] that have been found up and down the Mediterranean show the ubiquity of the amphorae, but they also show that cargoes were generally mixed, and alongside the amphorae and other goods that have survived, there lie the fine wares that were not traded for their contents but for themselves, for whatever reason – personal use, prestige and status, dedication in a sanctuary, deposition in a tomb – in this last instance one thinks particularly of Etruscan tombs in which some of the best quality Attic painted pottery was placed. It is perhaps too extreme to suggest that fine wares were stowed aboard as space fillers and might make the merchant a

bare profit on the side. Both weight and volume are important to an
seagoing merchant or shipowner, and the care with which the fine ware
would have to be packed aboard would suggest that they were profitabl
enough to pay the man back for the trouble expended on them.[28]

Pottery, whether for itself or as a container, was made to be sold, bu
there is little hard evidence on the different aspects of selling – where th
sales took place, how and by whom the transactions were made, etc. Ther
was doubtless much variety: a potter in business in a small way might tak
his products round by donkey to local villages or set up his stall in th
market square of the nearest town. We read of a 'pot-market' in ancien
Athens,[29] the word used (*hai chytrai*) suggesting that it may have been fo
the sale of coarse wares; smaller towns would not perhaps have neede
such a precise point of sale. Some potters might venture in a caique fron
island to island, perhaps taking a selection of pots for sale and receivin
orders for the next visit. Travel by sea could be dangerous, though easie
than the slow overland routes, but for both methods, large consignments o
pottery would need very careful packing.

Some Attic vase scenes show selling in progress. Some indicate clearl

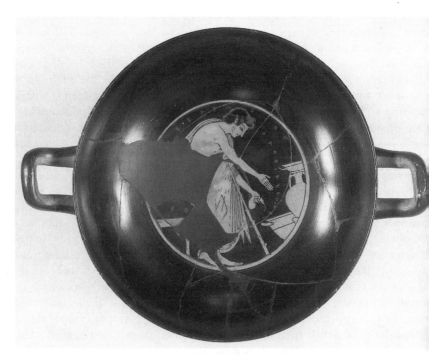

VI.4 Buying pottery in an Athenian shop, ca. 500 B.C.

hat it is the contents that are being sold (oil, perfume, wine), others may
>e pictures of customers buying pottery in the shop (Fig. VI.4).[30]

The big concerns are likely to have had customers come to their
workshop, either individuals buying in small quantities for home use, a
>rojected party, a family funeral or a dedication, or traders who would sell
o customers further away. The traders either came themselves and ordered
;oods on sight, already made or in the process of being shaped and
>ainted, or may have sent along an order for a particularly popular line,
vhether plain or decorated, to be picked up later by slaves, or taken down
o an agreed point by some of the pottery personnel. It is doubtful how
much buying of pottery was carried on at the quayside; the trademarks (see
>p. 126–9), especially the batch notations for party sets, table ware or
mixed, seem to suggest that the order was made up at the shop.

In those cases where the pots were made as containers, the orders would
>resumably be delivered to the local vineyards, oil presses, etc. for filling
>efore being sent for dispatch or distribution. Many of these would be
1eavy-duty pieces, but special commissions might be in fine ware such as
he Attic black-figure Panathenaic amphorae (see pp. 53–5), made every
our years as containers for the prize oil and handed out in large numbers
o the winners at the festival, who no doubt took both pride and pleasure
n the prize and in the contents.[31]

Merchants are rarely named, and their names and origins are only
letected in part and with difficulty from such evidence as the trademarks.[32]
We know of a Sakon, a Simon (most likely an Athenian), Achenatos
perhaps a Sicilian) and then such partial names as Archi-, Mnesi-, Smi-,
Ar-, Me-. The best-known name is that of Sostratos of Aegina.[33] He is
mentioned by Herodotus (Book 4, ch. 152): 'The Samian merchants, on
heir return home [from Tartessos], made a greater profit on their cargo
han any Greeks of whom we have precise knowledge, with the exception
of Sostratos of Aegina, the son of Laodamas – with him, nobody can
:ompare.' Recently an inscribed stone anchor-stock was found just outside
he sanctuary of Hera at Gravisca, the port for Tarquinia, the Etruscan city
m southern Etruria. It carries the words, in Aeginetan script of ca. 500
3.C.: 'I am of Aeginetan Apollo; Sostratos, son of [], made'. Either this is
he very same man mentioned by Herodotus or a member of his family.
'urther evidence to link the name to one and the same man comes from the
rademark SO on almost a hundred Attic vases of the later sixth century,
ome tied indirectly with graffiti in Aeginetan script. The principle of
Occam's razor might reduce all three sets of evidence to one man, but
,ostratos did not make his fortune simply from selling pottery. He came to
Athens to buy pottery that would accompany his more profitable cargo and
would have exchanged his load for some commodity such as Etruscan
metal, which he would carry on to another port of call or bring back as his

return cargo. Sostratos is good evidence for merchants in the century, no matter what their place of origin, moving from port to port, carrying and trading in goods of various states and cities. Some merchants may have owned more than one ship, some only one; many would have owned none at all and hired a ship in whole or part. The long-distance merchant (*emporoi*) who took Corinthian pottery to southern Italy and Sicily in such quantities or to Naucratis in Egypt, and those who took Attic black- and red-figure to all corners of the known world, were not assisting the states of Corinth and Athens; whether they were Eretrians, Aeginetans, Ionians or Phoenicians, their profit was for themselves, the shipowners, the moneylenders or maybe even the potters.

Much fine pottery never strayed far from its place of manufacture and the majority is to be found in its home town or in neighbouring areas. Protoattic and Boeotian are rarely found beyond their own local boundaries, nor is Corinthian red-figure. South Italian and Sicilian wares having developed out of imported Attic pottery, were themselves mainly restricted in their distribution to their own regions. It would seem that some pottery-making centres had special connections at some distance away, e.g. Chios with Naukratis.[34] Long-distance movement is the exception, and Athens is unique in the spread and quantity of her exported vases, though even some particular shapes of her pottery were not exported, especially funerary vases.[35]

In the matter of long-distance movement the best known examples are perhaps the pendent semicircle skyphoi which mark the spread of Euboea influence both East and West,[36] and the numerous vases that went from Corinth to the West in the late eighth and seventh centuries (and which have always been central to any study of Greek settlement in south Italy and Sicily).[37] By the late seventh century, Athenian vases are found in Corinthian Western markets; the earliest Attic vase yet found in the West ca. 600 B.C., is a fragment (most likely of an amphora) by the Nessos Painter from Caere, in Etruria.[38] During the sixth century, pottery from Athens is found as far away as Etruria, France and Spain in the West, deep into Asia Minor, round the Black Sea, and in Egypt and Africa. The work of the painter Kleitias (575–550 B.C.) has been found in an Etruscan tomb, in Egypt and in Gordion, the capital of Phrygia in Asia Minor.[39] The earliest example of Attic pottery in south Russia is a vase by the Painter of Acropolis 606, from Theodosia (ca. 550 B.C.).[40] It is also in the sixth century that Athenian potters and painters begin to produce work that was specifically directed at foreign markets; the best known example is Nikosthenes who provided for the needs of the Etruscans by imitating and elaborating on their own pottery and also using East Greek features which were accepted by his Etruscan customers.[41] The Persian expansion in the sixth century saw East Greek potters and painters leaving their homeland

ɔn the coast of Asia Minor and transferring their skills to the West, e.g. the ƿotters and painters of Caeretan hydriai in Etruria.[42]

In the fifth century markets changed. After the battle of Cyme in 474 ʒ.C. Etruscan imports of Attic pottery are fewer, whereas the north Italian ɔentres such as Felsina and Spina at the head of the Adriatic route rise in mportance after the Archaic period. It was still possible for an enterprising ƿotter to find varied outlets for his wares. The work of Sotades and the ʂotades Painter has been found at Vulci and Capua, on Cyprus, in Egypt, ɪnd in the Black Sea region and Persia. The potter and painter of the piece ɔound in Egypt (at Memphis) furnished a scene of Greeks versus Orientals ɔn a vase in the shape of a camel with Persian mahoot; it doubtless found ɪn eager purchaser.[43] Though pottery would have travelled alongside basic ɔommodities and would not have dictated trade routes, destination cannot ɪave been altogether pot-luck. Some Attic black-figure pottery was ɗeposited in Celtic tombs, the best known being that at Vix in central ʄrance.[44] Another example is that from Klein-Aspergle (near Ludwigsburg, Wirtemberg) where the Attic cups, both red-figure and black, were ɗecorated with thin gold attachments of Celtic design that enhanced the ɪppearance of the ware in a manner to suit the family of the deceased.[45] More recently, Attic black and patterned pieces have been discovered in the ɔomb of Philip II of Macedon, at Ageae (Vergina).[46]

It is difficult to calculate the effects of the Peloponnesian War on the ɗistribution of pottery, both within Greece itself and beyond. As there was ɪo state control of such dealings, potteries doubtless continued to seek the ɔutlets they could find. The decline of Athenian imports into Corinth has ƿeen linked to the development of a local red-figure at the time.[47] The ʂicilian expedition of 415 B.C. has been blamed for the fall in imports to ɦe Greeks on the island and in southern Italy, and has been seen to lead to ɪn increased output of the local businesses which provided for the home ɱarkets.[48] Athens' main export areas in the fourth century lie to the east (the Greek islands and Cyprus), to the south (Egypt and North Africa) and ɔ the Black Sea area.[49]

NOTES

I Introduction

1. Ziomecki 1975, 88–98.

2. See Jones 1986, ch. 12 on present-day traditional potteries, with Table 12. for a list of fifty. See now Blitzer 1990.

3. For some notes on the more important museums, see Cook 1972, 360–4.

4. For exhibitions, see e.g. Mayo 1982 (on south Italian pottery), von Bothmer 1985 (on the Amasis Painter); Aellen, Cambitoglou and Chamay 1986 (on the Darius Painter); Spivey 1988 (on the Micali Painter).

5. E.g. *The Athenian Agora, Results of Excavations conducted by the America School of Classical Studies at Athens* (Princeton, 1953–); *Corinth, Results of the Excavations conducted by the American School of Classical Studies at Athen* (Princeton, 1932–); *Fouilles de Delphes, École française d'Athènes* (Paris, 1902–); *Délos, Exploration archéologique de Délos faite par l'École française d'Athène* (Paris, 1909–).

6. For salerooms and catalogues, see e.g. Sotheby's, Christie's and Ede's Münzen und Medaillen in Basel. For the case against trade in antiquities, see Meye 1977; Greenfield 1989; Cleere 1989.

7. Some of the periodicals are quoted in the notes to the following chapters; the provide the source for statements made in the text.

8. The most important listing of publications in the field of Classical archaeolog is to be found in the annual *L'Année philologique* which contains information on publications on all aspects of classical studies. Also useful is the biennial bulletin on pottery that is published in *Revue des Études Grecques*.

9. Best-known general treatments of Greek pottery are Arias, Hirmer and Shefton 1962; Lane 1971; Cook 1972; Simon and Hirmer 1981; Williams 1985 See also Sparkes 1991. Scheibler 1983, which looks at all aspects of the potter industry, is to be translated into English (see review by Johnston 1985b).

10. For a thread through the *CVA* labyrinth, see Carpenter 1984. Mention migh also be made here of Beazley's volumes 1956, 1963, 1971 and the addend. Carpenter 1989. They have no illustrations and list with publication references the Attic black-figure and red-figure vase-painters that Beazley distinguished. This wor of connoisseurship and taxonomy is now under the aegis of the Beazley Archive in the Ashmolean Museum, Oxford.

11. E.g. Empereur and Garlan 1986; Peacock and William 1986, esp. ch. 2.
12. For congresses, see e.g. Lissarrague and Thelamon 1983 (Rouen); Moon 1983 (Wisconsin); Brijder 1984 (Amsterdam); True 1987 (Malibu); Christiansen and Melander 1988 (Copenhagen).

II Making

1. For aspects of pottery production, see Noble 1966 (rev. ed. 1988); Shepard 1968; Jones 1986; Rice 1987; Arafat and Morgan 1989. See also Birmingham 1974 and Brijder 1984, Cuomo di Caprio 1985.
2. Recent studies which concentrate on or make use of evidence for modern traditional potteries are Hampe and Winter 1962 and 1965; Peacock 1982; Arnold 1985; Jones 1986. See also Blitzer's chapter on traditional pottery production at Kentri, Crete in Betancourt 1984, 143–57. See now Blitzer 1990.
3. For the transport of clay in small and large quantities, see Benson 1985, Jones 1986, 53 and ch. 12; Boardman 1986, 252–3; Gill 1987a, 82–3.
4. Cook 1959; Johnston 1979, 50–1; Snodgrass 1980a, 126–9.
5. For Corinth and its potteries, see Roebuck 1972, 116–25; Stillwell and Benson 1984; Benson 1984; Salmon 1984, ch. 7. See also Pemberton 1970, 265–70; Amyx and Lawrence 1975. For Athens, see Scheibler 1983, 107–8 with nn. 53–7; Jones 1984, 23–5. For both Corinth and Athens, see Arafat and Morgan 1989, esp. 311–29.
6. For modern pithos making, see Hampe and Winter 1962 and Jones 1986, 353ff. For freehand pottery, see Kourou 1987 and 1988.
7. See Sparkes and Talcott 1970, 34–6. For cooking-pot clays, see Jones 1984, 29.
8. For ancient illustrations of vases being made, see Richter 1923, 64–79 (for the written evidence, see 87–105; Cuomo di Caprio 1985, part 3); Beazley 1944 (now in Kurtz 1989), 87–103; Metzler 1969; Ziomecki 1975, 88–98; Arafat and Morgan 1989, 316–19. One picture shows a woman at work as a painter, see Kehrberg 1982.
9. Strong and Brown 1976, 75–6. Clay wheels have a small diameter and may have had a wooden frame attached to the outer rim. For Minoan potters' wheels, see now Evely 1988.
10. A detailed series of photographs showing the stages in making a modern version of an Attic black-figure kylix is included in Noble 1966 (rev. ed. 1988) figs. 1–72.
11. Hambidge 1920 and Caskey 1922 have not been superseded for their collection of detailed and accurate line-drawings of Greek pottery.
12. There has been much discussion on the nature of the paint used, see Noble 1966 (rev. ed. 1988), 31–47; Winter 1978.
13. On the preliminary sketch, see Corbett 1965; de Puma 1968. It seems to have been first used in the seventh century.
14. For multiple brushes, see Boardman 1960; and against, Eiteljorg 1980. Some have detected the use of templates for patterns, see Hemelrijk 1984, 88–9, 96–7, 105–8, 112–15.

15. For different suggestions, see Noble 1966 (rev. ed. 1988), 56–68; Seiter 1976; Winter 1978, 57–8.
16. For mistakes in painting, see Farnsworth 1959.
17. The author of the poem is not known. For interpretations, see Cook 194 and 1951; Noble 1966 (rev. ed. 1988), 102–13 (by M.J. Milne).
18. For illustrations of firing, see the Penteskouphia plaques: Richter 1923, fig 72–80 and Cuomo di Caprio 1984, 72–82; Arafat and Morgan 1989, 317–19.
19. For kilns, see Cook 1961; Winter 1978; Peacock 1982, 67–83 (Roman; Scheibler 1983, 107–10 and 204, nn. 63–9; Cook 1984a; Jones 1986, 832–3, esp Table 10.2; Arafat and Morgan 1989, 321–5.
20. For failures in stacking, see Farnsworth 1959.
21. For test pieces, see Beazley 1944 (now in Kurtz 1989) 121, n. 1; Farnswort 1960; Noble 1966 (rev. ed. 1988), 74.
22. For failures in firing, see Farnsworth 1959.
23. See Jones 1986 for all these aspects. For a recent statement of th petrographic method, see Williams 1990. The Munsell code is often used t establish a colour or shade.

III Dating

Ideas about chronology are always in a state of flux, particularly for the Archai period and earlier. What is presented here is in the main the orthodo understanding, with some references to recent challenges, mainly centred on th Late Archaic/Early Classical periods. For a review of the recent controversy ove chronology spearheaded by E.D. Francis and M. Vickers, see Cook 1989 which list the relevant articles.

1. The best known example is the so-called Brygos Tomb at Capua, see Beazle 1945; Williams 1985, 45–8. See also Vickers and Bazama 1971 for an example c a tomb in Cyrenaica, and Corbett 1960, 60 for other comments on the dangers c laying too much stress on the evidence of isolated tomb-groups. For dating i relation to potters' and painters' families, see Boardman 1988a.
2. Lane 1971, 20.
3. For ancient chronology, see Bengtson 1970, 27–35; Samuel 1972, 57–138 Bickermann 1980, 62–91; Crawford and Whitehead 1983, 618–22.
4. Marathon: Kurtz and Boardman 1971, 108–12, 121, 247; Francis 1990, 134 n. 82. Koumanoudes 1978 argues against the identity of the mound as that c Marathon.
5. Themelis 1977, 226–44, 297–8; Snodgrass 1983a, 166.
6. Athens, Kerameikos, the tomb of the ambassadors from Corcyra: Knigg 1972a, 584–605; 1972b, 258–65; 1976, pls. 112–13.
7. Rheneia, Purification Pit: Dugas 1952; Cook 1955, 267–9; Kurtz an Boardman 1971, 189 and 198; Zaphiropoulou 1973; Bruneau and Ducat 1983, 2 and 268.
8. Thespian polyandrion: Kurtz and Boardman 1971, 248; Schilardi 1977.
9. Athens, Kerameikos, the tomb of the Lacedaimonians: Ohly 1965, 314–2 Kurtz and Boardman 1971, 108–12, 121, esp. 110; Willemsen 1977.

10. Athens, Kerameikos, the Dexileos monument: Vermeule 1970; Kurtz and oardman 1971, 108; Burn 1987, 7–8, 87–8.
11. For an attempt to sort out the early dates, see Cook 1969. For a recent etailed study of the chronology of Corinthian pottery on which the early dating inges, see Amyx 1988, 397–434. The following notes give references to recent eactions to Cook's timetable, and Snodgrass 1987, 57 points to 'the danger of xpecting the evidence of excavation to speak to us in the same clear language as at of an historical event' and questions the connections that have previously been ken as fundamental. I have adhered to more traditional approaches.
12. Hama(th): Coldstream 1968, 311–13; Hawkins 1982, 415–17; Braun 982, 9; Francis and Vickers 1985, 131–6.
13. Aziris: Boardman 1966; 1980, 153–5.
14. Daphnae: Cook 1954, 57–60; Austin 1970, 20; Braun 1982, 44 ('Daphnae annot fail to be identical with Tell Defenneh, excavated in 1880'); Francis and ickers 1985, 137–8.
15. Athens: the evidence is very complex. See Vickers 1985b, 22–33; Francis nd Vickers 1988; Francis 1990, 109–11. The relief figures on the statue bases uilt into the Themistoklean Wall in 479 B.C. are close in appearance to the figures f the Pioneer Group of Attic vase-painters, see Robertson 1987, 15.
16. Motya: Coldstream 1964, 105–12, 118–22; Isserlin and du Plat Taylor 974.
17. Olynthus: Gude 1933 (for the sources); Robinson et al. 1929–52; Scichilone 963.
18. Koroni: McCredie 1966; Grace 1974.
19. Corinth: Edwards 1975, 189–91.
20. See e.g., Francis and Vickers 1985, 137 (Old Smyrna); Boardman 1965 (arsus); Graham 1982, 140–1 (Massalia).
21. There is a vast bibliography on the Western colonies, see Coldstream 1968, 22–7 and recently Graham 1982, 83–195 and 480–7, with the review by Burn 983, 251–2. For the pre-colonial Greek presence, see Ridgway 1984, Part I, /hitehouse and Wilkins 1985, and for a recent general survey, Cordano 1986. On hucydides and the Sicilian chapters, see Gomme, Andrewes and Dover 1970, 98–210 (Dover).
22. Pithecusa: Coldstream 1968, 316–17; Kurtz and Boardman 1971, 307; ook 1972, 263; Graham 1982, 97–103; Ridgway 1984, Part II, and 1988a & b, 55–61.
23. Cumae: Graham 1982, 97–103; Ridgway 1988b, 655–61.
24. Sicilian colonies: Graham 1982, 103–4 (Naxos), 105–6 (Syracuse), 104–5 (eontini), 106–8 (Megara Hyblaea). For Megara Hyblaea, see also Boardman 980, 174–7. See more generally Snodgrass 1987, 51–64.
25. Sybaris: Boardman 1980, 178–9; Graham 1982, 109–10.
26. Taras: Kurtz and Boardman 1971, 308–9; Graham 1982, 112–13.
27. Ephesos, Artemis temple: Robertson 1975, 83–4 (sixth-century temple), 07–8 (fourth-century temple); Ridgway 1977, 9; Boardman 1978a, 160–1; 1980, 9–100; Bammer 1982, 72 and 1984. For a new theory on the date, see Vickers 985b, 9–22 (with bibliography).
28. Delphi, Siphnian treasury: Picard and de la Coste-Messelière 1928, 57–171;

Robertson 1975, 152–9; Moore 1977; Ridgway 1977, 8–9; Boardman 1978
158–9; Watrous 1982, 159–72; Moore 1985; Hurwit 1985, 295–301; Daux a
Hansen 1987; Stewart 1990, 128–9. For the close connection with the Andokid
Painter, see von Bothmer 1966.

29. Francis and Vickers 1983, 54–67; a reply, Boardman 1984b, 162–
Vickers 1985a, 9–12 (n. 36 casts doubt on the identity of the building); anoth
reply, Amandry 1988, 593–609.

30. Delphi, the Apollo temple: Picard and de la Coste-Messelière 1931, 15–7
Robertson 1975, 161–2; Boardman 1978a, 155–6; Amandry 1988, 609; Stewa
1990, 86–9.

31. Delphi, the Athenian treasury: de la Coste-Messelière 1957, esp. 259–
(Appendix 2, Chronology); Robertson 1975, 167–70; Ridgway 1977, 236–
Boardman 1978a, 159–60; Boardman 1982, 3–165; Stewart 1990, 131–
Francis 1990, 44–5, 100–4.

32. Eretria, the Apollo temple: von Bothmer 1957, 124–6; Robertson 197
163–4; Touloupa 1986, 143–51; Boardman 1988d, nos. 120–1; Stewart 199
137.

33. Francis and Vickers 1983, 49–54; replies, Boardman 1984b, 161–2 a
Amandry 1988, 602. See now Francis 1990, 8–16, 24–5.

34. Olympia, the Zeus temple: Ashmole, Yalouris and Frantz 1967, 6–
Ashmole 1972, 1–89; Robertson 1975, 271–91; Boardman 1985, 33–50; Stewa
1990, 142–6.

35. Athens, the Parthenon: the bibliography is large, see Robertson 1975, 29
316; Robertson and Frantz 1975; Brommer 1963, 1967, 1977, 1979; Cook 1984
Boardman and Finn 1985; Boardman 1985, 96–145; Stewart 1990, 150–60. F
the accounts, see Burford 1963; Lewis 1981, 436–51; cf. Meiggs and Lewis 19
(rev. ed. 1989) no. 59.

36. Kallimachos' Victory (Athens, Acropolis 690): Raubitschek 1949, 18ff., n
13; Shefton 1950, 140–64; Harrison 1971, 5–24; Robertson 1975, 644–5, n.
and pl. 56a; Boardman 1978a, 86–7; Hurwit 1985, 324; Stewart 1990, 131–2.

37. Agorakritos' Nemesis at Rhamnous: Despinis 1970; 1971; Ridgway 198
171–3; Boardman 1985, 147, 207; Stewart 1990, 269–70. The base: Petrak
1981, 227–53; 1986.

38. Paionios' Victory at Olympia: Robertson 1975, 287–8; Ridgway 198
108–11; Boardman 1985, 176; Stewart 1990, 89–92.

39. Tyrantslayers at Athens: Shefton 1960; Ridgway 1970, 79–83; Brunnsåk
1971; Taylor 1981; Boardman 1985, 24–5; Landwehr 1985, 27–47; Boardm
1988d, no. 141; Stewart 1990, 135–6 and 251–2. See also n. 57.

40. (a) Myron's Discobolos: Ridgway 1970, 84–86; Robertson 1975, 34
Boardman 1985, 80, 148–9. (b) Myron's Athena & Marsyas: Ridgway 197
85–6; Robertson 1975, 341–3; Weis 1979; Daltrop 1980; Boardman 1985, 8
Stewart 1990, 147. (c) Pheidias' Athena Parthenos: Schuchhardt 1963, 31–5
Leipen 1971; Robertson 1975, 311–16; Ridgway 1981, 161–7; Boardman 198
110–12; Stewart 1990, 157–8.

41. Dexileos' grave monument: Robertson 1975, 369; and see n. 10 above.

42. Dancing caryatid monument: Vatin 1983. The inscription also nam
Praxiteles as the sculptor.

43. Record reliefs: Robertson 1975, pl. 123a (409/408 B.C.), 373 and 684, n. 32 partial list); Fuchs 1979, figs. 608 (409/408 B.C.), 619 (375/374 B.C.), 624 347/346 B.C.), 626 (295/294 B.C). See also Meiggs and Lewis 1969 (rev. ed. 1989) os. 84 and 94.

44. Angelitos' Athena (Athens Acropolis 140): Raubitschek 1939–40, 28–36; aubitschek 1949, 26ff., no. 22; Ridgway 1970, 29–31; Brouskari 1974, 129–30; obertson 1975, 179; Boardman 1978a, 87 and 1988d, no. 136. The two vases are n Attic red-figure neck-amphora by the Alkimachos Painter, London BM 1928.1– 7.57 (Beazley 1963, 529, no. 12; Carpenter 1989, 254) and an Attic red-figure inochoe from the Group of Berlin 2415, New York, MM 08.258.25 (Beazley 963, 776, no. 3; Carpenter 1989, 288).

45. See nn. 39 and 57.

46. See n. 40 and Boardman 1956, 18–20. The vase is an Attic red-figure chous, erlin F 2418 (Robertson 1975, pl. 113b; Boardman 1985, fig. 64).

47. The treatment of the connections between the Parthenon sculptures and ase-painting is extensive. See especially Brommer 1967, 182–3; 1977, 154–5; hefton 1982; Schwab 1986; Arafat 1990, 166–72. The vase that has been onnected with the Helen and Menelaus metopes (North 24–5) is an Attic red-gure oinochoe, Vatican 16535 (Beazley 1963, 1173, below; Carpenter 1989, 329) nd that with the young knight (West 25) is an Attic red-figure pelike in the manner f the Washing Painter, Berlin F 2357 (Beazley 1963, 1134, no. 8). For the West ediment and vases, see Metzger 1951, 324–6, and for the East pediment and ases, see Harrison 1967, 30, 39–40 and Shefton 1982. For the Parthenos and ase-painting, see Leipen 1971. Arafat and Morgan 1989, 324 suggest that the birth f Athena in vase-painting was killed off by the pedimental treatment of the arthenon.

48. Zeus at Olympia: Shefton 1982, for the throne.

49. Pausias: Pliny *HN* 35.123–7 (Overbeck 1760). Pebble mosaics: Robertson 965; 1967; 1975, 485–91; Williams and Fisher 1976, 114, n. 13; Robertson 981a, 172–6; Salzmann 1982. For the vases, see Trendall and Cambitoglou 1978, 89–90; Trendall 1989, 80.

50. For historical characters and scenes, see Hölscher 1973, 30–31.

51. Arkesilas by the Arkesilas Painter, Paris, Cab. Méd. 189 (4899): Chamoux 953, 258–63; Arias, Hirmer and Shefton 1962, pls. 74 and XXIV; Stibbe 1972, 15ff., 195ff., pl. 61, 2, no. 194; Hölscher 1973, 30; Hooker 1980, 86f.; Simon nd Hirmer 1981, pl. XV; Boardman 1984a, no. 372. On silphium, see Chamoux 985. On the cup Schaus 1983, 88–9 interprets 'Onexo' as 'Enoxo', wife of rkesilas II.

52. Shefton 1954, 308.

53. Lane 1933–4, 161–2; Boardman 1974, 195.

54. Anakreon: Caskey and Beazley 1954, 55–61 on no. 99; Kurtz and oardman 1986, 65–70.

55. Croesus by Myson, Paris, Louvre G 197: Beazley 1963, 238, no. 1; Beazley 971, 349; Arias, Hirmer and Shefton 1962, pl. 131; Hölscher 1973, 30–1; oardman 1975a, fig. 171, and 1988d, no. 230; Carpenter 1989, 201. The date of ne fall of Sardis: Andrewes 1982, 401–2.

56. Boardman 1982, 15–16. See also Francis 1990, 71–2.

57. For the Tyrantslayers, see n. 39 and Beazley 1948, 26–8; Hölscher 197 85–8; Robertson 1975, 185–6; Prag 1985, 102–3.

58. The Panathenaic prize amphorae are London BM B 605, and Hildesheir Pelizaus Museum 1253 and 1254 (Beazley 1956, 411, nos. 4 and 412, nos. 2 and Carpenter 1989, 107).

59. Boston MFA 98.836: Vermeule 1970, 103–7, fig. 7; Brunnsåker 1971, p 24, 7; Thompson and Wycherley 1972, 155–8.

60. The Persians: Bovon 1963; Hölscher 1973, 38–49; Hölscher 1974; Barre and Vickers 1978, 17–24 and pls. 1–2; Pinney 1984, 181–3; Williams 1986 (n. 1 gives a full bibliography of Persians on vases); Boardman 1988d, no. 236. See als Kahil 1972.

61. Pronomos: Duris 76F29 (= Athenaeus 4.184D). The Pronomos krate Naples 3240: Beazley 1963, 1336, no. 1; Arias, Hirmer and Shefton 1962, pl 218–19; Trendall and Webster 1971, 28, no. II, 1; Simon and Hirmer 1981, pl 228–9; Simon 1982a, pl. 9; Carpenter 1989, 365.

62. Alexander: Naples 3256 and 3220; Hölscher 1973, 174–80; Giuliani 197' Trendall and Cambitoglou 1982, 18/40 and 18/47 and 484–5; Trendall 1989, 1 and 89.

63. Boreas and Oreithyia: Kaempf-Dimitriadou 1979, 105ff., nos. 340–39 Brommer 1980, 11–16; Simon and Hirmer 1981, pls. 178–9; Robertson 198 14–15; Boardman 1988d, no. 231. Cf. Aegina, Arafat 1990, 77–88, etc.

64. Herakles: Boardman 1972; 1975b; 1978c; 1989b; Williams 1980, 144, 25; Boardman 1982; Shapiro 1983. Theseus: Sourvinou-Inwood 1971; Barro 1972; Sourvinou-Inwood 1979; Boardman 1982; Francis and Vickers 1983, 49 54; Francis 1990, 49–51 and passim. For recent comments on this trend, s Osborne 1983–4 and Cook 1987a.

65. For the Geometric and Archaic periods, see Carter 1972; Snodgrass 197' 1980a, 183–94; 1980b; 1982; 1987, ch. 5. See also more generally March 1987

66. Vermeule 1966, 6.

67. Boardman 1983, 29.

68. Trendall and Webster 1971.

69. Boston MFA 63.1246, by the Dokimasia Painter: Beazley 1963, 165 Vermeule 1966; Davies 1969; Boardman 1975a, fig. 224; Prag 1985, 102– Carpenter 1989, 234.

70. Tokyo, Fujita: Simon 1982a, pl. 7, 1–2; 1982b, 141–2, pl. 37a–1 Boardman 1988d, no. 200. See also Sutton 1980, 28–9.

71. London BM 1947.7–14.8: Trendall 1967, 27, no. 85, pl. 8, 1; Trendall ar Webster 1971, II.11; Sutton 1980, 95–133 (424 B.C.); Seaford 1982; 1984, 49–5 (ca. 408 B.C.); Vickers 1987, 187–97; Trendall 1989, 19–20.

72. Malibu, The J. Paul Getty Museum 82.AE.63: Green 1985, 95–8, 111–1 Taplin 1987, 93–6.

73. Jeffery 1961 (2nd. ed. 1990) 63–5; Woodhead 1981; Millar 1983, 9 Immerwahr 1990.

74. 'Kalos' names: Richter 1958, 43–5, 65, 93, 117; Beazley 1956, 664–7 1963, 1559–1616; 1971, 317–19, 505–8; Carpenter 1989, 147–8 and 388–9 Kleine 1973, 78–93. New names: Carpenter 1989, 391–9.

75. Francis and Vickers 1981, 97–136.

76. 'Signatures': Payne 1931, 158–69; Beazley 1956 and 1963 passim and
553–8; 1971, 523; Lorber 1979; Amyx 1988. New names appear from time to
ime, see Frel 1973 and pp. 145, n. 28, 149, n. 38.

77. Polias: Boardman 1956, 20–24.

78. Panathenaic prize amphorae: Beazley 1951 (rev. ed. 1986) ch. 8; 1956,
·03–17; Frel 1973; Boardman 1974, ch. 7; Brandt 1978; Rhodes 1981, 671 and
ommentary on 49.3 and 60; Andrewes 1982, 410–11; Moore & Philippides 1986,
2–17; Carpenter 1989, 105–9.

79. The Burgon amphora, London BM B 130: Beazley 1956, 89, no. 1; Corbett
960, 52–8; Boardman 1974, fig. 296; Boardman 1988d, no. 204; Carpenter
989, 24. Athens, Kerameikos: Frel 1973, 7, fig. 4 and 11, fig. 7.

80. Frel 1973, 18–19; Eschbach 1986.

81. Edwards 1957; Frel 1973, 29–30 (Sarapion, agonothetes, 98–97 B.C.).

82. 'Hadra' hydriai: Guerrini 1964; Cook 1966; 1968–9; Fraser 1972, I 138ff.;
I 104ff. with nn. 248–9; Callaghan 1980; Callaghan 1984; Cook 1984b;
Callaghan and Jones 1985, Enklaar 1985 and 1986; Jones 1986, 734–77.

83. Ostraka: Vanderpool 1970; Lewis 1974; Francis and Vickers 1981, 100–1;
Harvey 1984, 72; Francis and Vickers 1988, 144–5. See now Lang 1990.

84. Transport amphorae: Grace 1979; Empereur and Garlan 1986. For a prime
xample of the use to which stamped amphora handles can be put for dating
·urposes, see Grace 1985 on the Middle Stoa in the Athenian Agora.

85. Impressed cups; Lévêque and Morel 1980, 91; Morel 1981, 46–50. See
Chapter V n. 29.

86. Scientific dating: Jones 1986, ch. 10.

IV Shapes

1. The best-known example of a vase name denoting an object in a scene is the
hydria' on the François vase, Florence 4209: Beazley 1956, 76, no. 1; Carpenter
989, 21. For 'lebes', see Athens, Acropolis 590: Graef and Langlotz 1925, pl. 27a.

2. See Sparkes 1975.

3. Still basic is Richter and Milne 1935, with older bibliography cited. See also
ow Kanowski 1984. Most general books on Greek pottery have a section on
names; those books that deal with one shape sometimes go into the question of the
·riginal name(s) for the shape, e.g. Haspels 1936, 127–8 (on the lekythos) and
Philippaki 1967, xvii–xxii (on the stamnos).

4. Stone inscriptions: Amyx 1958 on the vase names on the Attic Stelai; for
·nventories, see Lewis 1986.

5. Vase names on vase inscriptions: Sparkes and Talcott 1970, 4–9; Lazzarini
973–4; Johnston 1979, 32–3. This evidence tends to show how wide a usage a
name could have. The names used in trademark graffiti present a slightly different
·erminology, see pp. 126–9.

6. For kados, see nn. 17–18 below.

7. For scratched names, see n. 5 above and nn. 8–18 below.

8. Chiot chalice, Chios, from Chios: Jeffery 1961 (new ed. 1990), pl. 65, 42e;

Boardman 1967, pls. 97, 614; Lazzarini 1973–4, pl. 66, 3 and p. 346; Lem⬥ 1986, 234, fig. 1.

9. Rhodian skyphos, Copenhagen NM 10151: Jeffery 1961 (new ed. 1990), ⌐ 67, 1; Lazzarini 1973–4, pl. 66, 1 and p. 346; Boardman 1984a, no. 379b.

10. Attic cup-skyphos, lost: Vanderpool 1967; Lazzarini 1973–4, pl. 70, 2 ar⬥ p. 351.

11. Attic Siana cup, Paris, Louvre F 66, from Etruria: Lazzarini 1973–4, pl. 6. 1 and p. 343.

12. Rhodian Late Geometric skyphos, Ischia, from Ischia: Jeffery 1961 (new e 1990) pl. 47, 1; Coldstream 1968, 277; Meiggs and Lewis 1969 (rev. ed. 1989), n⬥ 1; Lazzarini 1973–4, pl. 64, 1 and p. 342; Boardman 1980, 167, fig. 20: Boardman and Hammond 1982, 100, fig. 16; Millar 1983, 93–4; Boardma⬥ 1984a, no. 378; Ridgway 1988a, 105, n. 2 (for bibliography).

13. Boeotian black kantharos, Paris, Louvre, MNC 370 (L 198), from Thespia⬥ Jeffery 1961 (new ed. 1990), pl. 9, 18; Lazzarini 1973–4. pl. 73, 1 and p. 357.

14. Attic red-figure aryballos, Athens NM 15375, from Athens: Richter ar⬥ Milne 1935, fig. 106; Beazley 1963, 447, no. 274; Lazzarini 1973–4, pl. 74, 2 ar⬥ p. 360; Carpenter 1989, 241.

15. Protocorinthian pointed aryballos, London BM A 1054, from Cumae: Jeffe⬥ 1961 (new ed. 1990) pl. 47, 3; Lazzarini 1973–4, pl. 73, 2 and p. 360; Lorb⬥ 1979, no. 9.

16. Corinthian aryballos, Corinth Museum C-54-1, from Corinth: Roebu⬤ 1955; Boegehold 1965 (he proposes ⟨m⟩olpa = 'dance' and thus removes t⬥ connection with the shape); Lazzarini 1973–4, pl. 74, 1 and p. 362; Lorber 197⬥ no. 39; Amyx 1988, 560, no. 17.

17. Attic black-figure amphora, once on the market: Sparkes and Talcott 197⬥ 7; Lazzarini 1973–4, pl. 75, 1, 3 and p. 364; Sparkes 1975, 127, n. 27.

18. Athens, Kerameikos 7357, from the Athenian Kerameikos: Sparkes 1975, ⌐ 12b; Knigge 1976, pl. 95, 1 and p. 192.

19. Beazley 1940–5, 18–19, n. 2.

20. The study of potters on the basis of direct comparison of shapes h⬥ increased recently. A pioneering work is Bloesch 1940 on Attic kylikes and 1951 ⬤ amphorae. For more recent studies of individual shapes (mainly Attic), see Die⬙ 1964 (hydriai); Philippaki 1967 (Attic stamnoi); Rudolph 1971 (Attic squ⬥ lekythoi); Callipolitis-Feytmans 1974 (Attic plates); Becker 1977 (Attic pelika⬥ Borell 1978 (Geometric cups); Schneider-Hermann 1980 (south Italian nestorides Brijder 1983 (Attic sixth-century kylikes); Neeft 1987 (Protocorinthian aryballo⬥ McPhee and Trendall 1987 and 1990 (fish plates); Stibbe 1989 (Laconian mixin⬥ bowls); Kearsley 1989 (skyphoi). There are also many articles that deal wi⬥ particular shapes, some of which are mentioned in the following notes.

21. Immerwahr 1984a and 1990.

22. Oxford, Ashmolean Museum 189: Beazley 1956, 349 bottom; Beazley 197⬥ 159–60.

23. For the problem of 'epoiesen' (= 'made'), see Beazley 1944 (now in Kur⬥ 1989), 107–15 and more recently Cook 1971; Robertson 1972; Eisman 197⬥ Vickers 1985c, esp. 126, n. 175; Robertson 1985, 21–2; Arafat and Morgan 198⬥ 319–21.

24. Krater fr., Ischia, from Ischia: Buchner 1971, 67; Jeffery 1977, 64; oardman 1980, 167, fig. 184; Boardman, Edwards, Hammond & Sollberger 1982, 29, fig. 106, 2.

25. Krater, Rome, Conservatori: Arias, Hirmer and Shefton 1962, pls. 14–15; oardman 1980, 193, fig. 227; Simon and Hirmer 1981, pls. 18–19; Boardman 984a, no. 367.

26. From Smyrna: Boardman 1984a, no. 380; from Chios: see n. 8 above; from chaca: Lorber 1979, no. 7, Amyx 1988, 683.

27. Protocorinthian aryballos, Boston MFA 98.900: Jeffery 1961 (new ed. 990), pl. 6, 22; Lorber 1979, no. 10.

28. For Athens the information is full. See Beazley 1944 (now in Kurtz 1989), 956, 1963 and 1971. For new names, see Carpenter 1989, 400–6.

29. Boeotian names: Raubitschek 1966; Sparkes 1967, 122–3 (on Teisias the thenian); Maffre 1975, 415–25; Kilinski 1982, 272.

30. For the Attic evidence, see Beazley 1956, 1963 and 1971, and Carpenter 989. See also Boardman 1974 and 1975a. For Xenophantos, see Beazley 1963, 407; 1971, 488. For Nikias, see Beazley 1963, 1333, no. 1; 1971, 480 and arpenter 1989, 365. For Amasis, see von Bothmer 1981a and 1985, 37–9 and oardman 1987b. For Kleophrades, see von Bothmer 1981a and 1985, 230–1; oardman 1988d, no. 172. For the two makers of one kylix (Glaukytes and rchicles, and Anakles and Nikosthenes), see Beazley 1944 (now in Kurtz 1989), 08–9, and for the Nearchos and Ergotimos families, see Boardman 1988a.

31. Frel 1973, fig. 4.

32. Bakchios: Beazley 1956, 413, nos. 1 and 2; 1986, pl. 99, 6; Carpenter 1989, 07; Kittos: Beazley 1951, pl. 46, 4 and 47, 1; 1956, 413; 1986, pl. 100, 3–4; arpenter 1989, 107.

33. Athens EM 161: Kern 1913, pl. 27, 5; Kirchner 1940, 6320; Peek 1955, 97.

34. Keil 1913, 232 and 239; Preuner 1920, 70–1; Engelmann 1980, no. 1420.

35. Beazley 1943, 456–7; 1951, 97; Robertson 1985, 21–2.

36. Richter 1941, 388; Vickers 1985c, 127, n. 177.

37. For the phormiskos, see Touchefeu-Meynier 1972; for reeded baskets, see rann 1962, 14–15 and 62; for wood, see Rieth 1940; Brann 1962, 14; Boardman 987a, 289–90. Nuts and shells: Beazley 1940–5; Greifenhagen 1982.

38. Alabastron: Beazley 1938, 4; Boardman 1980, 142–3 and 152–3; oardman 1984a, no. 301; Vickers 1985c, 112, n. 34; Robertson 1985, 23.

39. The relationship between clay and metal vases has recently become a subject or lively discussion. See especially the work of Vickers 1983; 1984; 1985c; 1986, 37–51; Vickers, Impey and Allan 1986, pls. 1–30; Gill 1986a, 9–30, and 1988a; ill and Vickers 1989 and 1990. For contrary views, see Robertson 1985, 20–3; ook 1987b; Boardman 1987a.

40. Persian rhyton: Hoffmann 1962, 1967 and 1989; phiale: von Bothmer 1962; oardman 1968; Freyer-Schauenburg 1986; Boardman 1987a, 289; lydion: oardman 1980, 99, figs. 114–16; 1984a, no. 300. See also Boardman 1967, 69ff. and Shefton 1989.

41. Jackson 1976, 38; Rasmussen 1979, 68ff., 110–16, and 1985; Kurtz and oardman 1986, 35–7.

42. Transport amphorae: Grace 1979; Empereur and Garlan 1986; cf. Peacoↄ and Williams 1986. Pithoi, etc.: Courby 1922, 40–108; Schäfer 1957; Sparkes aₙ Talcott 1970, 36–7. Cf. Weinberg 1954.

43. Coarse wares: Amyx 1958; Sparkes 1962 and 1965; Sparkes and Talcc 1970, 33–6; Riley 1979; Scheffer 1981; Jones 1986, 724–7.

44. Household wares: Sparkes and Talcott 1970, 34.

45. Many books on Greek pottery are concerned with or have a section ↄ shapes and list the functions under each name, e.g. Richter and Milne 1935; Noↆ 1966 (rev. ed. 1988), 11–28; Cook 1972, ch. 8; Boardman 1974, 1975a aₙ 1989a; Schiering 1983, 139–59; Kanowski 1984. In this chapter functions a dealt with first, followed by a partial list of modern and conventional names wⁱ some outline drawings. For a small book on usage, see Sparkes and Talcott 19.̃ and cf. Thompson 1971. For an attempt to formalise the study of shapes, sↄ Gardin 1976.

46. Public pots: Lang 1960; Lang and Crosby 1964, 1–68; Thompson aₙ Wycherley 1972, 44–5, 55; Lang 1976, 51–2. For the hydria as voting urn, s von Bothmer 1974, 15.

47. For the aryballos, see Beazley 1927–8 and Haspels 1927–8.

48. Panathenaics: Beazley 1951 (rev. ed. 1986), ch. 8; Frel 1973; Boardmₐ 1974, ch. 7. For the total, see Johnston 1987a. A warning has recently been givↄ against using the surviving inscribed Panathenaics to gauge the total output f other vases, see Arafat and Morgan 1989, 326–7. The vases without an inscriptiↄ were not given as prizes; they were replicas. The shape was borrowed for red-figuↄ painting in Attic and south Italian potteries.

49. Traveller's mug: Mallwitz and Schiering 1964, 169–82; pilgrim flasↄ Mingazzini 1967.

50. Metalworkers and shoemakers: Ziomecki 1975; oil-sellers: Boardmₐ 1976b; vintage: Sparkes 1976; bee-keeping: Jones, Graham and Sackett 197 397–414 with Appendix I (by Geroulanos) and II (by Jones). On rural finds, s now Snodgrass 1990.

51. Most books on Greek pottery show examples of drinking cups, bowls aₙ jugs, and the scenes with the objects in use were very popular subjects for va decoration. See now particularly Vickers 1978 and Lissarrague 1987. As is to ▮ expected at a party, some cups were meant to amuse the guests with trick stems thↄ leak and rattle, with sexual organs in place of feet and with bowls in the shape breasts. The figured scenes also show the nature of the entertainment; sↄ Lissarrague 1987, 49–59. For symposia in a wider context, see Murray 1990. Fↄ moulded cups, see Richter 1967, Kahil 1972 and Guy 1981. For 'Megarian' bowↆ see pp. 109–10.

52. For fish-plates, see McPhee and Trendall 1987 and 1990. Two small useↆ books on lamps: Perlzweig 1963 and Bailey 1963. For chamber pots, see Sparkↄ and Talcott 1970, 8, 65 and 231; Sparkes 1975, 128; Knauer 1985.

53. Kitchen pots: Sparkes 1962 and 1965; Sparkes and Talcott 1970, 187–23 Sparkes 1981; Scheffer 1981. See also Morris 1985 and Grandjean 1985.

54. For dolls and such, see Thompson 1971; for spinning and weaving, Jenkiↄ 1986. For an Attic black-figure cup given as a prize for wool-working, see Milↄ 1945.

55. Oil and perfume containers: Haspels 1936; Hellström 1965, 23–8; oardman 1976b; for the residue in pots found today, see Jones 1986, 839–47. For ioulded perfume-pots, see Higgins 1959; Trumpf-Lyritzaki 1969; Amyx 1988, 12–33. For unguentaria, see Anderson-Stojanovic 1987.

56. Athens NM 12271: Haspels 1936, 124–30. Other names inscribed on vases re for nard and cinnamon.

57. Exaleiptron: Scheibler 1964 and 1968.

58. Weddings: Fink 1974; Roberts 1978.

59. Funerals and funerary vases: Kurtz and Boardman 1971; Vermeule 1979; urtz 1984; Garland 1985. Clay sarcophagi: Cook 1981. On the change from ietal to clay offerings, see Hoffmann 1988, 151–3.

60. Festivals: Parke 1977; Simon 1983. Anthesteria: van Hoorn 1951; Artemis stival: Kahil 1977; Adonis festival: Weill 1966; Servais-Soyez 1981. Vases from ie Athenian Acropolis: Graef and Langlotz 1925 and 1933.

61. Bron and Lissarrague 1984, 8 and see all their chapter I; Lissarrague 1987, 6.

62. Beazley 1974, 6.

63. Aesthetics: Sichtermann 1963; Lane 1971; Schiering 1983.

V Decoration

1. For the rare addition of decoration, see n. 22 below.

2. Decorated pithoi: Courby 1922, 33–114; Schäfer 1957; Ervin 1963; Caskey 976. Cf. Weinberg 1954. For some with polychrome paint, see n. 21. For freehand ots, see Kourou 1987 and 1988.

3. Protogeometric and Geometric: Desborough 1952; Coldstream 1968; chweitzer 1971; Murray 1975. For early Boeotian see Ruckert 1976.

4. Protocorinthian and Corinthian (seventh and sixth centuries): Payne 1931 and 933; Amyx 1988. For incision on bronzes, see Boardman 1980, 69–71.

5. Black-figure (non-Attic): Lane 1933–34, Stibbe 1972, Pipili 1987 (Laconian); parkes 1967 (Boeotian); Boardman 1952, von Bothmer 1969, Ure 1973 :uboean); Beazley 1947, Spivey 1987, Martelli 1987 (Etruscan).

6. Protoattic (= seventh-century Athenian): Cook 1934–5; Morris 1984 (she iggests that the island of Aegina was a production centre); Osborne 1989. Black-gure (Attic): Beazley 1928 (now in Kurtz 1989), 1951 (rev. ed. 1986), 1956; oardman 1974; Moore & Philippides 1986; Carpenter 1989, 1–148. Corinthian range-ground: Amyx 1988, 387–95.

7. Cabeiric: Wolters and Bruns 1940; Sparkes 1967, 125–7; Braun and iaevernick 1981, 1–74.

8. Red-figure (Attic): the bibliography is immense. Richter 1958; Beazley 1963 nd 1971; Boardman 1975a and 1989a; Carpenter 1989, 149–390. Beazley's ctures on some red-figure painters are now in Kurtz 1989.

9. For panel-painting, see n. 11 below. New theory: Vickers 1985c; Cook 987b; Boardman 1987a, 286–8.

10. For inventors, see e.g. von Bothmer 1966, 205 (the Andokides Painter); Villiams 1985, 36–7 (Nikosthenes and Psiax). Psiax worked in black-figure, red-gure, white-ground, Six techniques and coral red.

11. Panel-painters: Rumpf 1934, 1947, 1951; Robertson 1959, 121–35; 197 240–70; Schaus 1988; Stansbury-O'Donnell 1989.

12. For a recent appreciation of late fifth century vase-painting, see Burn 198 Kerch vases: Schefold 1930; Boardman 1989a, 190–4.

13. Boeotian red-figure: Lullies 1940; Ure 1958; Sparkes 1967, 123– Corinthian red-figure: Herbert 1977; McPhee 1983. Laconian red-figure: McPh 1986. Red-figure made in Chalcidice: McPhee 1981.

14. Sicilian and South Italian red-figure: Trendall 1967; Trendall a Cambitoglou 1978 and 1982; Mayo 1982; Trendall 1987 and 1989. Emigratio MacDonald 1981.

15. Etruscan and other red-figure: Beazley 1947; del Chiaro 1974; Marte 1987.

16. Attic white-figure: Haspels 1936, 106–7, 153–6; Haspels 1969; Boardm, 1974, 64, 178, 188; Kurtz 1975, 116–17. Etruscan: Beazley 1947, 178–9, 195, c xii; Trendall 1987, 364.

17. Early white-ground: Coldstream 1968, 168, etc.; Williams 1982, 24, n. 2 Boardman 1986 (some Chiot possibly made at Naukratis).

18. White-ground (Attic): Beazley 1938 (now in Kurtz 1989); Mertens 197 Kurtz 1975; Mertens 1977; Wehgartner 1983; Boardman 1989a, ch. 4. Invento of Attic white-ground have been suggested: von Bothmer 1966, 207 and Merte 1974, 91 (the Andokides Painter); Williams 1982, 25–7 and 1985, 34– (Nikosthenes); Wehgartner 1983 (Nikosthenes). Nikosthenes' two signed oinocho are considered to be the very earliest Attic white-ground. White-ground cup Mertens 1974; Burn 1985.

19. 'Hadra' hydriai: see Chapter III, n. 82. Lagynoi: Leroux 1913.

20. Payne 1931, 100; Beazley 1951 (rev. ed. 1986) 19; Robertson 1959, 5 Williams 1983a, 33; Schaus 1988. Examples of early non-vase painting are e.g. t Thermon metopes of the seventh century: Payne 1925–6; the Isthmia wa paintings of the seventh century: Broneer 1971, 33–4, pls. A–C; the wooden Pit plaques of the sixth century: Boardman 1984a, no. 323; the wooden Saqqa plaque, ca. 500 B.C.: Boardman 1984a, no. 299; Lycian tomb paintings, ca. 5 B.C.: Mellink 1973.

21. Polychrome: Payne 1927–8 (Cretan pithoi); Payne 1933, 18–21, 94–7 a Amyx 1988, 539–40 (Protocorinthian and Corinthian); Boardman 1968 (Chio Hemelrijk 1984, 65 (Caeretan). General: Boardman 1986, 252; Schaus 198 107–8.

22. St Valentin: Howard and Johnson 1954. Coarse ware: Crosby 1955. Reli Zervoudaki 1968.

23. The Lentini Group (Sicilian): Trendall 1967, 583–92; 1989, 235–8.

24. 'Hadra' hydriai: see Chapter III, n. 82. The Lipari Group: Bernabò Brea a Cavalier 1986; Trendall 1989, 239–42. Canosa: Williams 1985, 69. Centurip Wintermeyer 1975.

25. Coral red: Farnsworth and Wisely 1958; Winter 1968; Sparkes and Talc 1970, 19–20; Cohen 1970–1. The intentional red should not be confused with t accidental and random red which many vases fire. The Exekias cup is Muni 2044: Beazley 1956, 146, no. 21; Carpenter 1989, 41. The early fifth-centu volute-krater is in the J. Paul Getty Museum in Malibu, 84.AE. 974: Walsh 198

70, no. 24; Noble 1988, colour plate VII. For Sotades and the technique, see Burn 985, 100–2.

26. Black gloss: Sparkes and Talcott 1970, 9–31, 47–186, 236–336 (Attic); Morel 1980 and 1981 ('Campanian'). For a good recent catalogue of the rich ariety of black, see Hayes 1984.

27. Attic fourth century: Köpcke 1964. West Slope: Thompson 1934 (new ed. 987) 438–47; Rotroff 1991. Gnathia: Forti 1965; Green 1976; Morel 1980, 9–91. Etruscan: Pianu 1982.

28. Attic red-figure cups with incision and with stamping: Ure 1936 and 1944. n example of a white-ground oinochoe with stamping is London BM D 14: eazley 1963, 1213, no. 2; Carpenter 1989, 347. Figured stamps: Sparkes 1968.

29. Non-Attic incising and stamping: Morel 1980; 1981, 46–50; Hayes 1984, 7 (Herakles); Jentel 1968, 19ff.; Morel 1980, 91 and Boardman 1987a, 284 Arethusa heads). Fourth-century kraters, etc.: Köpcke 1964. Silvering on south talian black: Boardman 1987a, 284–5.

30. Appliqué: Courby 1922, 123ff; Köpcke 1964; Zervoudaki 1968; Trumpf-yritzaki 1969. Plakettenvasen: Thompson 1934 (new ed. 1987), 423–6; Andreassi 979; Hayes 1984, 89; Dohrn 1985. Askoi and gutti: Jentel 1976.

31. Moulded vases: Higgins 1959; Tuchelt 1962 and Ducat 1966 (plastic); Hoffmann 1962, 1967 and 1989, Guy 1981 (rhyta); Beazley 1929 and Biers 1983 head vases). See also Kahil 1972 and Chapter IV p. 76.

32. Phialai: Richter 1941 and Boardman 1987a, 284–5. 'Megarian' bowls: Courby 1922, 227–447; Hausmann 1959; Rotroff 1982 (new chronology).

33. For a useful resumé on inscriptions, see Cook 1972, ch. 10. On Corinthian ase inscriptions, see Amyx 1988, 547–615 and for Attic, Immerwahr 1990. For raffiti, see Chapter VI.

34. Naxian fragment: Daux 1961, 851, fig. 3.

35. Corinthian: Lorber 1979, 109–10; Amyx 1988, 201, 255–6. Attic: Beazley 956 and Boardman 1974 (black-figure) and Beazley 1963 and Boardman 1975a nd 1989a (red-figure). See also Carpenter 1989.

36. Paestan: Trendall 1987, chs. v and vii. The Lasimos signature on an Apulian olute-krater in the Louvre (K 66) is a modern addition, see Trendall and Cambitoglou 1982, 913. Hadra: Berlin inv. 3767: Guerrini 1964, 10ff., pl. 1 A 1; Cook 1968–9, 127ff.; Callaghan 1984, 791.

37. Letterers: Immerwahr 1984 and 1990. Occasionally the letters of an nscription are reserved with the black adjusted around them, see Robertson 1981b, 3–4 and Vickers 1985c, 118, n. 98.

38. For the names, see Beazley 1956 and 1963; Boardman 1974 and 1975a; Carpenter 1989, 400–6. For Timonidas, see Amyx 1988, 563–4. For Lydos the lave (not the same as the more famous Lydos), see Canciani 1978. Vickers 1985c, 26–8, has recently advanced the unorthodox view that the 'egrapsen' man was the lesigner of a presumed metal original from which the pottery vase was copied, and he 'epoiesen' man was the original silversmith.

39. E.g. the François vase (Florence 4209: Beazley 1956, 76, no. 1; Carpenter 1989, 21) has words for 'seat', 'spring' and 'cauldron'. The Sophilos lebes (Athens NM 15499: Beazley 1956, 39, no. 16; Carpenter 1989, 10) has 'games for Patroklos'.

40. Leningrad inv. 615: Beazley 1963, 1594, no. 48; Carpenter 1989, 389.
41. Asopodoros' lekythos is Athens NM 15375: Beazley 1963, 447, no. 274
Carpenter 1989, 241. Chiot vases: Cook and Woodhead 1952; Boardman 196?
243–5; Williams 1983b; Lemos 1986; Boardman 1986.
42. Munich 2307: Beazley 1963, 26, no. 1; Carpenter 1989, 155–6. Thi
inscription, which was once seen as a challenge from the painter Euthymides to
rival's skill in painting, is now being understood to refer to the dancers on the vase
and it is these that Euphronios is said to be incapable of emulating. See Arafat an
Morgan 1989, 320.
43. Papyrus rolls: Immerwahr 1964, 1973 and 1990; March 1987, 61.
44. Kalos names: see Chapter III, nn. 74–5.
45. Panathenaics: see Chapter III, nn. 78–81.
46. Literacy, nonsense and poor spelling: Vickers 1985c, 127. Non-Attic centres
Corinth: Lorber 1979, Amyx 1988, 547–615; Laconia: Stibbe 1972. For
foreigner writing on a Laconian cup, see Schaus 1979 who suggests that th
Naukratis Painter (if he was the letterer of his own paintings) may have been fron
Cyrene and gone to work in Sparta. For literacy, see Havelock 1982 and 198€
Gentili 1988; Harris 1989.
47. Immerwahr 1984 and 1990.
48. Beazley and Payne 1929, 266–7.
49. Kurtz 1985a, 237–8. See also Kurtz 1983 and von Bothmer 1987. Th
Beazley Archive in the Ashmolean Museum, Oxford keeps track of nev
publications of Beazley's attributions and of new attributions by means c
computer.
50. Mention might be made here of books that have been devoted to individu.
painters. In the 1930s a series Bilder Griechischer Vasen dealt with such painters a
Exekias, the Berlin Painter, the Pan Painter, the Lewis Painter. Recently a nev
series, Kerameus, has begun on a much larger scale and includes the Affecte
(Mommsen 1975), the Swing Painter (Böhr 1982), the Antimenes Painter (Burov
1989), the Shuvalov Painter (Lezzi-Hafter 1982), the Eretria Painter (Lezzi-Hafte
1988) and the Phiale Painter (Oakley 1990). There are also Kerameus volumes o
Clazomenian Sarcophagi (Cook 1981) and the Caeretan Hydriai (Hemelrijk 1984
See also Bakir 1981 on Sophilos, Tiverios 1976 on Lydos, Karouzou 1956 and vo
Bothmer 1985 on the Amasis Painter, Burn 1987 on the Meidias Painter, Schmic
1960 on the Apulian Darius Painter.
51. Athens and Corinth: Herbert 1977, 48, Amyx 1988, 679–81; East Greec
and the West: e.g. Boardman 1980, 202–6; Corinth, Athens and Boeotia
Kleinbauer 1964, Sparkes 1967, 119–20, Amyx 1988, 678–82; Athens, south Ital
and Sicily: MacDonald 1981, Trendall 1989, 17–18, 29, 158, 233.
52. For examples of modern names, see Beazley 1956 and 1963; Amyx 198€
Trendall 1989; Carpenter 1989.
53. For a critique of the present state, see Hoffmann 1979 and 1988; Vicke
1985c, 126–8; for a defence, see Robertson 1976; 1985.
54. See Jacobsthal 1927. For a basic general book of wide range, see Petrie 193
and for a simple book of Greek ornament, see Connell 1968.
55. Hemelrijk 1984, 88–115.

56. For an attempt to provide a systematic code for organising pattern, see
;ardin 1978. See also Salomé 1980.

57. Tondo compositions: van der Grinten 1966. See also von Bothmer 1972b
1ew ed. 1987) 3; Hurwit 1977.

58. Everyday life: see Chapter IV, nn. 45–60 for various aspects, and for the use
,hich can be made of vase-paintings for other aspects, see e.g. Snodgrass 1964
1rms and armour); Morrison and Williams 1968 and Morrison and Coates 1986
)ared ships); Anderson 1961 (horsemanship); Harris 1964 and 1972 and
waddling 1980 (athletics and sports); Beck 1975 (education); Williams 1983c
women); Garland 1990 (daily life); Dover 1978 (homosexuality); Thompson 1984.

59. For the definitive lexicon of mythological compositions, see Kahil 1981–. For
series of well illustrated books of myth, see Schefold 1966; 1978; 1981; Schefold
1nd Jung 1988. Also helpful are the lists of mythological stories in art in Brommer
971–6; 1973; 1980; and Brommer's monographs on Herakles (1953 and 1984),
'heseus (1982) and Odysseus (1983). There are useful treatments and biblio-
raphies in Boardman 1974; 1975a; 1989a. A popular book is Henle 1973 and
ee now Carpenter 1991.

60. Orestes: Prag 1985.

61. Synoptic treatment: Snodgrass 1982; 1987, ch. 5.

62. Boulogne 558: Beazley 1956, 145, no. 18; 1971, 60; Carpenter 1989, 40.

63. Burn 1987, 67.

64. For a recent treatment of myths using vase-painting to elucidate texts, see
1arch 1987 and see also Carpenter 1991.

65. Carpenter 1986, xvi.

66. For structuralist/anthropological treatments of vase-painting, see Hoffmann
977 and 1979; Bérard 1983; Lissarrague and Thelamon 1983; Bérard 1984;
1offmann 1985–6; Lissarrague 1987; Hoffmann 1988.

67. Bérard 1984, 5.

68. Literature: Stewart 1983; March 1987. For the Kleophrades Painter's
loseness to literature, see Boardman 1976a.

69. Epic: Johansen 1967; Kannicht 1982; Cook 1983.

70. Theatre: Trendall and Webster 1971.

71. Persians: see Chapter III, n. 60. Politics: Boardman 1978b; 1984c; 1989b;
rancis 1990; anti: Cook 1987a; Arafat and Morgan 1989, 331–2. The example of
.egina: Arafat 1990, 77–89; Boreas: Chapter III, n. 63.

72. Schaus 1988.

73. Arafat 1990, 166–72.

74. See now Stansbury-O'Donnell 1989.

75. Persians: de Vries 1977, 546–8; Aeneas: Galinsky 1969; Arimaspians:
1etzger 1951, 327–32.

VI Out of the shop

'his chapter looks mainly at figured wares and hence is only a partial
icture. The wider picture of ceramics and trade needs much more space.

1. Nogara 1951; Noble 1966 (new ed. 1988) 207 and fig. 254; von Bothme 1972a, 9–11.

2. Lang 1976, 23–51. Pheidias' mug, found at Olympia: Mallwitz and Schieri 1964, 169–82; Heilmeyer 1981, 447–8. Melosa's cup, New York, Metropolita Museum 44. 11. 1: Milne 1945; Jeffery 1961 (new ed. 1990), pl. 53, 1; Coc 1987c, fig. 54. Public pots: Lang 1976, 51–2. For a booklet on graffiti, see Lar 1974.

3. Dipylon jug, Athens NM inv. 192, from the Athenian Kerameikos: Simon ar Hirmer 1981, pl. 11, below. Insults: Lang 1976, 11–15; Vermeule 1984, 302.

4. Gill 1986b.

5. Tare: Lang 1976, 64–8.

6. Abecedaria: Lang 1976, 6–7; Boardman 1984a, nos. 376–7 (Jeffery).

7. Messages and lists: Lang 1976, 8–11. Athens, Agora P 17824: Lang 197 fig. 18; Lang 1976, 8, B1, pl. 2. Names on sherds: Lang 1976, 16–21.

8. Johnston 1985a; cf. the 'shopping list', Athens, Agora P 10810: Sparkes ar Talcott 1958, fig. 23; Lang 1974, fig. 49; Lang 1976, 10, B12, pl. 2.

9. For ostraka, see Chapter III, n. 83. The words 'ostrakon/ostraka' are also use to denote pottery fragments that have lists, accounts, etc. written in ink on the surface; they are mainly found in Egypt and are Hellenistic in date.

10. Dipinti: Lang 1976, passim; Johnston 1979, 48.

11. Trademarks: Amyx 1958; Johnston 1974; and especially Johnston 1979.

12. Beazley 1967, 143 (poi); Johnston 1978, 224–5 (en).

13. Johnston 1973; 1978.

14. Naples 151600: Johnston 1978. It is also published in Scheibler 1983, 14 figs. 128–9.

15. See n. 11 for bibliography; cf. also Pritchett 1953 and 1956; Lang 1976.

16. Markle 1985, 293–7. See now Vickers 1990.

17. Johnston 1978, 223, n. 9 quotes modern potters who see 'no difficulty thinking in terms of a production (from clay to fired vessels) of at least a hundre small glazed bowls a day'.

18. The possible double-entendre in the scene makes the reference difficult interpret closely, see Anderson 1981.

19. Amyx 1958, 178–86.

20. Amyx 1958, 279.

21. Johnston 1974, 149; cf. Boardman 1988b, 30.

22. Glotz 1926; Hopper 1979; Boardman 1980, 16–18 and passim; Garnse Hopkins and Whittaker 1983.

23. Timber: Meiggs 1982, ch. 12.

24. Stone: Snodgrass 1983b.

25. Transport amphorae: Grace 1979; Koehler 1979; 1981; 1986; Garlan 198 Empereur and Garlan 1986; Whitbread 1986a and b; Peacock and Williams 198 Trademarks are scratched on amphorae but do not connect with those found fine wares; they may have served the same purpose.

26. Attic/Chalcidian SOS amphorae for oil: Johnston and Jones 1978; Jon 1986, 706–12. cf. Boardman 1976b and Valavanis 1986.

27. For a useful brief listing of those ships carrying mixed cargoes, see G

987a, 83–5; 1987b, 123–4; 1988c, 178–9; 1988d, 4–6. See generally hrockmorton 1987.

28. Recent polemic: Boardman 1988b; Gill 1988a and b; Boardman 1988c; Gill 988c and d; McGrail 1989. For pottery and economics, see also Vallet and Villard 963; Morel 1983; Scheffer 1988; Hannestad 1988; Arafat and Morgan 1989, 36–41. Some fine wares that could be sealed may have carried contents: perfume ь aryballoi and lekythoi, olives and figs in amphorae and pelikai. Coarse wares ere also traded, see de Paepe 1979; Riley 1984; Arafat and Morgan 1989, 336, ho point out that coarse wares were imported for immediate, practical reasons – ıey were better at their job than locally produced pots.

29. Wycherley 1957, nos. 656, 684; Thompson and Wycherley 1972, 170–3.

30. See Webster 1972, 61, 67, 99–101, 248. Oil- and perfume-sellers: Beazley 956, 393, no. 16; 396, nos. 22 & 25; Beazley 1963, 185, no. 30; 285, nos. 1–2; 96, no. 1; 604, no. 51; 1154, no. 38bis; Haspels 1936, 209, no. 81; Florence inv. 2732; Tarquinia RC 1663; Vatican 413. Wine-sellers: Beazley 1956, 299, no. 20; eazley 1963, 445, nos. 252; 1162, nos. 17 & 18; Altenburg 189; Athens Acr. 681 .; Athens Agora P 10408. Pottery-sellers and buyers: Beazley 1963, 24, no. 14; 56, no. 1; 540, no. 4; Beazley 1971, 216 (?).

31. Panathenaics have been found in graves, sanctuaries and domestic contexts. ɔr Panathenaics, see Chapter IV nn. 78–81.

32. Johnston 1974; 1979, 49.

33. Sostratos: Harvey 1976; Boardman 1980, 206; Snodgrass 1980a, 138; 1illar 1983, 95–6; Johnston 1987b, 134.

34. Chios-Naukratis: Boardman and Vaphopoulou-Richardson 1986.

35. For the Athenian pottery trade, see Boardman 1979, with charts showing the roportions of black-figure and red-figure, and proportions of red-figure shapes, om selected sites. See now Perreault 1986 (for export to the Near East) and Rosati 989 for computer analysis on the distribution of Attic pottery. White-ground ·kythoi found outside Attica indicate where Athenians were living and dying: see urtz 1975, 59, 141–3; Boardman 1980, 229; Williams 1982.

36. Kearsley 1989.

37. See Roebuck 1972; Salmon 1984, 103–16; Benson 1985; Amyx 1988, 94–484; Arafat and Morgan 1989, 337–9. Those states known in literature as ading states but with no recognisable local pottery production (e.g. Aegina and 1iletus) cannot yet be traced in the archaeological record.

38. Nessos Painter: Beazley 1956, 5, no. 3; Carpenter 1989, 2.

39. Kleitias: Beazley 1956, 76, no. 1 (from Chiusi, 'The François Vase'); 78, no. 3 (from Gordion); 78, no. 14 (from Naukratis); von Bothmer 1981b (from uxor).

40. The Painter of Acropolis 606: Beazley 1956, 81, no. 7 (from Theodosia).

41. Nikosthenes: Rasmussen 1985; cf. also the earlier Tyrrhenian ovoid neck-ımphorae. See Williams 1982, 26 for Nikosthenes' use of East Greek features. cf. 'hapter V, n. 75 for subject matter in vase decoration that was tailored to suit the references of particular customers.

42. Caeretan: Hemelrijk 1984.

43. The Sotades workshop: Beazley 1963, 764, no. 9 (from Paphos, Cyprus);

772, no. θ (from Meroe, Nubia) and Carpenter 1989, 287; Beazley 1963, 768, n
31 and 773, middle (Susa) and Carpenter 1989, 287; Beazley 1963, 765 no. 1
(Kerch); 767, no. 21 (Babylon); Beazley 1971, 416, iota (Egypt) and Carpent
1989, 287; and see Kahil 1972.

44. Vix: Beazley 1956, 20, no. 14, and 1971, 86; Joffroy 1979, pls. 56–8, X
pp. 74–5, 137–9; Collis 1984, 97, fig. 24d.

45. Klein-Aspergle: Jacobsthal and Langsdorff 1929, pls. 33 & 34c; Beazl
1963, 831, no. 25, and 1971, 422; Collis 1984, 125, fig. 34j–k; Kimmig 1988.

46. Vergina: Andronikos 1984, 156, figs. 121–2.

47. Corinth: MacDonald 1982; Arafat and Morgan 1989, 338–9.

48. South Italy: Trendall 1989, ch. 1. Gnathia (see pp. 105–6) is exceptional i
that it wins orders in the eastern Mediterranean and beyond, and has been found
north Africa, Egypt, the Greek islands, Cyprus and the Black Sea region. See Gre
1979.

49. See Shefton 1982 and Boardman 1989a, 235–6.

BIBLIOGRAPHY

Adriani 1983 & 1984, *Alessandria e il mondo ellenistico-romano: studi in onore di Achille Adriani*, Rome, 1983 & 1984.

Aellen, Cambitoglou & Chamay 1986, Aellen, C., Cambitoglou, A. & Chamay, J., *Le Peintre de Darius et son milieu*, Geneva, 1986.

Amandry 1988, Amandry, P., 'A propos de monuments de Delphes', *BCH* 112 (1988) 591–610.

Amyx 1958, Amyx, D.A., 'The Attic Stelai III: vases and other containers', *Hesperia* 27 (1958) 163–307.

Amyx 1988, Amyx, D.A., *Corinthian Vase-Painting of the Archaic Period*, Berkeley and Los Angeles, 1988.

Amyx & Lawrence 1975, Amyx, D.A. & Lawrence, P., *Archaic Corinthian Pottery & the Anaploga Well, Corinth VII.II*, Princeton, 1975.

Anderson 1961, Anderson, J.K., *Ancient Greek Horsemanship*, Berkeley & Los Angeles, 1961.

Anderson 1981, Anderson, G., 'ΛΗΚΥΘΙΟΝ and ΑΥΤΟΛΗΚΥΘΟΣ', *JHS* 101 (1981) 130–2.

Anderson-Stojanovic 1987, Anderson-Stojanovic, V.R., 'The chronology and function of ceramic unguentaria', *AJA* 91 (1987) 105–22.

Andreassi 1979, Andreassi, G., 'Una idria inedita con relievi e la fabbrica delle "Plakettenvasen"', in Trendall 1979, 21–9.

Andrewes 1982, Andrewes, A., 'The tyranny of Pisistratus' in Boardman & Hammond 1982, 392–416.

Andronikos 1984, Andronikos, M., *Vergina*, Athens, 1984.

Arafat 1990, Arafat, K., *Classical Zeus*, Oxford, 1990.

Arafat & Morgan 1989, Arafat, K. & Morgan, C., 'Pots and Potters in Athens and Corinth: a review', *OJA* 8 (1989) 311–46.

Arias, Hirmer & Shefton 1962, Arias, P.E., Hirmer, M. & Shefton, B.B., *A History of Greek Vase Painting*, London, 1962.

Arnold 1985, Arnold, D.E., *Ceramic Theory and Cultural Process*, Cambridge 1985.

Ashmole 1972, Ashmole, B., *Architect and Sculptor in Classical Greece*, London, 1972.

Ashmole, Yalouris & Frantz 1967, Ashmole, B., Yalouris, N. & Frantz, A., *Olympia, the Sculptures of the Temple of Zeus*, London, 1967.

Austin 1970, Austin, M.M., *Greece and Egypt in the Archaic Age*, PCPS Supplement 2 (1970).

Bailey 1963, Bailey, D.M., *Greek and Roman Pottery Lamps*, London, 1963.

Bakir 1981, Bakir, G., *Sophilos, ein Beitrag zu seinem Stil*, Mainz, 1981.

Bammer 1982, Bammer, A., 'Forschungen im Artemision von Ephesos von 1976 bis 1981', *Anat. Stud.* 32 (1982) 61–87.

Bammer 1984, Bammer, A., *Das Heiligtum der Artemis von Ephesos*, Graz, 1984.

Barker, Lloyd & Reynolds 1985, Barker, G., Lloyd, J. & Reynolds, J., *Cyrenaica in Antiquity*, BAR International Series 236 (1985).

Barrett & Vickers 1978, Barrett, A.A. & Vickers, M., 'The Oxford Brygos cup reconsidered', *JHS* 98 (1978) 17–24.

Barron 1972, Barron. J.P., 'New light on old walls: the murals of the Theseion', *JHS* 92 (1972) 20–45.

Beazley 1927–8, Beazley, J.D., 'Aryballos', *ABSA* 29 (1927–8), 187–215.

Beazley 1928, Beazley, J.D., 'Attic Black-figure: a sketch', *PBA* 14 (1928) 217–63.

Beazley 1929, Beazley, J.D., 'Charinos', *JHS* 49 (1929) 38–78.

Beazley 1938, Beazley, J.D., *Attic White Lekythoi*, Oxford, 1938.

Beazley 1940–5, Beazley, J.D., 'Miniature Panathenaics', *ABSA* 41 (1940–5) 10–21.

Beazley 1943, Beazley, J.D., 'Panathenaica', *AJA* 47 (1943) 441–65.

Beazley 1944, Beazley, J.D., 'Potter and painter in Ancient Athens', *PBA* 30 (1944) 87–125.

Beazley 1945, Beazley, J.D., 'The Brygos tomb at Capua', *AJA* 49 (1945) 153–8.

Beazley 1947, Beazley, J.D., *Etruscan Vase-Painting*, Oxford, 1947.

Beazley 1948, Beazley, J.D., 'Death of Hipparchos', *JHS* 68 (1948) 26–8.

Beazley 1951, Beazley, J.D., *The Development of Attic Black-figure*, Berkeley and Los Angeles, 1951 (rev. ed. by D. von Bothmer & Mary Moore, 1986).

Beazley 1956, Beazley, J.D., *Attic Black-Figure Vase-Painters*, Oxford, 1956.

Beazley 1963, Beazley, J.D., *Attic Red-Figure Vase-Painters*, Oxford, 1963.

Beazley 1967, Beazley, J.D., 'An oinochoe in Basle', *AK* 10 (1967) 142–3.

Beazley 1971, Beazley, J.D., *Paralipomena*, Oxford, 1971.

Beazley 1974, Beazley, J.D., *The Berlin Painter*, Mainz, 1974.

Beazley 1986, see Beazley 1951.

Beazley & Payne 1929, Beazley, J.D. & Payne, H.G.G., 'Attic black-figured fragments from Naukratis', *JHS* 49 (1929) 253–72.

Beck 1975, Beck, F.A.G., *Album of Greek Education*, Sydney, 1975.

Becker 1977, Becker, R.M., *Formen Attischer Peliken von der Pionier-Gruppe zum Beginn der Frühklassik*, Tübingen, 1977.

Bengtson 1970, Bengtson, H., *An Introduction to Ancient History*, Los Angeles & London, 1970.

Benson 1984, Benson, J.L., 'Where were the Corinthian workshops now represented in the Kerameikos of Corinth (750–400 B.C.)?' in Brijder 1984, 98–101.

orinthian pottery' in *Greek Vases II*, 17–20.

Bérard 1983, Bérard, C., 'Iconographie – Iconologie – Iconologique', *Etudes de ettres* 1983, Pt. 4, 5–37.

Bérard 1984, Bérard, C. et al., *La Cité des Images, Religion et Société en Grèce ntique*, Fernand Nathan – L.E.P., 1984 (English ed. *A City of Images, Iconography nd Society in Ancient Greece*, trans. D. Lyons, Princeton, 1989).

Bernabò Brea & Cavalier 1986, Bernabò Brea, L. & Cavalier, M., *Le ceramica olicroma liparese di età ellenistica*, Rome, 1986.

Betancourt 1984, Betancourt, P.P., *Eastern Cretan White-on-Dark Ware*, ennsylvania, 1984.

Betts, Hooker & Green 1988, Betts, J.H., Hooker, J.T. & Green, J.R., *Studies in Ionour of T.B.L. Webster II*, Bristol, 1988.

Bickermann 1980, Bickermann, E.J., *Chronology of the Ancient World*, London, 980.

Biers 1983, Biers, W.R., 'Some thoughts on the origins of the Attic head vase' in Moon 1983, 119–26.

Birmingham 1974, Birmingham, J., *Domestic Pottery in Greece and Turkey*, ydney,1974.

Blitzer 1984, Blitzer, H., 'Traditional pottery production in Kentri, Crete: orkshops, materials, techniques and trade' in Betancourt 1984, 143–57.

Blitzer 1990, Blitzer, H., 'Storage jar production and trade in the traditional Mediterranean', *Hesperia* 59 (1990) 675–711.

Bloesch 1940, Bloesch, H., *Formen Attischer Schalen*, Bern, 1940.

Bloesch 1951, Bloesch, H., 'Stout and Slender in the Late Archaic Period', *JHS* 71 1951) 29–39.

Boardman 1952, Boardman, J., 'Pottery from Eretria', *ABSA* 47 (1952) 1–48.

Boardman 1956, Boardman, J., 'Some Attic fragments: pot, plaque and lithyramb', *JHS* 76 (1956) 18–25.

Boardman 1960, Boardman, J., 'The multiple brush', *Antiquity* 34 (1960) 85–9.

Boardman 1965, Boardman, J., 'Tarsus, Al Mina and Greek chronology', *JHS* 85 1965) 5–15.

Boardman 1966, Boardman, J., 'Evidence for the dating of Greek settlements in Cyrenaica', *ABSA* 61 (1966) 150–2.

Boardman 1967, Boardman, J., *Excavations in Chios 1952–1955: Greek Emporio*, ABSA Supplementary Vol. 6 (1967).

Boardman 1968, Boardman, J., 'A Chian phiale mesomphalos from Marion', Report of the Department of Ancient Cyprus 1968, 12–15.

Boardman 1972, Boardman, J., 'Herakles, Peisistratos and sons', *RA* 1972, 7–72.

Boardman 1974, Boardman, J., *Athenian Black Figure Vases*, London, 1974.

Boardman 1975a, Boardman, J., *Athenian Red Figure Vases, the Archaic Period*, London, 1975.

Boardman 1975b, Boardman, J., 'Herakles, Peisistratos and Eleusis', *JHS* 95 1975) 1–12.

Boardman 1976a, Boardman, J., 'The Kleophrades Painter at Troy', *AK* 19 1976) 3–18.

Boardman 1976b, Boardman, J., 'The olive in the Mediterranean: its culture and se', *Phil. Trans. R. Soc. Lond.* 275 (1976) 187–96.

Boardman 1978a, Boardman, J., *Greek Sculpture, the Archaic Period*, Londo 1978.

Boardman 1978b, Boardman, J., 'Exekias', *AJA* 82 (1978) 11–25.

Boardman 1978c, Boardman, J., 'Herakles, Delphi and Kleisthenes of Sikyo *RA* 1978, 227–34.

Boardman 1979, Boardman, J., 'The Athenian Pottery Trade', *Expedition* 197 33–40.

Boardman 1980, Boardman, J., *Greeks Overseas* (3rd ed.), London, 1980.

Boardman 1982, Boardman, J., 'Herakles, Theseus and Amazons' in Kurtz Sparkes 1982, 1–28.

Boardman 1983, Boardman, J., 'Symbol and story in Geometric art' in Moc 1983, 15–36.

Boardman 1984a, Boardman, J. (ed.), *The Cambridge Ancient History, Plates Volume III*, Cambridge, 1984.

Boardman 1984b, Boardman, J., 'Signa tabulae priscae artis', *JHS* 104 (198 161–3.

Boardman 1984c, Boardman, J., 'Image and politics in sixth century Athens' Brijder 1984, 239–47.

Boardman 1985, Boardman, J., *Greek Sculpture, the Classical Period*, Londo 1985.

Boardman 1986, Boardman, J., 'Archaic Chian pottery in Naukratis' Boardman & Vaphopoulou-Richardson 1986, 251–8.

Boardman 1987a, Boardman, J., 'Silver is white', *RA* 1987, 279–95.

Boardman 1987b, Boardman, J., 'Amasis: the implications of his name' in Tr 1987, 141–52.

Boardman 1988a, Boardman, J., 'Dates and doubts', *AA* 1988, 423–5.

Boardman 1988b, Boardman, J., 'Trade in Greek decorated pottery', *OJA* (1988) 27–33.

Boardman 1988c, Boardman, J., 'The Trade Figures', *OJA* 7 (1988) 371–3.

Boardman 1988d, Boardman, J. (ed.), *The Cambridge Ancient History, Plates Vol. IV*, Cambridge, 1988.

Boardman 1989a, Boardman, J., *Athenian Red Figure Vases: the Classic Period*, London, 1989.

Boardman 1989b, Boardman, J., 'Herakles, Peisistratos and the Unconvinced *JHS* 109 (1989) 108–9.

Boardman, Edwards, Hammond & Sollberger 1982, Boardman, J., Edward I.E.S., Hammond, N.G.L. & Sollberger, E., *The Cambridge Ancient History III* (2nd ed.), Cambridge, 1982.

Boardman & Finn 1985, Boardman, J. & Finn, D., *The Parthenon and Sculptures*, London, 1985.

Boardman & Hammond 1982, Boardman, J. & Hammond, N.G.L., *T Cambridge Ancient History III.3* (2nd ed.), Cambridge, 1982.

Boardman, Hammond, Lewis & Ostwald 1988, Boardman, J., Hammon N.G.L., Lewis, D.M. & Ostwald, M., *The Cambridge Ancient History IV* (2nd ed Cambridge, 1988.

Boardman & Vaphopoulou-Richardson 1986, Boardman, J. & Vaphopoulo Richardson, C.E., *Chios, A Conference at the Homereion in Chios*, Oxford, 198

Boegehold 1965, Boegehold, A.L., 'An archaic Corinthian inscription', *AJA* 69 965) 259–62.

Böhr 1982, Böhr, E., *Der Schaukelmaler*, Kerameus 4, Mainz, 1982.

Borell 1978, Borell, B., *Attisch Geometrische Schalen, Eine spät-geometrische eramikgattung und ihre Beziehungen zum Orient*, Mainz, 1978.

von Bothmer 1957, von Bothmer, D., *Amazons in Greek Art*, Oxford, 1957.

von Bothmer 1962, von Bothmer, D., 'A gold libation bowl', *MMAB* 21 (1962) 54–66.

von Bothmer 1966, von Bothmer, D., 'Andokides the potter and the Andokides ainter', *MMAB* 25 (1966) 201–12.

von Bothmer 1969, von Bothmer, D., 'Euboean Black-figure in New York', *MMJ* (1969) 27–44.

von Bothmer 1972a, von Bothmer, D., 'The ancient repairs' in Moore & von othmer 1972, 9–11.

von Bothmer 1972b, von Bothmer, D., *Greek Vase Painting: an Introduction*, ew York, 1972 (new ed. 1987).

von Bothmer 1974, von Bothmer, D., 'Two bronze hydriai in Malibu', *Getty MJ* (1974) 15–22.

von Bothmer 1981a, von Bothmer, D., '"Αμασις, 'Αμάσιδος', *GettyMJ* 9 (1981) -4.

von Bothmer 1981b, von Bothmer, D., 'A new Kleitian fragment from Egypt', *AK* 4 (1981) 66–7.

von Bothmer 1985, von Bothmer, D., *The Amasis Painter and his World*, Malibu & London, 1985.

von Bothmer 1987, von Bothmer, D., 'Greek Vase-Painting: two hundred years f connoisseurship' in True 1987, 184–204.

Bovon 1963, Bovon, A., 'La représentation des guerriers perses et la notion de arbare dans la 1re moitié de Ve siècle', *BCH* 87 (1963) 579–602.

Brandt 1978, Brandt, J.R., 'Archaeologica Panathenaica I: Panathenaic prize mphorae from the sixth century B.C.', *Acta ad archaeologiam et artium historiam ertinentia, Institutum Romanum Norvegiae et Oslo, Universitätsforl* 8 (1978) -23.

Brann 1962, Brann, E.T.H., *Late Geometric and Protoattic Pottery, the Athenian gora VIII*, Princeton, 1962.

Braun 1982, Braun, T.F.R.G., 'The Greeks in Egypt' in Boardman & Hammond 982, 32–56.

Braun & Haevernick 1981, Braun, K. & Haevernick. Th. E., *Bemalte Keramik nd Glas aus dem Kabirenheiligtum bei Theben, Das Heiligtum bei Theben IV*, erlin, 1981.

Brijder 1983, Brijder, H.A.G., *Siana Cups I and Komast Cups, Allard Pierson eries 4*, Amsterdam, 1983.

Brijder 1984, Brijder, H.A.G. (ed.), *Ancient Greek and Related Pottery, roceedings of the International Vase Symposium in Amsterdam, 12–15 April 984, Allard Pierson Series 5*, Amsterdam, 1984.

Brijder, Drukker & Neeft 1986, Brijder, H.A.G., Drukker, A.A. & Neeft, C.W., nthousiasmos: essays on Greek and related pottery presented to J.M. Hemelrijk, msterdam, 1986.

Brommer 1953, Brommer, F., *Herakles, die zwölf Taten des Helden in antik* *Kunst und Literatur*, Münster-Köln, 1953 (4th ed. 1979, Eng. ed. 1980).
Brommer 1963, Brommer, F., *Die Skulpturen der Parthenon-Giebel*, Mair 1963.
Brommer 1967, Brommer, F., *Die Metopen des Parthenon*, Mainz, 1967.
Brommer 1971–6, Brommer, F., *Denkmälerlisten zur griechischen Heldensa I-IV*, Marburg, 1971–6.
Brommer 1973, Brommer, F., *Vasenlisten zur griechischen Heldensage* (3rd ed Marburg, 1973.
Brommer 1977, Brommer, F., *Der Parthenonfries*, Mainz, 1977.
Brommer 1979, Brommer, F., *The Sculptures of the Parthenon*, Londc 1979.
Brommer 1980, Brommer F., *Göttersagen in Vasenlisten*, Marburg, 1980.
Brommer 1982, Brommer, F., *Theseus, die Taten des griechischen Helden in a antiken Kunst und Literatur*, Darmstadt, 1982.
Brommer 1983, Brommer, F., *Odysseus, die Taten und Leiden des Helden antiker Kunst und Literatur*, Darmstadt, 1983.
Brommer 1984, Brommer, F., *Herakles II, die unkanonischen Taten des Helde* Darmstadt, 1984.
Bron & Lissarrague 1984, Bron, C. & Lissarrague, F., 'Le vase à voir' in Béra 1984, 7–17.
Broneer 1971, Broneer, O., *Temple of Poseidon, Isthmia I*, Princeton, 1971.
Brouskari 1974, Brouskari, M.S., *The Acropolis Museum: a descript catalogue*, Athens, 1974.
Bruneau & Ducat 1983, Bruneau, P. & Ducat, J., *Guide de Délos* (2nd ec Paris, 1983.
Brunnsåker 1971, Brunnsåker, S., *The Tyrantslayers of Kritios and Nesiotes* (2 ed.), Stockholm, 1971.
Buchner 1971, Buchner, G., 'Recent work at Pithekoussai (Ischia) 1965–71', A 1970–1, 63–7.
Burford 1963, Burford, A., 'The builders of the Parthenon' in *Parthenos a Parthenon, Supplement to Greece and Rome* 10 (1963), 23–35.
Burford 1972, Burford, A., *Craftsmen in Greek and Roman Society*, Londc 1972.
Burn 1983, Burn, A.R., 'CAH III', *CR* 33 (1983) 249–55.
Burn 1985, Burn, L., 'Honey pots: three white-ground cups by the Sotac Painter', *AK* 28 (1985) 93–105.
Burn 1987, Burn, L., *The Meidias Painter*, Oxford, 1987.
Burow 1989, Burow, J., *Der Antimenesmaler*, Kerameus 7, Mainz, 1989.
Callaghan 1980, Callaghan, P.J., 'The trefoil style and second-century Had vases', *ABSA* 75 (1980) 33–47.
Callaghan 1984, Callaghan, P.J., 'Knossian artists and Ptolemaic Alexandria' Adriani 1983 & 1984, 789–94.
Callaghan & Jones 1985, Callaghan, P.J. & Jones, R.E., 'Hadra hydriae a central Crete: a fabric analysis', *ABSA* 80 (1985) 1–17.
Callipolitis-Feytmans 1974, Callipolitis-Feytmans, D., *Les Plats attiques à figu noires*, Paris, 1974.

Cameron & Kuhrt 1983, Cameron, A. & Kuhrt, A., *Images of Women in antiquity*, London, 1983.

Canciani 1978, Canciani, F., 'Lydos, der Sklave', *AK* 21 (1978) 17–22.

Carpenter 1984, Carpenter, T.H., *Summary Guide to CVA*, Oxford, 1984.

Carpenter 1986, Carpenter, T.H., *Dionysian Imagery in Archaic Greek Art*, Oxford, 1986.

Carpenter 1989, Carpenter, T.H., *Beazley Addenda* (2nd ed.), Oxford, 1989.

Carpenter 1991, Carpenter, T.H., *Art and Myth in Ancient Greece*, London, 991.

Carter 1972, Carter, J., 'The beginnings of narrative art in the Greek Geometric eriod', *ABSA* 67 (1972) 25–58.

Cartledge & Harvey 1985, Cartledge, P. & Harvey, F.D., *Crux, essays presented* ɔ *G.E.M. de Ste. Croix on his 75th birthday*, Exeter, 1985.

Caskey 1922, Caskey, L.D., *Geometry of Greek Vases*, Boston, 1922.

Caskey 1976, Caskey, M.E., 'Notes on relief pithoi of the Tenian-Boeotian ɤoup', *AJA* 80 (1976) 19–41.

Caskey & Beazley 1954, Caskey, L.D. & Beazley, J.D., *Attic Vase-Paintings in ɔe Museum of Fine Arts, Boston, II*, Oxford, 1954.

Casson 1938, Casson, S., 'The modern pottery trade in the Aegean', *Antiquity* 12 1938) 464–73.

Chamoux 1953, Chamoux, F., *Cyrène sous la monarchie des Battiades*, Paris, 953.

Chamoux 1985, Chamoux, F., 'Du silphion' in Barker, Lloyd & Reynolds 1985, 65–72.

del Chiaro 1974, del Chiaro, M.A., *Etruscan Red-figured Vase-painting at Caere*, erkeley, 1974.

Christiansen and Melander 1988, Christiansen, J. and Melander, T., *Ancient ʃreek and Related Pottery, Proceedings of the 3rd Symposium, Copenhagen ιugust 31-September 4 1987*, Copenhagen, 1988.

Cleere 1989, Cleere, H. (ed.), *Archaeological Heritage Management in the Modern Vorld*, London, 1989.

Cohen 1970–1, Cohen, B., 'Observations on coral-red', *Marsyas* 15 (1970–1) –12.

Coldstream 1964, Coldstream, J.N., 'Motya, a Phoenician–Punic site near ⁄Iarsala, Sicily', *The Annual of the Leeds University Oriental Society* 4 (1962–3) 4–131.

Coldstream 1968, Coldstream, J.N., *Greek Geometric Pottery*, London, 1968.

Collis 1984, Collis, J., *The European Iron Age*, London, 1984.

Connell 1968, Connell, P., *Greek Ornament*, London, 1968.

Cook 1934–5, Cook, J.M., 'Protoattic pottery', *ABSA* 35 (1934–5) 165–219.

Cook 1948, Cook, R.M., 'Notes on the Homeric epigram to the potters', *CR* 62 ⁤948) 55–7.

Cook 1951, Cook, R.M., 'The Homeric epigram to the potters', *CR* 1 (1951) 9.

Cook 1954, Cook, R.M., *Corpus Vasorum Antiquorum Great Britain, London, ʃritish Museum 8 (13)*, London, 1954.

Cook 1955, Cook, R.M., 'Thucydides as Archaeologist', *ABSA* 50 (1955) 266– ⁰.

Cook 1959, Cook, R.M., 'Die Bedeutung der bemalten Keramik für de griechischen Handel', *JDAI* 74 (1959) 114–23.

Cook 1961, Cook, R.M., 'The "double stoking tunnel" of Greek kilns', *ABSA* 5 (1961) 64–7.

Cook 1966, Cook, B.F., 'Inscribed Hadra vases', *Metropolitan Museum of A Papers* 12, New York, 1966.

Cook 1968–9, Cook, B.F., 'A dated Hadra vase in the Brooklyn Museum', *Th Brooklyn Museum Annual* 10 (1968–9) 114–38.

Cook 1969, Cook, R.M., 'A note on the absolute chronology of eighth an seventh centuries B.C.', *ABSA* 64 (1969) 13–15.

Cook 1971, Cook, R.M., '"Epoiesen" on Greek vases', *JHS* 91 (197 137–8.

Cook 1972, Cook, R.M., *Greek Painted Pottery* (2nd ed.), London, 1972.

Cook 1981, Cook, R.M., *Clazomenian Sarcophagi*, Kerameus 3, Mainz, 1981.

Cook 1983, Cook, R.M., 'Art and epic in archaic Greece', *BABesch.* 58 (198 1–10.

Cook 1984a, Cook, R.M., 'The Calke Wood kiln' in Brijder 1984, 63–6.

Cook 1984b, Cook, B.F., 'Some groups of Hadra vases' in Adriani 1983 an 1984, 795–803.

Cook 1984c, Cook, B.F., *The Elgin Marbles*, London, 1984.

Cook 1987a, Cook, R.M., 'Pots and Pisistratan propaganda', *JHS* 107 (198 167–9.

Cook 1987b, Cook, R.M., 'Artful crafts: a commentary', *JHS* 107 (1987) 169 71.

Cook 1987c, Cook, B.F., *Greek Inscriptions*, London, 1987.

Cook 1989, Cook, R.M., 'The Francis–Vickers chronology', *JHS* 109 (198 164–70.

Cook & Woodhead 1952, Cook, R.M. & Woodhead, A.G., 'Painted inscriptio on Chiot pottery', *ABSA* 47 (1952) 159–70.

Corbett 1960, Corbett, P.E., 'The Burgon and Blacas Tombs', *JHS* 80 (196 52–8.

Corbett 1965, Corbett, P.E., 'Preliminary sketch in Greek vase-painting', *JHS* 8 (1965) 16–28.

Cordano 1986, Cordano, F., *Antiche Fondazioni Greche. Sicilia e Ital Meridionale*, Palermo, 1986.

de la Coste-Messelière 1957, de la Coste-Messelière, P., *Sculpture du Trésor d Athéniens, Fouilles de Delphes IV. iv*, Paris, 1957.

Courbin 1963, Courbin, P. (ed.), *Etudes archéologiques*, Paris, 1963.

Courby 1922, Courby, F., *Les Vases grecs à reliefs*, Paris, 1922.

Crawford 1983, Crawford, M. (ed.), *Sources for Ancient History*, Cambridg 1983.

Crawford & Whitehead 1983, Crawford, M. & Whitehead, D., *Archaic a Classical Greece*, Cambridge, 1983.

Crosby 1955, Crosby, M., 'Five comic scenes from Athens', *Hesperia* 24 (195 76–84.

Cuomo di Caprio 1984, Cuomo di Caprio, N., 'Pottery kilns on pinakes fro Corinth' in Brijder 1984, 72–82.

Cuomo di Caprio 1985, Cuomo di Caprio, N., *La ceramica in archeologia*, ɔme, 1985.

Daltrop 1980, Daltrop, G., *Il Gruppo Mironiano di Atena e Marsia nei Musei ɪticani*, Rome, 1980.

Daux 1961, Daux, G., 'Chronique des Fouilles 1960', *BCH* 85 (1961) 601–954.

Daux & Hansen 1987, Daux, G. & Hansen, E., *Le Trésor de Siphnos, Fouilles de elphes II*, Paris, 1987.

Davies 1969, Davies, M.I., 'The Oresteia before Aischylos', *BCH* 93 (1969) 14–60.

Desborough 1952, Desborough, V.R. d'A., *Protogeometric Pottery*, Oxford, ۱52.

Despinis 1970, Despinis, G., 'Discovery of the scattered fragments and congnition of the type of Agorakritos' statue of Nemesis', *AAA* 3 (1970) 407– ۱.

Despinis 1971, Despinis, G.I., Συμβολὴ στὴ μελέτη του ἔργου τοῦ ɪγορακρίτου, Athens, 1971.

Diehl 1964, Diehl, E., *Die Hydria: Formgeschichte und Werwendung im Kult des ltertums*, Mainz, 1964.

Dohrn 1985, Dohrn, T., 'Schwarzgefirnsste Plakettenvasen', *RM* 92 (1985) 77– ٥6.

Dover 1978, Dover, K.J., *Greek Homosexuality*, London, 1978.

Ducat 1966, Ducat, J., *Les Vases plastiques rhodiens archaiques en terre cuite*, ɪris, 1966.

Dugas 1952, Dugas, C., *Les Vases attiques à figures rouges. Dèlos XXI*, Paris, ۱52.

Edwards 1957, Edwards, G.R., 'Panathenaics of Hellenistic and Roman times', esperia 26 (1957) 320–49 & 383.

Edwards 1975, Edwards, G.R., *Corinthian Hellenistic Pottery, Corinth VII.iii*, ·inceton, 1975.

Eisman 1974, Eisman, M.M., 'A further note on ΕΠΟΙΕΣΕΝ signatures', *JHS* 94 974) 172.

Eiteljorg 1980, Eiteljorg, H., 'The fast wheel, the multiple brush compass and thens as home of the Protogeometric style', *AJA* 84 (1980) 445–52.

Empereur & Garlan 1986, Empereur, J.-Y. & Garlan, Y., *Recherches sur les nphores grecques, Athens Colloquium 1984, BCH* Supplément XIII, Paris, 1986.

Engelmann 1980, Engelmann, H., *Die Inschriften von Ephesos IV*, Bonn, 1980.

Enklaar 1985, Enklaar, A.H., 'Chronologie et peintres de hydries de Hadra', *ABesch.* 60 (1985) 106–51.

Enklaar 1986, Enklaar, A.H., 'Les hydries de Hadra II: formes et ateliers', *ABesch.* 61 (1986) 41–65.

Ervin 1963, Ervin, M., 'A relief pithos from Mykonos', *ADelt* 18 (1963) 37–75.

Eschbach 1986, Eschbach, N., *Statuen auf Panathenäischen Preisamphoren des 4 ·s v. Chr.*, Mainz, 1986.

Evely 1988, Evely, D., 'The potters' wheel in Minoan Crete', *ABSA* 83 (1988) ۱–126.

Farnsworth 1959, Farnsworth, M., 'Types of Greek glaze failure', *Archaeology 2* (1959) 242–50.

Farnsworth 1960, Farnsworth, M., 'Draw pieces as aids to correct firing', *AJA* (1960) 72–5.

Farnsworth & Wisely 1958, Farnsworth, M. & Wisely, H., 'Fifth centu intentional red glaze', *AJA* 62 (1958) 165–73.

Fink 1974, Fink, F.F., *Hochzeitsszenen auf attischen schwarzfigurigen u rotfigurigen Vasen*, Diss., Vienna, 1974.

Forti 1965, Forti, L., *La ceramica di Gnathia*, Naples, 1965.

Francis 1990, Francis, E.D., *Image and Idea in fifth century Greece: art a literature after the Persian Wars*, London, 1990.

Francis & Vickers 1981, Francis, E.D. & Vickers, M., 'Leagros kalos', *PCPS 2 (1981) 97–136.

Francis & Vickers 1983, Francis, E.D. & Vickers, M., 'Signa priscae artis: Eret and Siphnos', *JHS* 103 (1983) 49–67.

Francis & Vickers 1985, Francis, E.D. & Vickers, M.J., 'Greek Geometric potte at Hama and its implications for Near Eastern chronology', *Levant* 17 (198 131–8.

Francis & Vickers 1988, Francis, E.D. & Vickers, M.J., 'The Agora revisite Athenian chronology c. 500–450 B.C.', *ABSA* 83 (1988) 143–67.

Fraser 1972, Fraser, P.M., *Ptolemaic Alexandria*, Oxford, 1972.

Frel 1973, Frel, J., *Panathenaic Prize Amphoras*, Athens, 1973.

Freyer-Schauenburg 1986, Freyer-Schauenburg, B., 'Eine attisch rotfigurige Phi in Kiel' in Schauenburg 1986, 115–20.

Fuchs 1979, Fuchs, W., *Die Skulptur der Griechen* (2nd ed.), Munich, 1979.

Galinsky 1969, Galinsky, G.K., *Aeneas, Sicily and Rome*, Princeton, 1969.

Gardin 1976, Gardin, J.C., *Code pour l'analyse des formes de poteries*, Par 1976.

Gardin 1978, Gardin, J.C., *Code pour l'analyse des ornaments*, Paris, 1978.

Garlan 1983, Garlan, Y., 'Le commerce des amphores grecques' in Garnsey a Whittaker 1983, 37–44.

Garland 1985, Garland, R., *The Greek Way of Death*, London, 1985.

Garland 1990, Garland, R., *The Greek Way of Life*, London, 1990.

Garnsey, Hopkins & Whittaker 1983, Garnsey, P.D., Hopkins, K. & Whittak C.R., *Trade in the Ancient Economy*, London, 1983.

Garnsey & Whittaker 1983, Garnsey, P.D. & Whittaker, C.R., *Trade a Famine in Classical Antiquity* (Cambridge Philological Society Suppl. Vol. Cambridge, 1983.

Gentili 1988, Gentili, B., *Poetry and its Public in Ancient Greece*, Baltimo 1988.

Gill 1986a, Gill, D.W.J., 'Classical Greek fictile imitations of precious me vases' in Vickers 1986, 9–30.

Gill 1986b, Gill, D.W.J., 'Two Herodotean dedications from Naukratis', *JHS 1 (1986) 184–7.

Gill 1987a, Gill, D.W.J., 'Metru. menece: an Etruscan painted inscription on mid 5th century B.C. red-figure cup from Populonia', *Antiquity* 61 (1987) 82–7

Gill 1987b, Gill, D.W.J., 'An Attic lamp in Reggio: the largest batch notati outside Athens', *OJA* 6 (1987) 121–5.

Gill 1988a, Gill, D.W.J., 'Expressions of wealth: Greek art and society', *ntiquity* 62 (1988) 735–43.

Gill 1988b, Gill, D.W.J., 'Trade in Greek decorated pottery: some corrections', *JA* 7 (1988) 369–70.

Gill 1988c, Gill, D.W.J., 'The distribution of Greek vases and long distance trade' in Christiansen and Melander 1988, 175–85.

Gill 1988d, Gill, D.W.J., 'Silver anchors and cargoes of oil: some observations on hoenician trade in the western Mediterranean', *PBSR* 43 (1988) 1–12.

Gill & Vickers 1989, Gill, D.W.J. & Vickers, M., 'Pots and kettles', *RA* 1989, 79–303.

Gill & Vickers 1990, Gill, D.W.J. & Vickers, M., 'Reflected glory: pottery and recious metal', *JDAI* 105 (1990) 1–30.

Giuliani 1977, Giuliani, L., 'Alexander in Ruvo, Eretria und Sidon', *AK* 20 (1977) 26–42.

Glotz 1926, Glotz, G., *Ancient Greece at Work*, London, 1926.

Gomme, Andrewes & Dover 1970, Gomme, A.W., Andrewes, A. & Dover, K.J., *Historical Commentary on Thucydides, Vol. IV*, Oxford, 1970.

Grace 1974, Grace, V.R., 'Revisions in early Hellenistic chronology', *AM* 89 (1974) 193–203.

Grace 1979, Grace, V.R., *Amphoras and the Ancient Wine Trade*, Princeton, 1979 (rev. ed.).

Grace 1985, Grace, V.R., 'The Middle Stoa dated by amphora stamps', *Hesperia* 54 (1985) 1–53.

Graef & Langlotz 1925, Graef, B. & Langlotz, E., *Die Antiken Vasen von der kropolis zu Athen I*, Berlin, 1925.

Graef & Langlotz 1933, Graef, B. & Langlotz, E., *Die Antiken Vasen von der kropolis zu Athen II & III*, Berlin, 1933.

Graham 1982, Graham, A.J., 'The colonial expansion of Greece' and 'The Vestern Greeks' in Boardman & Hammond 1982, 83–175.

Grandjean 1985, Grandjean, Y., 'Tuyères ou supports?', *BCH* 109 (1985) 265–9.

Green 1976, Green, J.R., *Gnathia Pottery in the Akademisches Kunstmuseum onn*, Mainz, 1976.

Green 1979, Green, J.R., 'Ears of corn and other offerings' in Trendall 1979, 1–90.

Green 1985, Green, J.R., 'A representation of the *Birds* of Aristophanes', *Greek ases* II (1985) 95–118.

Greenfield 1989, Greenfield, J., *The Return of Cultural Treasures*, Cambridge, 989.

Greifenhagen 1982, Greifenhagen, A., 'Eichellekythen', *RA* 1982, 151–62.

van der Grinten 1966, van der Grinten, E.F., *On the Composition of the ledallions in the Interior of Greek Black- and Red-figured Kylixes*, Amsterdam, 966.

Gude 1933, Gude, M., *A History of Olynthus*, Baltimore, 1933.

Guerrini 1964, Guerrini, L., *Vasi di Hadra: tentativo di sistemazione cronologica i una classe ceramica*, Rome, 1964.

Guy 1981, Guy, R., 'A ram's head rhyton signed by Charinos', *Arts in Virginia* 21 (1981) 2–15.

Hambidge 1920, Hambidge, J., *Dynamic Symmetry: the Greek Vase*, New Haven, 1920.

Hampe & Winter 1962, Hampe, R. & Winter, A., *Bei Töpfern und Töpferinnen in Kreta, Messenien und Zypern*, Mainz, 1962.

Hampe & Winter 1965, Hampe, R. & Winter, A., *Bei Töpfern und Zieglern südItalien, Sizilien und Griechenland*, Mainz, 1965.

Hannestad 1988, Hannestad, L., 'The Athenian potter and the home market' Christiansen and Melander 1988, 222–30.

Harris 1964, Harris, H.A., *Greek Athletes and Athletics*, London, 1964.

Harris 1972, Harris, H.A., *Sport in Greece and Rome*, London, 1972.

Harris 1989, Harris, W.V., *Ancient Literacy*, Harvard, 1989.

Harrison 1967, Harrison, E.B., 'Athena and Athens in the east pediment of the Parthenon', *AJA* 71 (1967) 27–58.

Harrison 1971, Harrison, E.B., 'The Victory of Kallimachos', *GRBS* 12 (197 5–24.

Harvey 1976, Harvey, F.D., 'Sostratos of Aegina', *La Parola del Passato* : (1976) 206–14.

Harvey 1984, Harvey, F.D., 'The Conspiracy of Agasias and Aeschines', *Klio* (1984) 58–73.

Haspels 1927–8, Haspels, C.H.E., 'How the aryballos was suspended', *ABSA* 2 (1927–8) 216–23.

Haspels 1936, Haspels, C.H.E., *Attic Black-figure Lekythoi*, Paris, 1936.

Haspels 1969, Haspels, C.H.E., 'A lekythos in Six's technique' *Muse* 3 (196 24–8.

Hausmann 1959, Hausmann, U., *Hellenistische Reliefbecher*, Kohlhamme 1959.

Havelock 1982, Havelock, E.A., *The Literate Revolution in Greece and Cultural Consequences*, Princeton, 1982.

Havelock 1986, Havelock, E.A., *The Muse Learns to Write*, Yale, 1986.

Hawkins 1982, Hawkins, J.D., 'The Neo-Hittite States in Syria and Anatolia' Boardman, Edwards, Hammond & Sollberger 1982, 372–441.

Hayes 1984, Hayes, J.W., *Greek and Italian Black Gloss Wares and Relate Wares in the Royal Ontario Museum*, Toronto, 1984.

Heilmeyer 1981, Heilmeyer, W.-D., 'Antike Werkstättenfunde in Griechenland AA 1981, 440–53.

Hellström 1965, Hellström, P., *Labraunda, Swedish Excavations and Research II, ii Pottery of Classical and Later Date, Terracotta Lamps and Glass*, Lund, 196.

Hemelrijk 1984, Hemelrijk, J.M., *Caeretan Hydriae*, Kerameus 5, Mainz, 1984

Henle 1973, Henle, J., *Greek Myths, A Vase Painter's Notebook*, Bloomingto 1973.

Herbert 1977, Herbert, S., *The Red-figured Pottery, Corinth VII. iv*, Princeto 1977.

Higgins 1959, Higgins, R.A., *Catalogue of the Terracottas in the Department Greek and Roman Antiquities, British Museum, Vol. II, Plastic Vases*, Londo 1959.

Hölscher 1973, Hölscher, T., *Griechische Historienbilder des 5. und 4. ahrhunderts v. Chr.*, Würzburg, 1973.

Hölscher 1974, Hölscher, T., 'Ein Kelchkrater mit Perserkampf', *AK* 17 (1974) ⁷8–85.

Hoffmann 1962, Hoffmann, H., *Attic Red-figured Rhyta*, Mainz, 1962.

Hoffmann 1967, Hoffmann, H., *Tarentine Rhyta*, Mainz, 1967.

Hoffmann 1977, Hoffmann, H., *Sexual and Asexual Pursuit: a structuralist pproach to Greek vase painting*, RAI Occasional Papers no. 34, 1977.

Hoffmann 1979, Hoffmann, H., 'In the wake of Beazley' *Hephaistos* 1 (1979) ₅1–70.

Hoffmann 1985–6, Hoffmann, H., 'Iconography and iconology', *Hephaistos* ⁷–8 (1985–6) 61–6.

Hoffmann 1988, Hoffmann, H., 'Why did the Greeks need imagery? An nthropological approach to the study of Greek vase painting', *Hephaistos* 9 (1988) 43–62.

Hoffmann 1989, Hoffmann, H., 'Rhyta and Kantharoi in Greek ritual', *Greek ⁷ases* IV (1989) 131–66.

Hooker 1980, Hooker, J.T., *The Ancient Spartans*, London, 1980.

van Hoorn 1951, van Hoorn, G., *Choes and Anthesteria*, Leiden, 1951.

Hopper 1979, Hopper, R.J., *Trade and Industry in Classical Greece*, London, 979.

Howard & Johnson 1954, Howard, S. & Johnson, F.P., 'The Saint-Valentin ⁷ases', *AJA* 58 (1954) 191–207.

Hurwit 1977, Hurwit, J., 'Image and frame in Greek art', *AJA* 81 (1977) 1–30.

Hurwit 1985, Hurwit, J., *The Art and Culture of Early Greece, 1100–480 B.C.*, :haca, 1985.

Immerwahr 1964, Immerwahr, H.R., 'Book rolls on Attic vases' in Ullman 1964.

Immerwahr 1973, Immerwahr, H.R., 'More book rolls on Attic vases', *AK* 16 1973) 143–7.

Immerwahr 1984, Immerwahr, H.R., 'The Signatures of Pamphaios', *AJA* 88 ₄984) 341–52.

Immerwahr 1990, Immerwahr, H.R., *The Attic Script*, Oxford, 1990.

Isserlin & du Plat Taylor 1974, Isserlin, B.J.J. & du Plat Taylor, J., *Motya I*, eiden, 1974.

Jackson 1976, Jackson, D.A., *East Greek Influence on Attic Vases*, Society for the ₄omotion of Hellenic Studies, Supplementary Paper no. XIII, London, 1976.

Jacobsthal 1927, Jacobsthal, P., *Ornamente griechischer Vasen*, Berlin, 1927.

Jacobsthal & Langsdorff 1929, Jacobsthal, P. & Langsdorff, A., *Die ₄onzeschnabelkannen*, Berlin, 1929.

Jeffery 1961, Jeffery, L.H., *The Local Scripts of Archaic Greece*, Oxford, 1961 ₂nd ed. 1990).

Jeffery 1977, Jeffery, L.H., *Archaic Greece*, London, 1977.

Jenkins 1986, Jenkins, I., *Greek and Roman Life*, London, 1986.

Jentel 1968, Jentel, M.-O., *Corpus Vasorum Antiquorum, France, Paris, Louvre*, 5 *(23)*, Paris, 1968.

Jentel 1976, Jentel, M.-O., *Les Gutti et les askoi à reliefs étrusques et apuliens*, ₂iden, 1976.

Joffroy 1979, Joffroy, R., *Vix et ses trésors*, Paris, 1979.

Johansen 1967, Johansen, K.F., *The Iliad in Early Greek Art*, Copenhagen, 196

Johnston 1973, Johnston, A.W., 'A graffito from Vassallaggi', *ZPE* 12 (197 265–9.

Johnston 1974, Johnston, A.W., 'Trademarks on Greek vases', *Greece and Ron* 21 (1974) 138–52.

Johnston 1978, Johnston, A.W., 'Lists of contents: Attic vases', *AJA* 82 (197 222–6.

Johnston 1979, Johnston, A.W., *Trademarks on Greek Vases*, Warminster, 197

Johnston 1985a, Johnston, A.W., 'A fourth century graffito from th Kerameikos', *AM* 100 (1985) 293–307.

Johnston 1985b, Johnston, A.W., review of Scheibler 1983, *AJA* 89 (198 181–3.

Johnston 1987a, Johnston, A.W., 'IG II 2 2311 and the number of Panathenai amphorae', *ABSA* 82 (1987) 125–9.

Johnston 1987b, Johnston, A.W., 'Amasis and the vase trade' in True 198 125–40.

Johnston & Jones 1978, Johnston, A.W. & Jones, R.E., 'The "SOS" amphora *ABSA* 73 (1978) 103–41.

Jones 1984, Jones, R.E., 'Greek potters' clays' in Brijder 1984, 21–30.

Jones 1986, Jones, R.E., *Greek and Cypriot Pottery, a Review of Scientij Studies*, Athens, 1986.

Jones & Catling 1986, Jones, R.E. & Catling, H.W., *Science in Archaeolo;* (Fitch Occasional Papers 2), Athens, 1986.

Jones, Graham & Sackett 1973, Jones, J.E., Graham, A.J. & Sackett, L.H., 'A Attic country house below the cave of Pan at Vari', *ABSA* 68 (1973) 355–452.

Kaempf-Dimitriadou 1979, Kaempf-Dimitriadou, S., *Die Liebe der Götter in d attischen Kunst des 5. Jahrhunderts v. Chr.*, Bern, 1979.

Kahil 1972, Kahil, L., 'Un nouveau vase plastique du potier Sotadès, au Mus du Louvre', *RA* 1972, 271–84.

Kahil 1977, Kahil, L., 'L'Artémis de Brauron: rites et mystère', *AK* 20 (197 86–98.

Kahil 1981–, Kahil, L., *Lexicon Iconographicum Mythologiae Classicae* Zürich and Munich, 1981–.

Kannicht 1982, Kannicht, R., 'Poetry and art: Homer and the monumer afresh', *Classical Antiquity* 1 (1982) 70–86.

Kanowski 1984, Kanowski, M.G., *Containers of Classical Greece*, St. Luci 1984.

Karouzou 1956, Karouzou, S., *The Amasis Painter*, Oxford, 1956.

Kearsley 1989, Kearsley, R., *The Pendent Semi-circle Skyphos*, BICS, Suppleme 44, 1989.

Kehrberg 1982, Kehrberg, I., 'The Potter-painter's wife', *Hephaistos* 4 (198 25–35.

Keil 1913, Keil, J., 'Ephesische Bürgerrechts- und Proxeniendekrete ausde vierten und dritten Jahrhundert v. Chr.', *JOAI* 16 (1913) 231–44.

Kern 1913, Kern, O., *Inscriptiones Graecae, Tabulae in usum scholarum*, Bon 1913.

Kilinski 1982, Kilinski, K., 'Theodoros: a new Boeotian potter', *AJA* 86 (1982) 72.

Kimmig 1988, Kimmig, W., *Das Kleinaspergle. Studien zu einem Füstengrabhügel der frühen Latènezeit bei Stuttgart*, Stuttgart, 1988.

Kirchner 1940, Kirchner, J. (ed.), *Inscriptiones Graecae, II-III, Inscriptiones Atticae Euclidis anno posteriores*, ed. minor, Part 3, Berlin, 1940.

Kleinbauer 1964, Kleinbauer, E., 'The Dionysios Painter and the "Corinthio-Attic" problem', *AJA* 68 (1964) 355–70.

Kleine 1973, Kleine, J., *Untersuchungen zur Chronologie der attischen Kunst von Peisistratos bis Themistokles*, Tübingen, 1973.

Knauer 1985, Knauer, E.R., 'οὐ γὰρ ἦν ἀμίς: a chous by the Oionokles Painter', *Greek Vases* II (1985) 91–100.

Knigge 1970, Knigge, U., 'Neue Scherben von Gefässen des Kleophrades-Malers', *AM* 85 (1970) 1–22.

Knigge 1972a, Knigge, U., 'Untersuchungen bei den Gesandtenstelen im Kerameikos zu Athen', *AA* 1972, 584–629.

Knigge 1972b, Knigge, U., 'Die Gesandtenstelen im Kerameikos', *AAA* 5 (1972) 258–65.

Knigge 1976, Knigge, U., *Der Südhügel, Kerameikos, Ergebnisse der Ausgrabungen IX*, Berlin, 1976.

Koehler 1979, Koehler, C.G., 'Transport amphoras as evidence for trade', *Arch. News* 8 (1979) 54–61.

Koehler 1981, Koehler, C.G., 'Corinthian developments in the study of trade in the fifth century B.C.', *Hesperia* 50 (1981) 449–58.

Koehler 1986, Koehler, C.G., 'Handling of Greek transport amphoras' in Empereur and Garlan 1986, 49–67.

Köpcke 1964, Köpcke, G., 'Golddekorierte attische schwarzfirniskeramik des vierten Jahrhunderts v. Chr.', *AM* 79 (1964) 22–84.

Koumanoudes 1978, Koumanoudes, P., 'A Marathon', *AAA* 11 (1978) 232–44.

Kourou 1987, Kourou, N., 'A propos de quelques ateliers de céramique fine, non tournée du type "Argien Monochrome"', *BCH* 111 (1987) 31–53.

Kourou 1988, Kourou, N., 'Handmade pottery and trade: the case of the "Argive monochrome" ware' in Christiansen and Melander 1988, 314–24.

Kurtz 1975, Kurtz, D.C., *Athenian White Lekythoi: Patterns and Painters*, Oxford, 1975.

Kurtz 1983, Kurtz, D.C., 'Gorgos' cup: an essay in connoisseurship' *JHS* 103 (1983) 68-86.

Kurtz 1984, Kurtz, D.C., 'Vases for the dead, an Attic selection 750–400 B.C.' in Brijder 1984, 314–28.

Kurtz 1985a, Kurtz, D.C., 'Beazley and the connoisseurship of Greek vases', *Greek Vases* II (1985) 237–50.

Kurtz 1985b, Kurtz, D., *Beazley and Oxford*, Oxford, 1985.

Kurtz 1989, Kurtz, D.C. (ed.), *Greek Vases, Lectures by J.D. Beazley*, Oxford, 1989.

Kurtz & Boardman 1971, Kurtz, D.C. & Boardman, J., *Greek Burial Customs*, London, 1971.

[170] BIBLIOGRAPHY

Kurtz & Boardman 1986, Kurtz, D.C. & Boardman, J., 'Booners', *Greek Vase* III (1986) 35–70.

Kyrieleis 1986, Kyrieleis, H. (ed.), *Archaische und Klassische Griechisch Plastik*, Mainz, 1986.

Lancaster 1947, Lancaster, O., *Classical Landscape with Figures*, London, 1947

Landwehr 1985, Landwehr, C., *Die antiken Gipsabgüsse aus Baiae*, Berlin, 1985

Lane 1933–4, Lane, E.A., 'Laconian Vase-Painting', *ABSA* 34 (1933–4) 99–189

Lane 1971, Lane, A., *Greek Pottery*, London, 1971 (3rd ed.).

Lang 1960, Lang, M., *The Athenian Citizen*, Princeton, 1960.

Lang 1974, Lang, M., *Graffiti in the Athenian Agora*, Princeton, 1974.

Lang 1976, Lang, M., *Graffiti and Dipinti, The Athenian Agora XXI*, Princeton 1976.

Lang 1990, Lang, M.L., *Ostraka, The Athenian Agora XXV*, Princeton, 1990.

Lang & Crosby 1964, Lang, M. & Crosby, M., *Weights, Measures and Token The Athenian Agora X*, Princeton, 1964.

Lazzarini 1973–4, Lazzarini, M.L., 'I nomi dei vasi greci nelle iscrizioni dei va stessi', *Arch. Class.* 25–6 (1973–4) 341–75.

Leipen 1971, Leipen, N., *Athena Parthenos: a reconstruction*, Toronto, 1971.

Lemos 1986, Lemos, A.A., 'Archaic Chian Pottery in Chios' in Boardman & Vaphopoulou-Richardson 1986, 233–49.

Leroux 1913, Leroux, G., *Lagynos, recherches sur la céramique et l'a ornemental hellénistiques*, Paris, 1913.

Lévêque & Morel 1980, Lévêque, P. & Morel, J.-P. (ed.), *Céramique hellénistiques et romaines*, Paris, 1980.

Lewis 1974, Lewis, D.M., 'The Kerameikos Ostraka', *ZPE* 14 (1974) 1–4.

Lewis 1981, Lewis, D.M., *Inscriptiones Graecae I*(3rd ed.), Berlin, 1981.

Lewis 1986, Lewis, D.M., 'Temple Inventories in Ancient Greece' in Vicker 1986, 71–81.

Lezzi-Hafter 1982, Lezzi-Hafter, A., *Der Schuwalowmaler. Ein Kannenwerksta der Parthenonzeit*, Kerameus 2, Mainz, 1982.

Lezzi-Hafter 1988, Lezzi-Hafter, A., *Der Eretria-maler, Werke un Weggefährten*, Kerameus 6, Mainz, 1988.

Lissarrague 1987, Lissarrague, F., *Un Flot d'images: une esthétique du banque grec*, Paris, 1987. (Eng. ed. *The Aesthetics of the Greek Banquet, Images of Win and Ritual*, trans. Andrew Szegedy-Maszak, Princeton, 1990)

Lissarrague & Thelamon 1983, Lissarrague, F. & Thelamon, F., *Image céramique grecque, actes du colloque de Rouen, 25–26 novembre, 1982*, Roue 1983.

Lloyd 1979, Lloyd, J. (ed.), *Excavations at Sidi Khebrish, Bengahzi (Berenice) I* Supplement to *Libya Antiqua*, 1979.

Lorber 1979, Lorber, F., *Inschriften auf korinthischen Vasen*, Berlin, 1979.

Lullies 1940, Lullies, R., 'Zur boiotischen rotfigurigen Vasenmalerei', *AM* 6 (1940) 1–27.

McCredie 1966, McCredie, J.J., *Fortified Military Camps in Attica, Hesper* Supplement XI, 1966.

MacDonald 1981, MacDonald, B.R., 'The emigration of potters from Athens i

ιe late fifth century B.C. and its effect on the Attic pottery industry', *AJA* 85
1981) 159–68.

MacDonald 1982, MacDonald, B.R., 'The import of Attic pottery to Corinth and
ιe question of trade during the Peloponnesian War', *JHS* 102 (1982) 113–23.

McGrail 1989, McGrail, S., 'The shipment of traded goods and of ballast in
ιntiquity', *OJA* 8 (1989) 353–8.

McPhee 1981, McPhee, I., 'Some red-figure vase-painters of the Chalcidice',
ιBSA 76 (1981) 297–308.

McPhee 1983, McPhee, I., 'Local red figure from Corinth 1973–80', *Hesperia* 52
1983) 137–53.

McPhee 1986, McPhee, I., 'Laconian red-figure from the British excavations in
ιparta', *ABSA* 81 (1986) 153–64.

McPhee & Trendall 1987, McPhee, I. & Trendall, A.D., *Greek Red-figured
ιish-plates*, Basel, 1987.

McPhee & Trendall 1990, McPhee, I. & Trendall, A.D., 'Addenda to *Greek
'ed-figured Fish-plates*', *AK* 33 (1990) 31–51.

Maffre 1975, Maffre J.J., 'Collection Paul Canellopoulos: Vases Béotiens', *BCH*
9 (1975) 409–520.

Mallwitz & Schiering 1964, Mallwitz, A. & Schiering, W., *Die Werkstatt des
ιheidias in Olympia (Olympische Forschungen V)*, Berlin, 1964.

March 1987, March, J.R., *The Creative Poet*, *BICS*, Supplement 49, London,
ι987.

Markle 1985, Markle, M.M., 'Jury pay and assembly pay at Athens' in Cartledge
ιnd Harvey 1985, 265–97.

Martelli 1987, Martelli, M., *Le ceramica degli Etruschi: la pittura vascolare*,
ιovara, 1987.

Mayo 1982, Mayo, M.E., *The Art of South Italy: Vases from Magna Graecia*,
ιichmond, Virginia, 1982.

Meiggs 1982, Meiggs, R., *Trees and Timber in the ancient Mediterranean World*,
ιxford, 1982.

Meiggs & Lewis 1969, Meiggs, R. & Lewis, D., *A Selection of Greek Historical
ιnscriptions to the End of the Fifth Century B.C.*, Oxford, 1969 (rev. ed. 1989).

Mellink 1973, Mellink, M., 'Excavations at Karatas-Semayük and Elmali, 1972',
ιJA 77 (1973) 293–303.

Mertens 1974, Mertens, J.R., 'Attic white-ground cups: a special class of vases',
ιMJ 9 (1974) 91–108.

Mertens 1977, Mertens, J., *Attic White-ground – its development on shapes other
ιan lekythoi*, Diss., New York, 1977.

Metzger 1951, Metzger, H., *Les Représentations dans la céramique attique du
Ve siècle*, Paris, 1951.

Metzler 1969, Metzler, D., 'Eine attische Kleinmeisterschale mit Töpferszenen in
ιarlsruhe', *AA* 1969, 138–52.

Meyer 1977, Meyer, K.E., *The Plundered Past, the traffic in art treasures*,
ιarmondsworth, rev. ed. 1977.

Millar 1983, Millar, F., 'Epigraphy' in Crawford 1983, 80–136.

Milne 1945, Milne, M.J., 'A prize for wool-working', *AJA* 49 (1945) 528–33.

Mingazzini 1967, Mingazzini, P., 'Qual'era la forma del vaso chiamato dai gre‹ kothon?', *AA* 1967, 344–66.

Mommsen 1975, Mommsen, H., *Der Affekter*, Kerameus 1, Mainz, 1975.

Moon 1983, Moon, W.G. (ed.), *Ancient Greek Art & Iconography*, Madiso‹ Wisconsin, 1983.

Moore 1977, Moore, M.B., 'The gigantomachy of the Siphnian Treasury reconstruction of the three lacunae', *BCH Supplement* IV (1977) 305–35.

Moore 1985, Moore, M.B., 'The west frieze of the Siphnian Treasury: a ne‹ reconstruction', *BCH* 109 (1985)131–56.

Moore & von Bothmer 1972, Moore, M.B. & von Bothmer, D., 'A nec‹ amphora in the collection of Walter Bareiss', *AJA* 76 (1972) 1–11.

Moore & Philippides 1986, Moore, M.B. & Philippides, M.Z.P., *Attic Blac‹ figured Pottery, The Athenian Agora XXIII*, Princeton, 1986.

Morel 1980, Morel, J.P., 'La céramique campanienne: acquis et problèmes' ‹ Lévêque & Morel 1980.

Morel 1981, Morel, J.P., *Céramique campanienne: les formes*, Rome, 1981.

Morel 1983, Morel, J.P., 'La céramique comme indice du commerce antiqu (réalités et interprétations)' in Garnsey & Whittaker 1983, 66–74.

Morris 1984, Morris, S.P., *The Black and White Style*, New Haven & Londo‹ 1984.

Morris 1985, Morris, S.P., 'ΛΑΣΑΝΑ: a contribution to the ancient Gree kitchen', *Hesperia* 54 (1985) 393–409.

Morrison & Coates 1986, Morrison, J.S. & Coates, J.F., *The Athenian Trirem* Cambridge, 1986.

Morrison & Williams 1968, Morrison, J.S. & Williams, R.T., *Greek Oared Shi‹ 900–322 B.C.*, Cambridge, 1968.

Murray 1975, Murray, R.L., *The Protogeometric Style: the First Greek Styl‹* Göteborg, 1975.

Murray 1990, Murray, O. (ed.), *Sympotica, a symposium on the* Symposio‹ Oxford, 1990.

Murray and Price 1990, Murray, O. and Price, S. (eds.), *The Greek City: fro‹ Homer to Alexander*, Oxford, 1990.

Neeft 1987, Neeft, C.W., *Protocorinthian Subgeometric Aryballoi*, Amsterdan 1987.

Noble 1966, Noble, J.V., *The Techniques of Painted Attic Pottery*, London, 196‹ (rev. ed. 1988).

Noble 1988, see Noble 1966.

Nogara 1951, Nogara, B., 'Un frammento de Douris nel Museo Gregorian‹ Etrusco', *JHS* 71 (1951) 129-32.

Oakley 1990, Oakley, J.H., *The Phiale Painter*, Kerameus 8, Mainz, 1990.

Ohly 1965, Ohly D., 'Kerameikos-Grabung Tätigkeitsbericht 1956-61', *AA* 196‹ 277–376.

Olin & Franklin 1980, Olin, J.S. & Franklin, A.D. (edd.), *Archaeologic‹ Ceramics*, Washington, 1980.

Osborne 1983–4, Osborne, R., 'The myth of propaganda and the propaganda ‹ myth', *Hephaistos* 5–6 (1983–4) 61–70.

Osborne 1989, Osborne, R., 'A crisis in archaeological history. The sevent‹

entury in Attica', *ABSA* 84 (1989) 297–322.

Overbeck 1959, Overbeck, J.A. *Die antiken Schriftquellen zur Geschichte der ildende Künste bei den Griechen*, Hildersheim, 1959.

de Paepe, de Paepe, P., 'A petrological study of coarse wares from Thorikos, S.E. Attica (Greece)' in *Miscellanea Graeca 2, Technological Studies*, Gent, 1979, 61–38.

Parke 1977, Parke, H.W., *Festivals of the Athenians*, London, 1977.

Payne 1925–6, Payne, H.G.G., 'On the Thermon metopes', *ABSA* 27 (1925–6) 24–32.

Payne 1927–8, Payne, H.G.G., 'Early Greek vases from Knossos', *ABSA* 29 1927–8) 224–98.

Payne 1931, Payne, H.G.G., *Necrocorinthia*, Oxford, 1931.

Payne 1933, Payne, H.G.G., *Protokorinthische Vasenmalerei*, Berlin, 1933.

Peacock 1982, Peacock, D.P.S., *Pottery in the Roman World: an ethno-rchaeological approach*, London, 1982.

Peacock & Williams 1986, Peacock, D.P.S. & Williams, D.F., *Amphorae and the Roman Economy: an introductory guide*, London, 1986.

Peek 1955, Peek, W., *Griechische Vers-Inschriften I Grab-Epigramme*, Berlin, 955.

Pemberton 1970, Pemberton, E.G., 'The Vrysoula Classical Deposit from Ancient Corinth', *Hesperia* 39 (1970) 265–307.

Perlzweig 1963, Perlzweig, J., *Lamps from the Athenian Agora*, Princeton, 1963.

Perreault 1986, Perreault, J.Y., 'Les importations attiques au Proche-Orient du Ie au milieu du Ve', *BCH* 110 (1986)145–75.

Petrakos 1981, Petrakos, B., 'La base de la Némésis d'Agoracrite', *BCH* 105 1981) 227–53.

Petrakos 1986, Petrakos, B., 'Προβλήματα της βάσης του αγάλματος της Νεμέσεως' in Kyrieleis 1986, II 89–107.

Petrie 1930, Petrie, F., *Decorative Patterns of the Ancient World*, London, 1930.

Philippaki 1967, Philippaki, B.,*The Attic Stamnos*, Oxford, 1967.

Pianu 1982, Pianu, G., *Ceramiche Etrusche sovradipinte (Tarquinia)*, Rome 982.

Picard & de la Coste-Meselière 1928, Picard, C. & de la Coste-Meselière, P., es Trésors 'ioniques', *Fouilles de Delphes IV. II*, Paris, 1928.

Picard & de la Coste-Meselière 1931, Picard, C. & de la Coste-Meselière, P., culptures des temples, *Fouilles de Delphes IV.III*, Paris, 1931.

Pinney 1984, Pinney, G.F., 'For the heroes are at hand', *JHS* 104 (1984) 181–3.

Pipili 1987, Pipili, M., *Laconian Iconography of the Sixth Century*, Oxford, 987.

Prag 1985, Prag, A.J.N.W., *The Oresteia: Iconographic and Narrative Tradition*, Warminster, 1985.

Preuner 1920, Preuner, E., 'Archäologisch-Epigraphisches', *JDAI* 35 (1920) 59–2.

Pritchett 1953 & 1956, Pritchett, W.K., 'The Attic Stelai Parts I and II', *Hesperia* 2 (1953) 225–311 and 25 (1956) 178–328.

de Puma 1968, de Puma, R.D., 'Preliminary sketches on some fragments by Makron in Philadelphia and Bryn Mawr', *AJA* 72 (1968) 152–4.

Rasmussen 1979, Rasmussen, T.B., *Bucchero Pottery from Southern Etruri* Cambridge, 1979.

Rasmussen 1985, Rasmussen, T., 'Etruscan shapes in Attic pottery', *AK* 2 (1985) 33–9.

Raubitschek 1939–40, Raubitschek, A.E., 'Early Attic votive monuments', *ABS* 40 (1939–40) 28–36.

Raubitschek 1949, Raubitschek, A.E., *Dedications from the Athenian Akropoli* Cambridge, Mass., 1949.

Raubitschek 1966, Raubitschek, I.K., 'Early Boeotian potters', *Hesperia* 3 (1966) 154–65.

Rhodes 1981, Rhodes, P.J., *A Commentary on the Aristotelian* Athenaic Politeia, Oxford, 1981.

Rice 1984, Rice, P. (ed.), *Pots and Potters: Current Approaches in Ceram* Archaeology, Los Angeles, University of California Press, 1984.

Rice 1987, Rice, P.M., *Pottery Analysis: a source book*, Chicago, 1987.

Richter 1923, Richter, G.M.A., *The Craft of the Athenian Potter*, New Have 1923.

Richter 1941, Richter, G.M.A., 'A Greek silver phiale in the Metropolita Museum', *AJA* 45 (1941) 363–89.

Richter 1958, Richter, G.M.A., *Attic Red-figured Vases: a survey*, New Have 1958 (2nd ed.).

Richter 1967, Richter, I., *Das Kopfgefäss. Zur Typologie einer Gafässform*, Diss Cologne, 1967.

Richter & Milne 1935, Richter, G.M.A. & Milne, M.J., *Shapes and Names* « Athenian Vases, New York, 1935.

Ridgway 1970, Ridgway, B.S., *The Severe Style in Greek Sculpture*, Princeto 1970.

Ridgway 1977, Ridgway, B.S., *The Archaic Style in Greek Sculpture*, Princeto 1977.

Ridgway 1981, Ridgway, B.S., *Fifth-Century Styles in Greek Sculpture*, Princeton 1981.

Ridgway 1984, Ridgway, D., *L'Alba della Magna Grecia*, Milan, 1984.

Ridgway 1988a, Ridgway, D., 'The Pithekoussai shipwreck' in Betts, Hooker ar Green 1988, 97–107.

Ridgway 1988b, Ridgway, D., 'Italy from the Bronze Age to the Iron Age' ar 'The Etruscans' in Boardman, Hammond, Lewis & Ostwald 1988, 623–33 ar 634–75.

Rieth 1940, Rieth, A., 'Die Entwicklung der Drechseltechnik', *AA* 1940, 616–3 Riley 1979, Riley, J., 'The Pottery' in Lloyd 1979, 91–467.

Riley 1984, Riley, J., 'Pottery analysis and the reconstruction of ancient exchang systems' in van de Leeuw and Pritchard 1984, 55–78.

Roberts 1978, Roberts, S.R., *The Attic Pyxis*, Chicago, 1978.

Robertson 1951, Robertson, M., 'The place of vase-painting in Greek art', *ABS* 46 (1951) 151–9.

Robertson 1959, Robertson, M., *Greek Painting*, Geneva, 1959.

Robertson 1965, Robertson, M., 'Greek mosaics', *JHS* 85 (1965) 72–89.

Robertson 1967, Robertson, M., 'Greek mosaics: a postscript', *JHS* 87 (196 133–6.

Robertson 1972, Robertson, M., '"Epoiesen" on Greek vases: other considerations', *JHS* 92 (1972) 180–3.

Robertson 1975, Robertson, M., *A History of Greek Art*, Cambridge, 1975.

Robertson 1976, Robertson, M., 'Beazley and after', *MJBK* 27 (1976) 29–46.

Robertson 1981a, Robertson, M., *A Shorter History of Greek Art*, Cambridge, 981.

Robertson 1981b, Robertson, M., 'Euphronios at the Getty', *Getty MJ* 9 (1981) 3–34.

Robertson 1985, Robertson, M., 'Beazley and Attic vase painting' in Kurtz 985b, 19–30.

Robertson 1987, Robertson, M., 'The state of Attic vase-painting in the mid-sixth :ntury' in True 1987, 13–28.

Robertson & Frantz 1975, Robertson, M & Frantz, A., *The Parthenon Frieze*, ondon, 1975.

Robinson et al. 1929–52, Robinson, D.M. et el., *Excavations at Olynthus I-XIV*, altimore, 1929–52.

Roebuck 1955, Roebuck, M.C. & C.A., 'A prize aryballos', *Hesperia* 24 (1955) 58–63.

Roebuck 1972, Roebuck, C., 'Some aspects of urbanization in Corinth', *Hesperia* 1 (1972) 96–127.

Rosati 1989, Rosati, R. (ed.), *La ceramica attica nel Mediterraneo. Analisi mputerizzata della diffusione. Le fasi iniziali (630–560 B.C.)*, Bologna, 989.

Rotroff 1982, Rotroff, S., *Hellenistic Pottery: Athenian imported and moldmade owls. The Athenian Agora XXII*, Princeton, 1982.

Rotroff 1991, Rotroff, S., 'Attic West Slope Vase Painting', *Hesperia* 60 (1991) 9–102.

Ruckert 1976, Ruckert, A., *Frühe Keramik Böiotiens* (10 Beiheft *AK*, 1976).

Rudolph 1971, Rudolph, W.W., *Die Bauchlekythos: ein Beitrag zur ormgeschichte der attischen Keramik des 5. Jahrhunderts v. Chr.*, Diss. Göttingen, *i*loomington, 1971

Rumpf 1934, Rumpf, A., 'Diligentissime mulieres pinxit', *JDAI* 49 (1934) –23.

Rumpf 1947, Rumpf, A., 'Classical and post-Classical Greek painting', *JHS* 67 *i*947) 10–21.

Rumpf 1951, Rumpf, A., 'Parrhasios'. *AJA* 55 (1951) 1–12.

Salmon 1984, Salmon, J.B., *Wealthy Corinth: a history of the city to 338 B.C.*,)xford, 1984

Salomé 1980, Salomé, M.-R., *Code pour l'analyse des représentations figurées sur 's vases grecs*, Paris, 1980.

Salzmann 1982, Salzmann, D., *Untersuchungen zu den antiken Kieselmosaiken*, erlin, 1982.

Samuel 1972, Samuel, A.E., *Greek and Roman Chronology*, Munich, 1972.

Schäfer 1957, Schäfer, J., *Studien zu den griechischen Relief-pithoi des 8.-6. Ihrhunderts v. Chr. aus Kreta, Rhodos, Tenos und Boiotien*, Kallmünz, 1957.

Schauenburg 1986, Böhr, E. & Martini, W. (edd.), *Studien zur Mythologie und 'asenmalerei. Konrad Schauenburg zum 65. Geburtstag am 16 April 1986*, Mainz, 986.

Schaus 1979, Schaus, G.P., 'A foreign vase painter in Sparta', *AJA* 83 (197⁹ 102–6.

Schaus 1983, Schaus, G.P., 'Two notes on Laconian vases', *AJA* 87 (1983) 85–⁹

Schaus 1988, Schaus, G.P., 'The beginning of Greek polychrome painting', *JH* 108 (1988) 107–17.

Scheffer 1981, Scheffer, C., *Acquarossa II, Part I: Cooking and Cooking Stand in Italy 1400–400 B.C.*, Stockholm, 1981.

Scheffer 1988, Scheffer, C., 'Workshop and trade patterns in Athenian black figure', in Christiansen & Melander 1988, 536–46.

Schefold 1930, Schefold, K., *Kertscher Vasen*, Berlin, 1930.

Schefold 1966, Schefold, K., *Myth and Legend in Early Greek Art*, Londo 1966.

Schefold 1978, Schefold, K., *Götter- und Heldensagen der Griechen in d spätarchaischen Kunst*, Munich, 1978.

Schefold 1981, Schefold, K., *Die Göttersage in der klassischen und hellenistische Kunst*, Munich, 1981.

Schefold & Jung 1988, Schefold, K. & Jung, F., *Die Urkönige, Perseu Bellerophon, Herakles und Theseus in der klassischen und hellenistischen Kuns* Munich, 1988.

Scheibler 1964, Scheibler, I., 'Exaleiptra', *JDAI* 79 (1964) 72–108.

Scheibler 1968, Scheibler, I., 'Exaleiptra: addenda', *AA* 1968, 389–97.

Scheibler 1983, Scheibler, I., *Griechische Töpferkunst*, Munich, 1983.

Schiering 1983, Schiering, W., *Die griechische Tongefässe: Gestalt, Bestimmu und Formenwandel* (2nd ed.), Berlin 1983.

Schilardi 1977, Schilardi, D.U., *The Thespian Polyandrion (424 B.C.): T Excavations and Finds from the Thespian State Burial*, PhD Princeton, Ann Arbo 1979.

Schmidt 1960, Schmidt, M., *Der Dareiosmaler und sein Umkreis*, Münster, 196

Schneider-Hermann 1980, Schneider-Hermann, G., *Red-figured Lucanian a Apulian Nestorides and their Ancestors*, Amsterdam, 1980.

Schuchhardt 1963, Schuchhardt, W.-H., 'Athena Parthenos', *Antike Plastik* 31–53, Berlin, 1963.

Schwab 1986, Schwab, K.A., 'A Parthenonian centaur', *Greek Vases* II, 89–94

Schweitzer 1971, Schweitzer, B., *Greek Geometric Art*, London, 1971.

Scichilone 1963, Scichilone, G., 'Olinto', *EAA* V (1963) 661–7.

Seaford 1982, Seaford, R.A.S., 'The date of Euripides' *Cyclops*', *JHS* 102 (198 161–72.

Seaford 1984, Seaford, R., *Euripides* Cyclops, Oxford, 1984.

Seiterle 1976, Seiterle, G., 'Die Zeichentechnik in der rotfigurigen Vasenmalere *AW* 7 (1976) 2–10.

Servais-Soyez 1981, Servais-Soyez, B., 'Adonis' in Kahil 1981, 222–29.

Shapiro 1983, Shapiro, H.A., 'Painting, politics and genealogy: Peisistratos a the Neleids' in Moon 1983, 87–96.

Shefton 1950, Shefton, B.B., 'The dedication of Callimachos (*IG* 1/2 609)', *ABS* 45 (1950) 140–64.

Shefton 1954, Shefton, B.B., 'Three Laconian vase painters', *ABSA* 49 (195 299–310.

Shefton 1960, Shefton, B.B., 'Some iconographic remarks on the Tyrannicides' *JA* 64 (1960) 173–9.

Shefton 1982, Shefton, B.B., 'The krater from Baksy' in Kurtz & Sparkes 1982, 49–81.

Shefton 1989, Shefton, B.B., 'East Greek influences in sixth century Attic vase-painting and some Laconian traits', *Greek Vases* IV (1989) 41–72.

Shepard 1968, Shepard, A.O., *Ceramics for the Archaeologist*, Washington, 968.

Sichtermann 1963, Sichtermann, H., *Die griechischen Vasen: Gestalt, Sinn und Kunstwerk*, Berlin, 1963.

Simon 1982a, Simon, E., *The Ancient Theatre*, London, 1982.

Simon 1982b, Simon, E., 'Satyr-plays on vases in the time of Aeschylus' in Kurtz & Sparkes 1982, 123–48.

Simon 1983, Simon, E., *The Festivals of Attica*, Madison, Wisconsin, 1983.

Simon & Hirmer 1981, Simon, E. & Hirmer, M. & M., *Die griechischen Vasen*, Munich, 1981 (2nd ed.).

Smithson 1968, Smithson, E.L., 'The tomb of a rich Athenian lady, ca. 850 B.C.', *Hesperia* 37 (1968) 77–116.

Snodgrass 1964, Snodgrass, A.M., *Arms and Armour of the Greeks*, London, 964.

Snodgrass 1979, Snodgrass, A.M., 'Poet and painter in eighth century Greece', *PCPS* 205 (1979) 118–30.

Snodgrass 1980a, Snodgrass, A., *Archaic Greece, the age of experiment*, London, 980.

Snodgrass 1980b, Snodgrass, A.M., 'Towards an interpretation of the Geometric figure-scenes', *AM* 95 (1980) 51–8.

Snodgrass 1982, Snodgrass, A.M., *Narration and Illusion in Archaic Greek Art*, London, 1982.

Snodgrass 1983a, Snodgrass, A., 'Archaeology' in Crawford 1983, 137–84.

Snodgrass 1983b, Snodgrass, A.M., 'Heavy freight in archaic Greece' in Garnsey, Hopkins & Whittaker 1983, 16–26.

Snodgrass 1987, Snodgrass, A., *An Archaeology of Greece*, Berkeley and Los Angeles, 1987.

Snodgrass 1990, Snodgrass, A., 'Survey archaeology and the rural landscape of the Greek city' in Murray and Price 1990, 113–26.

Sourvinou-Inwood 1971, Sourvinou-Inwood, C., 'Theseus lifting the rock and a cup near the Pithos Painter', *JHS* 91 (1971) 94–109.

Sourvinou-Inwood 1979, Sourvinou-Inwood, C., *Theseus as Son and Stepson*, *BICS*, Supplement 40, London, 1979.

Sparkes 1962, Sparkes, B.A., 'The Greek kitchen', *JHS* 82 (1962) 121–37.

Sparkes 1965, Sparkes, B.A., 'The Greek kitchen: addenda', *JHS* 85 (1965) 162–3.

Sparkes 1967, Sparkes, B.A., 'The taste of a Boeotian pig', *JHS* 87 (1967) 116–30.

Sparkes 1968, Sparkes, B.A., 'Black Perseus', *AK* 11 (1968) 3–15.

Sparkes 1975, Sparkes, B.A., 'Illustrating Aristophanes', *JHS* 95 (1975) 122–35.

Sparkes 1976, Sparkes, B.A., 'Treading the grapes', *BABesch.* 51 (1976) 47–64.

Sparkes 1981, Sparkes, B.A., 'Not cooking, but baking', *Greece and Rome* 2 (1981) 172–8.

Sparkes 1991, Sparkes, B.A., *Greek Art. Greece and Rome, New Surveys in th. Classics no. 22*, Oxford, 1991.

Sparkes & Talcott 1958, Sparkes, B.A. & Talcott, L., *Pots and Pans of Classic Athens*, Princeton, 1958.

Sparkes & Talcott 1970, Sparkes, B.A. & Talcott, L., *Black and Plain Pottery the 6th, 5th & 4th centuries B.C., The Athenian Agora XII*, Princeton, 1970.

Spivey 1987, Spivey, N.J., *The Micali Painter and his Followers*, Oxford, 1987

Spivey 1988, Spivey, N., *Un artista etrusco e il suo mondo: Il pittore di Mica* Rome, 1988.

Stansbury-O'Donnell 1989, Stansbury-O'Donnell, M.D., 'Polygnotos' *Iliupers* a new reconstruction', *AJA* 93 (1989) 203–15.

Stewart 1983, Stewart, A., 'Stesichoros and the François vase' in Moon 198. 53–74.

Stewart 1990, Stewart, A.F., *Greek Sculpture: an exploration*, Yale, 1990.

Stibbe 1972, Stibbe, C.M., *Lakonische Vasenmaler des sechsten Jahrhunderts ι Chr.*, Amsterdam, 1972.

Stibbe 1989, Stibbe, C.M., *Laconian Mixing Bowls*, Amsterdam, 1989.

Stillwell & Benson 1984, Stillwell, A.N. & Benson, J.L., *The Potters' Quarte The Pottery, Corinth XV.III*, Princeton, 1984.

Strong & Brown 1976, Strong, D. & Brown, D. (edd.), *Roman Crafts*, Londo 1976.

Sutton 1980, Sutton, D., *The Greek Satyr Play*, Meisenheim am Glan, 1980.

Swaddling 1980, Swaddling, J., *The Ancient Olympic Games*, London, 1980.

Taplin 1987, Taplin, O., 'Phallology, *Phlyakes*, Iconography and Aristophanes *PCPS* 213, n.s. 33 (1987) 92–104.

Taylor 1981, Taylor, M.W., *The Tyrant Slayers, the heroic image in fifth centur B.C. Athenian art and politics*, New York, 1981.

Themelis 1977, Themelis, P., 'Μαραθών: τὰ πρόσφατα ἀρχαιολογικὰ εὑρήματ σὲ σχέση μὲ τὴ μάχη', *ADelt* 29 (1974) A (1977) 226–44.

Thompson 1934, Thompson, H.A., 'Two centuries of Hellenistic potter *Hesperia* 3 (1934) 311–480 (reissued in H.A. Thompson and D.B. Thompso *Hellenistic Pottery and Terracottas*, with preface by S.I. Rotroff, Princeton, 1987

Thompson 1971, Thompson, D.B., *An Ancient Shopping Center: The Athenia Agora*, Princeton, 1971.

Thompson 1984, Thompson, H.A., 'The Athenian Vase-Painters and the Neighbors', in Rice 1984, 7–19.

Thompson & Wycherley 1972, Thompson, H.A. & Wycherley, R.E., *The Agor of Athens, The Athenian Agora XIV*, Princeton, 1972.

Throckmorton 1987, Throckmorton, P. (ed.), *History from the Sea: Shipwrec & Archaeology*, London, 1987.

Tiverios 1976, Tiverios, M., 'Ὁ Λύδος καὶ τὸ ἔργο του, Athens, 1976.

Touchefeu-Meynier 1972, Touchefeu-Meynier, O., 'Un nouveau "phormiskos" figures noires', *RA* 1972, 93–102.

Touloupa 1986, Touloupa, E., 'Die Giebelskulpturen des Apollo Daphnephoros-tempels in Eretria' in Kyrieleis 1986, I, 143–51.

Trendall 1967, Trendall, A.D., *The Red-figured Vases of Lucania, Campania and Sicily*, Oxford, 1967.

Trendall 1979, Cambitoglou, A. (ed.), *Studies in Honour of A.D. Trendall*, Sydney, 1979.

Trendall 1987, Trendall, A.D., *The Red-figured Vases of Paestum*, The British School at Rome, 1987.

Trendall 1989, Trendall, A.D., *Red-figure Vases of Southern Italy and Sicily*, London, 1989.

Trendall & Cambitoglou 1978 & 1982, Trendall, A.D. & Cambitoglou, A., *The Red-figured Vases of Apulia*, Oxford, 1978 & 1982.

Trendall & Webster 1971, Trendall, A.D. & Webster, T.B.L., *Illustrations of Greek Drama*, London, 1971.

True 1987, True, M. (ed.), *Papers on the Amasis Painter and his World*, Malibu, 1987.

Trumpf-Lyritzaki 1969, Trumpf-Lyritzaki, M., *Griechische Figurenvasen des reichen Stils und der späten Klassik*, Bonn, 1969.

Tuchelt 1962, Tuchelt, K., *Tiergefässe in Kopf- und Protomen-gestalt*, Berlin, 1962.

Ullman 1964, *Classical, Mediaeval and Renaissance Studies in Honour of Berhold Louis Ullman*, ed. Charles Henderson, Jr., Vol. I, Rome, 1964.

Ure 1936, Ure, A.D., 'Red figure cups with incised and stamped decoration I', *JHS* 56 (1936) 205–15.

Ure 1944, Ure, A.D., 'Red figure cups with incised and stamped decoration II', *JHS* 64 (1944) 67–77.

Ure 1958, Ure, A.D., 'The Argos Painter and the Painter of the Dancing Pan', *AJA* 62 (1958) 389–95.

Ure 1973, Ure, A.D., 'Observations on Euboean black-figure', *ABSA* 68 (1973) 25–31.

Valavanis 1986, Valavanis, P., 'Les amphores panathénaiques et le commerce athénien de l'huile' in Empereur & Garlan 1986, 453–60.

Vallet & Villard 1963, Vallet, G. & Villard, F., 'Céramique grecque et histoire économique' in Courbin 1963, 205–17.

Van de Leeuw & Pritchard 1984, van de Leeuw, S.E. and Pritchard, A.C., *The Many Dimensions of Pottery, Ceramics in Archaeology and Anthropology*, Amsterdam, 1984.

Vanderpool 1967, Vanderpool, E., 'Kephisophon's kylix', *Hesperia* 36 (1967) 187–9.

Vanderpool 1970, Vanderpool, E., *Ostracism at Athens*, Cincinnati, 1970.

Vatin 1983, Vatin, C., 'Les danseuses de Delphes', *CRAI* 1983, 26–40.

Vermeule 1966, Vermeule, E., 'The Boston Oresteia krater', *AJA* 70 (1966) 1–22.

Vermeule 1970, Vermeule, E., 'Five vases from the grave precinct of Dexileos', *JDAI* 85 (1970) 94–111.

Vermeule 1979, Vermeule, E., *Aspects of Death in Early Greek Art and Poetry*, Berkeley and Los Angeles, 1979.

Vermeule 1984, Vermeule, E., 'Tyres the lecher', in *Studies presented to Sterling Dow on his eightieth birthday*, Durham, North Carolina, 1984, 301–4.

Vickers 1978, Vickers, M., *Greek Symposia*, London, 1978.

Vickers 1983, Vickers, M., 'Les vases peints: image ou mirage' in Lissarrague and Thelamon 1983, 29–42.

Vickers 1984, Vickers, M., 'The influence of exotic materials on Attic white ground pottery' in Brijder 1984, 88–97.

Vickers 1985a, Vickers, M., 'Persepolis, Vitruvius and the Erechtheum Caryatids the iconography of Medism and servitude', *RA* 1985, 3–28.

Vickers 1985b, Vickers, M., 'Early Greek coinage, a reassessment', *NC* 14. (1985) 1–44.

Vickers 1985c, Vickers, M., 'Artful crafts: the influence of metalwork on Athenian painted pottery', *JHS* 105 (1985) 108–28.

Vickers 1986, Vickers, M. (ed.), *Pots and Pans, Precious Metals and Ceramics in the Muslim, Chinese and Graeco-Roman Worlds* (Oxford Studies in Islamic Art) Oxford, 1986.

Vickers 1987, Vickers, M., 'Alcibiades on stage: *Philoctetes* & *Cyclops*', *Historia* 36 (1987) 171–97.

Vickers 1990, Vickers, M., 'Golden Greece: relative values, minae, and temple inventories', *AJA* 94 (1990) 613–24.

Vickers & Bazama 1971, Vickers, M. & Bazama, A., 'A fifth century B.C. tomb in Cyrenaica', *Libya Antiqua* 8 (1971) 69–85.

Vickers, Impey & Allen 1986, Vickers, M., Impey, O. & Allen, J., *From Silver to Ceramic*, Oxford, 1986.

de Vries 1977, de Vries, K., 'Attic pottery in the Achaemenid Empire', *AJA* 8 (1977) 544–8.

Walsh 1985, Walsh, J., 'Acquisitions 1984', *GettyMJ* 13 (1985) 161–258.

Watrous 1982, Watrous, L.V., 'The sculptural program of the Siphnian Treasury at Delphi', *AJA* 86 (1982) 159–72.

Webster 1972, Webster, T.B.L., *Potter and Patron in Classical Athens*, London 1972.

Wehgartner 1983, Wehgartner, I., *Attisch Weissgrundige Keramik*, Mainz, 1983.

Weill 1966, Weill, N., 'Adoniazousai ou les femmes sur le toit', *BCH* 90 (1966) 664–98.

Weinberg 1954, Weinberg, S., 'Corinthian relief ware: pre-hellenistic period' *Hesperia* 23 (1954) 109–37.

Weis 1979, Weis, H.A., 'The "Marsyas" of Myron: old problems and new evidence', *AJA* 83 (1979) 214–19.

Whitbread 1986a, Whitbread, I., 'The application of ceramic petrology to the study of ancient Greek amphorae' in Empereur and Garlan 1986, 95–101.

Whitbread 1986b, Whitbread, I.K., 'A microscopic view of Greek transport amphorae' in Jones and Catling 1986, 49–52.

Whitehouse & Wilkins 1985, Whitehouse, R. & Wilkins, J., 'Magna Graecia before the Greeks: towards a reconciliation of the evidence', *BAR* International Series 245 (1985) 89–109.

Willemsen 1977, Willemsen, F., 'Zu den Lakedämoniergräbern im Kerameikos' *AM* 92 (1977) 117–57.

Williams 1980, Williams, D., 'Ajax, Odysseus and the arms of Achilles', *AK* 23 (1980) 137–45.

Williams 1982, Williams, D., 'An oinochoe in the British Museum and the Brygos Painter's work on a white ground', *JBM* 24 (1982) 17–40.

Williams 1983a, Williams, D., 'Sophilos in the British Museum' in *Greek Vases* 1 1983) 9–34.

Williams 1983b, Williams, D., 'Aegina, Aphaia-Tempel, V: the pottery from Chios', *AA* 1983, 155–86.

Williams 1983c, Williams, D., 'Women on Athenian vases: problems of interpretation' in Cameron & Kuhrt 1983, 92–106.

Williams 1985, Williams, D., *Greek Vases*, London, 1985.

Williams 1986, Williams, D., 'A cup by the Antiphon Painter and the battle of Marathon' in Schauenburg 1986, 75–81.

Williams 1990, Williams, D.F., 'The study of ancient ceramics: contribution of the petrographic method' in *Scienze in Archeologia*, edd. T. Mannoni & A. Molinari, Florence, 1990.

Williams & Fisher 1976, Williams, C.K. & Fisher, T.E., 'Corinth 1975: Forum Southwest', *Hesperia* 45 (1976) 99–162.

Winter 1968, Winter, A., 'Beabsichtigtes Rot (Intentional Red)', *AM* 83 (1968) 315–22.

Winter 1978, Winter, A., *Die Antike Glanztonkeramik, praktische Versuche*, Mainz, 1978.

Wintermeyer 1975, Wintermeyer, U., 'Die polychrome Reliefkeramik aus Centuripe', *JDAI* 90 (1975) 136–241.

Wolters & Bruns 1940, Wolters, P. & Bruns, G., *Das Kabirenheiligtum I*, Berlin, 1940.

Woodhead 1981, Woodhead, A.G., *The Study of Greek Inscriptions*, Cambridge, 1981 (2nd ed.).

Wycherley 1957, Wycherley, R.E., *Literary and Epigraphical Testimonia, The Athenian Agora III*, Princeton, 1957.

Zaphiropoulou 1973, Zaphiropoulou, P., 'Vases et autres objets de marbre de Rhenée', *BCH* Supplement I (1973) 601–36.

Zervoudaki 1968, Zervoudaki, E.A., 'Attische Polychrome Reliefkeramik des späten 5. und des 4. Jahrhunderts v. Chr.', *AM* 83 (1968) 1–88.

Ziomecki 1975, Ziomecki, J., *Les Représentations d'artisans sur les vases antiques*, Warsaw, 1975.

INDEX

Not all references to individual shapes, painters' names or mythological characters have been included in this index. For an alphabetical list of the major shapes, see pp. 79–92.

acanthus column, Delphi, 43
added colours, 20
Aegina, 10
Aeschylus
 Oresteia, 51
 Sphinx, 51–2
aesthetics of shape, 78–9.
agonothetai, 54
Agorakritos' Nemesis, Rhamnous, 42
alabaster, 70
alabastron, 70, 71, 75, 77, 78
Alexander, 49
amphoriskos, 77, 107
Anacreon, 47
Angelitos' Athena, 43
animals and monsters, 95
animal skin, 68, 70
Anthesteria, 78
Apollo temple, Delphi, 40–1
Apollo temple, Eretria, 41
appliqué designs, 107–9
archon eponymos, 54
'Arethusa cups', 59
Arethusa head, 107
Aristophanes
 Birds, 52
 Clouds, 52
Arkesilas, 46
Arretine red, 103
Artemis temple, Ephesos, 39–40
aryballos, 68, 79

ash urn, 78
askos, 62, 68, 77, 109
Athenian treasury, Delphi, 41
athletics, 74–5
athlothetai, 54
atomic absorption spectrophotometry, 26
Attic Stelai inscription, 63, 130
Aziris, Cyrenaica, 36

bakkaris, 84
basketwork, 123
Beazley (Sir) John D., 113
beehive, 75
'bilinguals', 97
black-figure, 19, 95–6
black gloss pottery, 103–10
Boeotian kantharos, 76
bolsal, 65, 107
bonfires, 11
'book illustrations', 50
Boreas, 49
bucchero, 71
burnishing, 17

Cabeiric vases, 96
Caere, Etruria, 66
Caeretan hydriai, 101, 116, 135
Canosa, 101
captions, 112
cargoes, 131, 133
Centuripe, 101

chemical study, 26
Chios, 66
Chiot chalices, 63, 76, 99, 112
choes, 78
chytrai, 71, 78
clays, 1, 8–13, 60, 68
colour, 95
comedy, Athenian, 52
compass, 94
compositions and subjects,
 117–22
congresses, 7
connoisseurship, 113–16
contexts, 29–31, 32–8
conventional names for painters,
 114–15
coral red, 20, 102–3
Corcyrean ambassadors, 33–4
Corinth, destruction of, 37
Croesus, 47
Cumae, 38
Cyrene, 36

Daphnae (Tell Defenneh), Egypt,
 36–7
dates
 absolute, 31–52
 relative, 28–31
decorating, 17–21
Delium, 34
demosion, 74, 124
dendrograms, 26
destruction levels, 35–7
Dexileos, 35, 43, 48
dinos, 62
dipinti, 124–5
distribution, 131–5
drama, Athenian, 50–2, 119, 122

eighth-of-an-inch' stripe, 19
engraving, 19
Ephesos, 39–40, 68
epics, 50, 119, 122
epinetron, 77
ethnography, 3, 10–11
Euripides' Cyclops, 52
evidence, types of, 2–3
exaleiptron, 77
exhibitions, 4–6

failures, 15, 20–1, 24, 25
family businesses, 10, 29, 67, 112

fauna, 94
firing, 21–6
floral patterns, 94, 116–17
forming, 13–17
foundation levels, 35, 37–8
fuel, 25
functions, 60–2, 71–3
funerary pottery, 77–8

geology, 1, 8–9
glass, 70
gloss, 17–18
Gnathia pottery, 105–6
gourds, 68
graffiti, 63, 124–5
grave goods, 29–31, 77–8
graves, datable, 32–5
gutti, 77

'Hadra' hydriai, 54–7, 100, 101,
 111
Hama(th) on the Orontes, 36
Herakles, 49–50
Herodotus, 125
historical figures and events, 46–9,
 122
hydriai, 61, 71, 74, 78, 107, 128

iconography, 119, 122
iconology, 122
immigrant workers, 11
incision, 95, 106–7
influences
 from literature, 122–3
 from works of art, 43–5, 122–3
inscriptions, 52–9, 110–13
Ithaca, 66
itinerant potters, 10
ivory, 70, 95, 123

kados, 63, 65, 71, 74
Kallimachos' Victory, Athens, 42
'kalos' names, 53, 112, 115
kantharoi, 76, 99, 107
Kerameikos cemetery, Athens, 33,
 35
'Kerch' vases, 98
kilns, 10, 21–6
klepsydra, 74
Kolias, Cape, 10
komos, 75
Koroni, Attica, 37

kotylon, kotylos, 63
krateriskoi, 78
kraters, 73, 75, 79, 99, 109, 128
kyathos, 71, 75
kylix, 63

Lacedaimonian grave, Athens, 35
Laconian lakainai, 76
lagynoi, 100
lebes, 61, 74, 75, 78, 79
lebes gamikos, 77, 78
lekanai, 73
lekanis, 77
lekythion, 128, 129, 130
lekythoi, 61, 63, 75, 77, 78, 96,
 99, 107, 109, 129
Lenaea, 78
Leontini, 38
letterers, 65, 112, 113, 125
lining-out, 19
literacy, 112
literary subjects, 50–2, 119–20,
 122
local preferences, 123
louteria, 71
loutrophoros, 77, 78
lydion, 71, 77

Marathon mound, 32–3
mascaroon handles, 109
Massalia (Marseilles), 37
mastoi, 76
Megara Hyblaea, 38
'Megarian' bowls, 76, 110
merchants, 133–4
metalwork, 68, 70–1, 79, 95,
 96–7, 106, 123
monochrome, 93–4
Morelli, G., 113
mosaics, 45–6
Motya, Sicily, 37
mould-made vases, 109–10
multiple brush, 18–19
museums, 3
Myron
 Athena & Marsyas, 43
 Discobolos, 42
myths and heroes, 49–50, 95,
 118–22

names of vases, 62–5, 128
narrative compositions, 118–22

Naxos, 38
Near-Eastern influences, 95
neutron activation analysis, 26
nonsense inscriptions, 112
numbers in workshops, 11

occasions and contexts, 73–8
oinochoe, 78, 99, 109
olpe, 63, 101
Olynthus, Chalcidice, 37
optical emission spectroscopy, 26
orange slip, 96
Oreithyia, 49
ostraka, 57, 125
outline technique, 96, 117
oxides and oxybapha, 129

paddle and anvil, 13, 71
Paestan pottery, 111
painters' names, 67, 111–12
Paionios' Victory, Olympia, 42
Panathenaic prize amphorae,
 53–4, 67–8, 75, 96, 112, 130,
 133
panel-painting, 98, 99–100, 101,
 118, 123
papyrus rolls, 112
Parthenon, Athens, 41–2, 43, 44,
 123
patterns, 45–6, 116–17
Pausias, 45
pelike, 75, 79, 129
perfume, 77
'Pergamene' red, 103
'Perserschutt', 37
Persians, 48
petrographic analysis, 26
Pheidias' Athena Parthenos, 43
phialai, 68, 71, 76, 78, 99, 107
phormiskos, 68, 78, 79
Pithecusa, 38, 66
pithoi, 13, 17, 61, 71, 75, 93, 101
'Plakettenvasen', 109
plemochoai, 78
poinçons, 107
polarising microscope, 26
polemarchoi, 35
politics, 122
polyandria, 32
polychrome, 20, 101–2
'poterion', 63
potteries, 8–13

potters, 65–8
potters' names, 66–8
potters' quarter, 11
preliminary sketch, 18
prices, 129–31
Pronomos, 48–9
psykter, 75
publications, 5–7
public life, 73–4
public pottery, 73–4, 124
pyxides, 68, 77, 78

record reliefs, 43
red-figure, 19, 96–8
reeds, 68
relief line, 20
relief work on vases, 101
religious occasions, 78
Rheneia Purification Pit, 34
rhyton, 70, 71, 76, 110
rouletting, 106–7

St Valentin group, 101
sale catalogues, 6
sales, 132–3
sarcophagi, 78
satyr-plays, 51–2
scientific approaches, 26–7, 59
secondary uses, 124
shipwrecks, 131–2
signatures, 53, 65
silhouette, 94
Siphnian treasury, Delphi, 40
'Six technique', 99
slaves, 11
Smyrna, Old, 37, 66
soldiers, 75
Sostratos, 133–4
stamnoi, 78, 129
stamping, 57–9, 106–7
structuralism, 120–1
stylistic comparisons, 38–46
subjects
 real life, 118
 myth, 118–22
Sybaris, 38
symposium, 75
synoptic composition, 119
Syracuse, 38

tamiai, 54
Taras, 38

Tarsus, 37
test pieces, 24
textile, 123
thermoluminescence, 59
Theseus, 49–50
Thespiai, 34–5
thin sectons, 26
thurible, 78
thymiaterion, 78
trademarks, 126–9
trades and industries, 75
tragedy, Athenian, 50–1
transport amphorae, 17, 26–7, 37,
 57–9, 61, 71, 75, 93, 131
travellers, 75
turntable, 10, 13
Tyrantslayers, 35, 42, 43, 47–8

unguentaria, 77

vintage, 75
'Vroulian' cups, 101

weaving, 76–7
weddings, 77
Western colonies, 38, 134
West Slope pottery, 104–5
wheel, 13–17
white-figure, 98–9
white-ground, 20, 98–100
women and pottery, 76–7
wood, 68–70
workshops, 10–13

Zeus temple and statue, Olympia,
 41, 44–5

Ancient references

Aristophanes, *Ecclesiazousae* v.
 102, 49; *Frogs* v. 1236, 130
Athenaeus *Deipnosophistai*
 4.184D, 142, n. 61

Diodorus *Histories* 14.47–53,
 16.53–4, 37

Eusebius, *Chron.* 96b, 36

Herodotus, *Histories* 1.86–92, 47;
 1.92, 39; 2.30, 37; 3.7.8, 3.39,

40; 4.152, 133; 4.157.3,
4.169.1, 36; 5.62, 40; 6.101, 41;
6.117, 32; 8.52–4, 9.3–13, 37

Macrobius, *Saturnalia*, 5.22.5, 40

Pausanias, *Periegesis* 1.1.1, 1.2.3,
37; 1.17–18, 123; 1.29.4, 32;
1.32.3, 32, 33; 1.33.2–3, 42;
3.6.4–6, 37; 5.10.2, 5.10.4, 41;
5.26.1, 42; 7.16, 37; 10.11.4,
41; 10.25–31, 123
Plato, *Republic* 467A, 10;

Symposium 221A–B, 34
Pliny, *Historia Naturalis*
35.123–7, 141, n. 49; 36.14, 40
Potter's epigram, 22

The Souda, 8

Thucydides, *Histories*, 1.8,
1.31–54, 34; 2.2, 31; 2.34.5,
32; 3.104, 4.93–101, 34;
6.3–5, 38

Xenophon, *Hellenica* 2.4.33, 35

SUBMARINE INSIGNIA
& SUBMARINE SERVICES
OF THE WORLD